Silver Treasures from the Land of Sheba

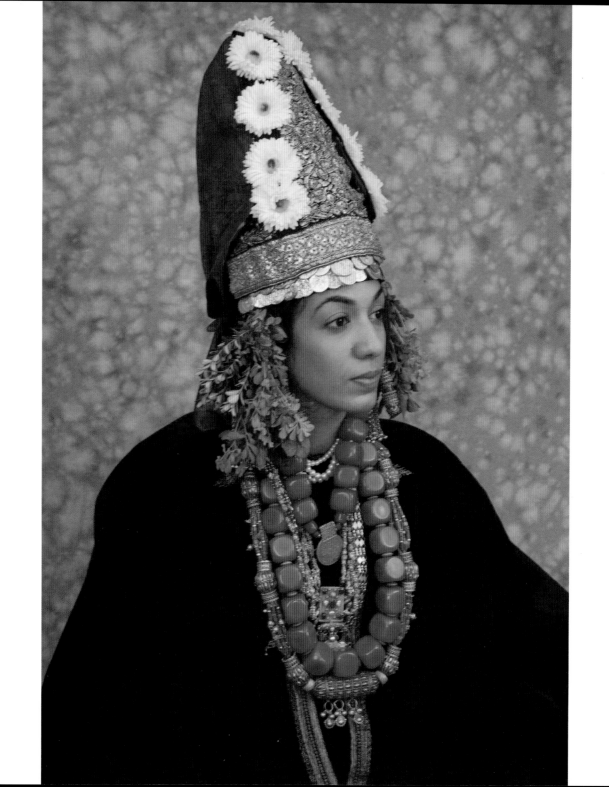

Silver Treasures
from the Land of Sheba

REGIONAL YEMENI JEWELRY

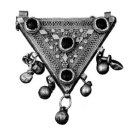

MARJORIE RANSOM

Photographs of jewelry and costumes by
ROBERT K. LIU

The American University in Cairo Press
Cairo New York

The majority of the jewelry and costumes illustrated in this book are part of the collection of David and Marjorie Ransom. Marjorie Ransom donated 400 pieces from this private collection to the Indiana University Museum of Archaeology and Anthropology in Bloomington, Indiana.

FRONTISPIECE. Sanaa: headdress (*qunba'i*), gilded silver embroidered on black polyester, mid-twentieth century • Zabid: headdress with brass coins, 28 cm, mid-twentieth century • Sanaa: hairpieces (*maratiq*), 13 cm, with red ceramic beads, worn only by the bride at her wedding • Northern mountains: hairpieces (*mashaqir*), 15 cm, worn mostly by Khawlan Sanaa brides (just the dangles show below the left chin) • Sanaa: amber beads (*saddaq*), 35 cm, made of real processed amber (the gilded coin pendant is called *masht* because of the comb-like piece affixed to the Imam Yahya coin, dated AH 1344 (AD 1925)) • Sanaa: gilded necklace with original string, 52 cm, with Gulf pearls, mulberry (*tut*) beads, and fine filigree beads, several cabochons set with glass decorate the central plaque and crescent pendant • Northern mountains: chain (*hunaysha*), 42 cm, worn as bridal chain • Sanaa: Czech processed amber beads, 60 cm • Sanaa: silver and coral necklace (*'aqd marjan*) • Sanaa: black cotton velvet dress, embroidered with silver thread • Greenery includes rue (*shadhab*) and basil (*rihan*). Photograph by Dagmar Painter.

This paperback edition first published in 2023 by
The American University in Cairo Press
113 Sharia Kasr el Aini, Cairo, Egypt
420 Lexington Avenue, Suite 1644, New York, NY 10170
www.aucpress.com

First published in hardback in 2014

ISBN 978 1 649 03333 8

Library of Congress Cataloging-in-Publication Data

Names: Ransom, Marjorie, author. | Liu, Robert K., photographer.
Title: Silver treasures from the land of Sheba : regional Yemeni jewelry /
 Marjorie Ransom ; photographs of jewelry and costumes by Robert K. Liu.
Identifiers: LCCN 2023003907 | ISBN 9781649033338 (trade paperback) | ISBN
 9781649033321 (adobe pdf)
Subjects: LCSH: Silver jewelry--Yemen (Republic) | Yemenis--Clothing.
Classification: LCC GT2252.Y4 R36 2023 | DDC 391.709533--dc23/eng/20230213

1 2 3 4 5 27 26 25 24 23

Designed by Bea Jackson

Printed in China

✵

I thank my dear friends

Kamal Rubaih and Hassan Bahashwan

for opening doors to families and silversmiths for me.

Your deep pride in your culture was contagious

and your knowledge is boundless.

Your dedication to my efforts to spread awareness of

Yemeni culture meant that no question went unanswered.

I could not have done this book without you.

✵

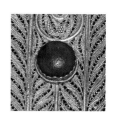

INTRODUCTION

CONTENTS

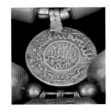

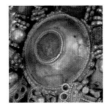

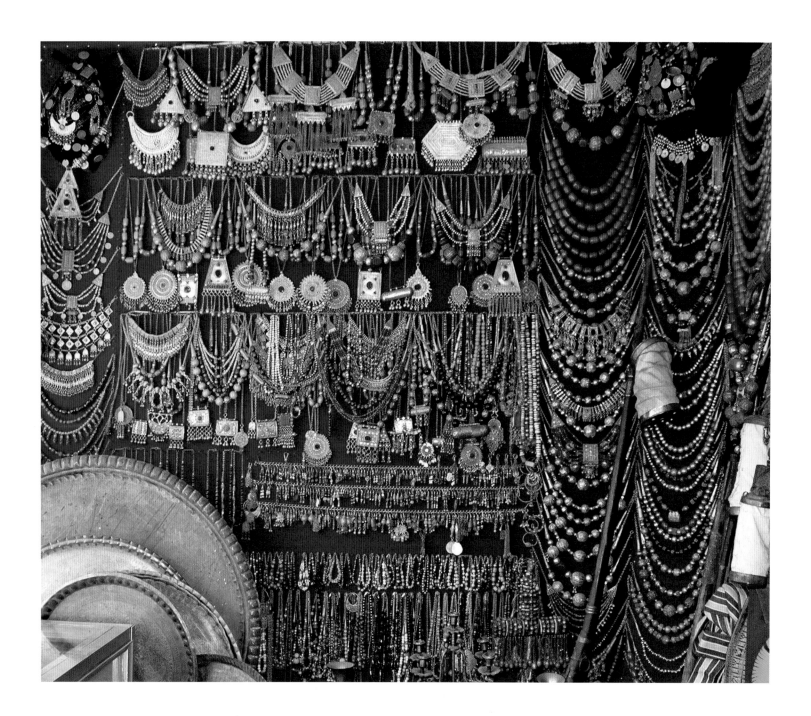

FOREWORD

H.E. Abdulkarim al-Eryani

SPECIAL ADVISER TO THE PRESIDENT OF THE REPUBLIC OF YEMEN

1. Taiz: the silver shop
of Sultan al-Amri, 2006.

In 1966 a young, handsome American couple was assigned to the U.S. Embassy in Yemen. Marjorie and David Ransom arrived in Taiz not knowing what to expect. Marjorie thought it would be tough for a woman diplomat, the only one in a conservative Muslim country. The warm welcome she received from men and women alike won her over and thus started a lifelong friendship with the country and many of its people. I am honored to be one of Marjorie and David's many Yemeni friends. I still have fond memories of David, who left us nine years ago, and remember working with David and Marjorie to start the American Institute for Yemeni Studies.

Marjorie's Yemen is very different from the Yemen most western travelers see today. In the 1960s she traveled with her husband all over the country and witnessed

many things not so common now. Reminiscing about those early days in Yemen she says, "I swear I saw an ostrich in Tihama. You never knew what you would see or experience. When I went to Rayma I saw a troop of baboons clambering up the mountainside. . . . In the mountains near Mahwit I saw the legendary *wabr* [a weasel-like creature]." In the decades that followed she was never too far from Yemen, and Yemen was never too far from her. "Yemen is a deep part of me. I am certainly part Yemeni," she once wrote. When asked why she loved Yemen so, she answered, "It is without exception the most beautiful country I have ever seen—dramatic mountains like Bukur on the way to Mahwit, lush lagoons and palm oases like Wadi Idim in Hadramaut, gorgeous white beaches in Mahra, exotic thatched huts in Tihama, amazing stone houses and colored glass *qamariya*s throughout the mountains."

When Marjorie Ransom bought her first piece of Yemeni silver jewelry back in the 1960s, she started weaving a bond with Yemen that would last a lifetime. To me and many other Yemenis, she is a dear friend who lived among us as one of us and touched the lives of countless people, a diplomat who sent many Yemeni students to study in the United States, and a researcher who visited and interviewed every silversmith in Yemen and documented that ancient art more thoroughly than anyone previously. Marjorie studied silver in Sanaa close up. She lived in the silver market and visited the silver dealers and craftsmen daily. She collected all the time, filling in blanks in her collection as she found pieces that made her narrative more complete. From Sanaa, her quest took her to Taiz, Sayyun, Aden, and Shihr, to remote spots in the northern mountains and to the far reaches of the long wadis in Hadramaut. She went to large and small settlements in Tihama. The variety of jewelry she has documented is an extraordinary testimony to the creativity of the silversmiths and their customers—Bedouin and tribeswomen. Their intricate costumes that are part of the Ransom collection are essential companions to the jewelry.

Yemen is in many ways a living museum. Its stark mountains have made

communication difficult even from valley to valley, to say nothing of interactions with the outside world. Age-old traditions are only now beginning to change, as cell phones and computers make inroads into the traditional tribal society. A gleaming highlight of this living museum is its silver jewelry. Each region in Yemen lends unique aspects of design and symbolism to its jewelry. Thus, the jewelry itself becomes a pattern of history and culture, giving us information that may be available in no other way. Silver jewelry is, indeed, the jewel in the crown of Yemen's history. And that heritage is quickly disappearing as silversmiths die out and gold takes the place of silver in the popular sense of what 'wealth' is.

Thus, the study of Yemen's silver jewelry is a look at the history of this complicated country itself, and how its various regions have developed. In particular, silver jewelry lends insights into the women of Yemen, for whom jewelry has been a mark of identity, security, and pride.

Marjorie Ransom's research could not have come at a better time. The women who wore the many pieces of jewelry in her extensive collection are her contemporaries; their daughters wear gold jewelry or light, machine-made silver. Many of the silversmiths are at the end of their working life; in most cases their sons have taken up other employment.

It does not surprise me that Marjorie was well received wherever she traveled in Yemen. She lived there twice for a total of four years before she began her research. She speaks Arabic and knows Yemeni culture. She has shown through all the years I have known her—and it is probably more than forty—a special love of Arab silver jewelry. She and her late husband David put together a remarkable collection that she has always exhibited both on her person and on the walls and surfaces of their home.

Some years ago, I heard Marjorie speak about Yemeni jewelry at a seminar on Yemeni culture in Washington, D.C. She guided me through her exhibition, *Silver Speaks*, at a museum there that included jewelry from five Arab countries,

but highlighted the jewelry from Yemen's northern mountains and Hadramaut. I encouraged her to devote some time to studying the jewelry of Yemen in greater depth and I am delighted that she chose to do so. I am happy as well that the American Institute for Yemeni Studies was able to assist her.

Marjorie's seminal work makes a great contribution to understanding Yemeni folk culture. I hope that it will be widely read and will serve as a valuable reference for years to come.

FOREWORD

Najwa Adra

AMERICAN INSTITUTE OF YEMENI STUDIES

I first met Marjorie Ransom in Sanaa in March 1978, when my husband, Daniel Varisco, and I traveled to Yemen as graduate students to conduct ethnographic research. Marjorie served as cultural attaché at the American embassy, and one of her duties was to assist American researchers in the country. Besides learning our way in a new city, we needed to finalize our research documents and visas and find a place to stay in Sanaa until these came through. We also needed to travel around Yemen to locate a suitable research site. Marjorie introduced us to Yemeni and expatriate scholars who gave us valuable advice. Knowing that I was interested in dancing, she took me with her to attend my first Yemeni wedding. Marjorie not only provided valuable guidance to us at this time, but welcomed us as friends. We could always visit her in her office or at home, ask questions, and discuss our reactions to our new surroundings.

Marjorie clearly loved and appreciated this rapidly developing country with its rich artistic and scholarly heritage. North Yemen at the time was bustling. Only a decade after the establishment of the Yemen Arab Republic, followed by a lengthy civil war, change was everywhere. In the countryside local communities built roads, mosques, and schools. Returning migrant workers from Saudi Arabia and the Gulf invested in electric generators and diesel-powered flour mills for their local communities. A dazzling range of consumer goods flooded the markets—everything from Scots marmalade and German rye breads to Gucci luggage and the very latest Parisian perfumes. Yemen has seen many changes in the past thirty years and is undergoing a particularly difficult time as I write this, but I will never forget the tremendous energy and entrepreneurship, combined with pride of heritage, that characterized North Yemen in the 1970s and 1980s. When Marjorie remarked that Yemenis were (already) poised to go into the twenty-first century, she was speaking from her wide experience working in a number of countries in the Middle East.

Over the years, Marjorie collected an impressive array of jewelry, costumes, and other crafts from Yemen, as well as from other countries in which she has worked and visited. Silver jewelry in Yemen was not only decorative, but a major item of movable wealth. Brides were given pieces of jewelry that they wore, and through which they could show off their family's wealth. As women accumulated cash, they often invested it in additional jewelry, which they could sell in times of need. As mentioned in this book, pieces of jewelry could also serve as amulets. Pendants often contained protective verses, usually taken from the Qur'an and copied onto small folded-up pieces of paper. As is the case elsewhere in the Middle East, coral, amber, certain colors, and even silver itself were considered protective against the dangers of envy or illness.

Unfortunately, Yemen's extraordinary silver-working traditions have succumbed to the forces of global consumerism and local economic stress as silver prices declined in favor of gold, and as many Jewish silversmiths emigrated to Israel in the 1950s. Soon

after our arrival in Sanaa I bought a beautiful old silver bracelet at the silver market. As I traveled throughout Yemen, women would comment on this bracelet. Young women in their late teens and early twenties would advise me to replace it with gold. But women in their thirties and older would admire my bracelet and then regretfully repeat a story that I heard everywhere I went. These women had sold their collections of silver jewelry for a pittance to itinerant traders who had traveled from village to village buying up silver, as they convinced local women that their jewelry was worthless. They would then sell the same pieces at inflated prices in Yemen's cities.

In *Silver Treasures from the Land of Sheba*, Marjorie has translated her love for Yemen and Yemeni traditions into a compelling narrative about a once vibrant tradition of silver jewelry that has nearly disappeared. Yet this beautifully illustrated book does not simply document a personal collection, as impressive as such a project would be. Marjorie has followed up with serious research throughout Yemen interviewing silversmiths as well as the women who have worn silver jewelry. The resulting volume contains information about jewelry-making techniques, styles of jewelry, and their variation across regional boundaries and through time, as well as when and where this jewelry was worn, and by whom. This book, then, will be of tremendous value to anyone researching the jewelry and crafts of the region. Marjorie has also aided and encouraged the work of contemporary Yemeni silversmiths, bringing some jewelers to the United States to exhibit and sell their work.

The forecast for the future of silver jewelry in Yemen is not entirely dim. Along with women's stories of regret that they sold off their silver jewelry, this book provides other, happier stories of women who kept their silver jewelry and were only too pleased to discuss and celebrate these pieces with an appreciative American researcher. As fashions have changed, I have noticed a renewed interest in silver jewelry on the part of urban and rural Yemenis. *Silver Treasures from the Land of Sheba* and Marjorie's forthcoming work on Yemeni silversmiths are likely to fuel and encourage this trend.

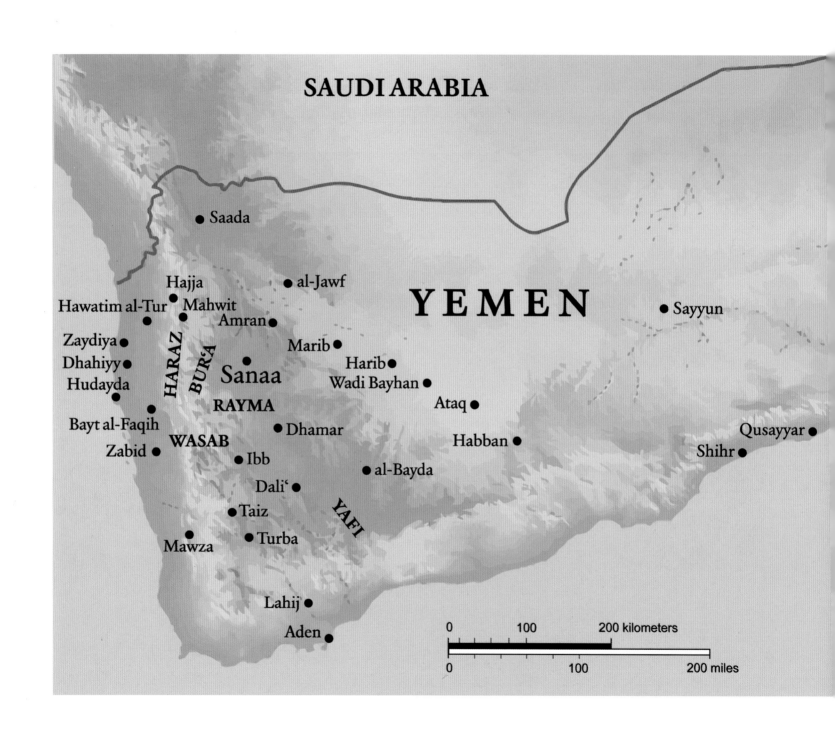

SAUDI ARABIA

YEMEN

Saada

Hajja
al-Jawf
Hawatim al-Tur Mahwit
Sayyun
Amran
Marib
HARAZ
Zaydiya
BUR'A
Harib
Dhahiyy
Sanaa
Wadi Bayhan
Hudayda
RAYMA
Ataq
Bayt al-Faqih
Dhamar
Qusayyar
WASAB
Habban
Zabid
Shihr
Ibb
Dali'
al-Bayda
Taiz
YAFI
Turba
Mawza
Lahij
Aden

0 100 200 kilometers

0 100 200 miles

MAP OF YEMEN

The flat map cannot do justice to the difficulty in reaching the remote areas of Yemen. It does show, though, how widespread the places are where jewelry was made and worn. The map also indicates the variety of the terrain – two seacoasts; high, often inaccessible mountains; and a huge desert to the north and northeast and through the middle of the country. There are also lush oases where beautiful jewelry was produced.

INTRODUCTION

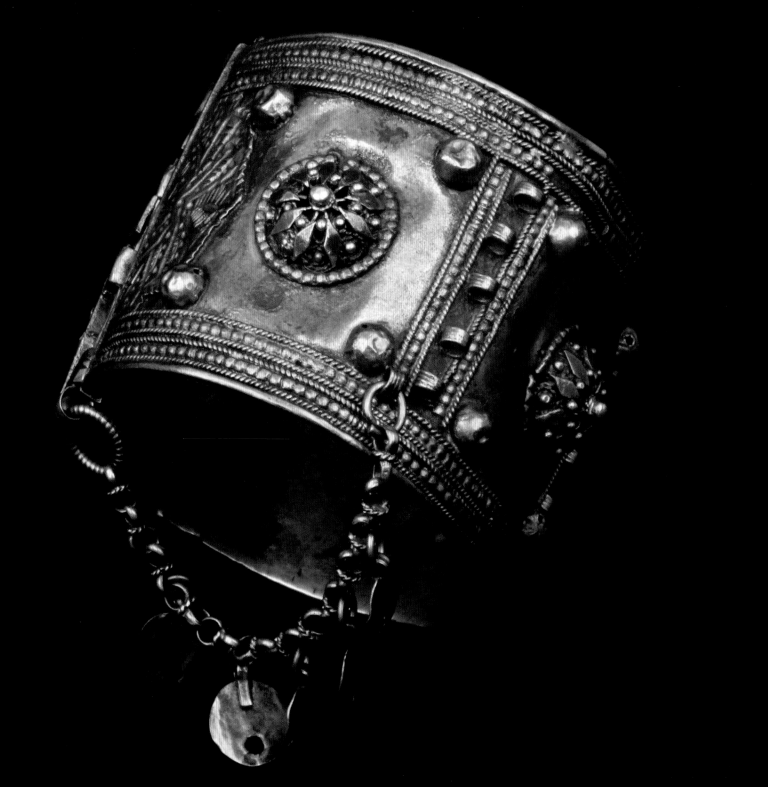

1

The Allure of Silver Jewelry

2. Mardin, Turkey: bracelet, 12 cm.

In 1960, when I was a graduate student at Columbia University in New York, I obtained a study grant to visit the Middle East for the first time. This area subsequently became my late husband's and my area of professional specialization over our thirty-year careers as United States diplomats. Toward the end of my initial visit, I traveled to Damascus, where I shopped for mementos for my family at a store in the Hamadiya Bazaar in the old city. Among the enormous array of Middle Eastern handicrafts on display, the wonderful bracelet shown in figure 2 caught my eye. It was pewter in color, not shiny, and made the clanking sound of a camel caravan. It held for me all the mystery and allure of the east that I was just getting to know, and its bulky size and geometric motif made it very pleasing to the eye. I had to have it! This bracelet became my personal signature piece of jewelry for many years to come, and the first in a collection that over the years has grown to more than nineteen hundred pieces.

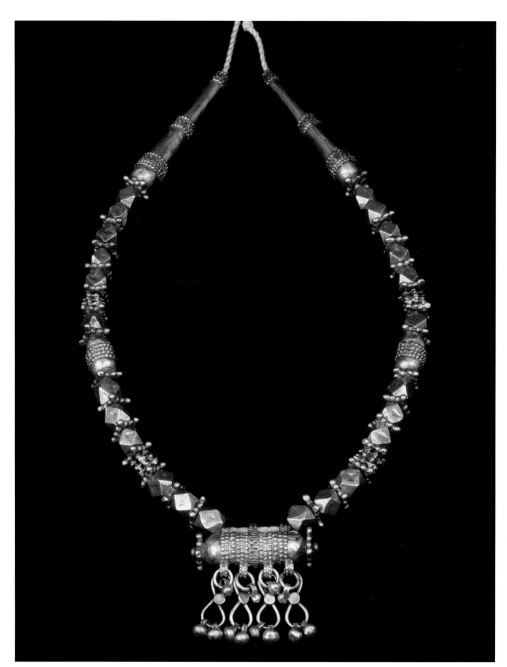

3. Najran, Saudi Arabia:

necklace, 60 cm.

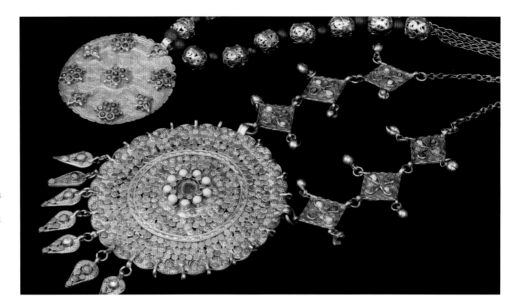

4. Taif, Saudi Arabia: gilded silver medallions purchased by David Ransom in 1969.

Five years after that introduction to the Middle East, I married David Ransom, whom I had met in a summer Arabic class at Princeton University. As we embarked on our tandem diplomatic careers, Arab silver jewelry became a joint pursuit. In the late 1960s, while posted in Jeddah, we learned that old family pieces were melted to make new jewelry for a bride. We began asking to see the baskets of discarded jewelry in silversmiths' shops destined for their melting pots and found lovely old Saudi pieces ready for destruction. Together we felt an urge to learn, document, and preserve an art form that we both found unique and beautiful. Some of the jewelry pieces were coarsely made, clearly done by amateurs or beginners. Others were more artistically assembled, such as the necklace in figure 3 that we rescued from a Jeddah melting pot. David not only shared my enthusiasm but over the years, on his own, found some of our best pieces, for example the gilded silver medallions in figure 4.

Our two postings to Yemen, in 1966 and 1975, proved pivotal to our study of silver and to the expansion of our collection. Yemeni Jewish craftsmen were known

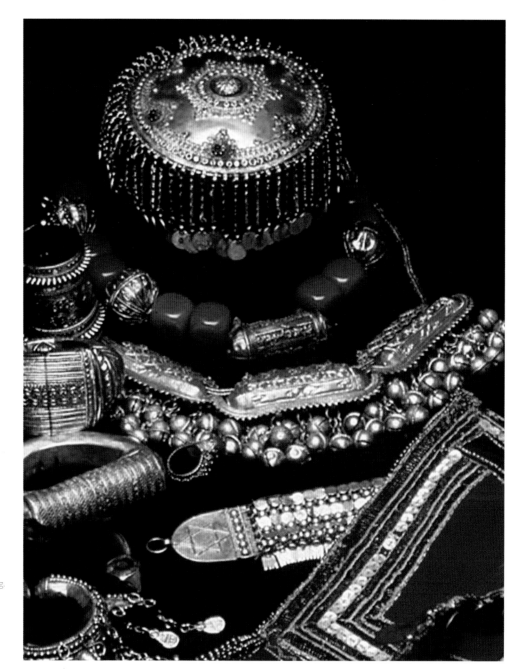

5. *Silver Speaks* exhibition catalog.

throughout the Middle East for their delicate work; they had comprised much of the silversmithing craft in North Yemen prior to their 1949 exodus to Israel. Although there were many fine Yemeni Muslim silversmiths, the art form was clearly threatened when the Jews departed. Preservation became for us a principal goal.

By the mid-1970s I was wearing beautiful old Arabic silver jewelry to nearly all diplomatic events I attended in order to spread knowledge of and appreciation for this unique art form. Our collection grew over the course of postings in Sanaa, Damascus, and Cairo and evolved from pieces just for me to wear, to larger and more spectacular pieces as adornment for our residences. We bought headdresses, hairpieces, and enormous belts. When we displayed them on our walls and tabletops we were able to compare pieces from different countries and regions and note the missing pieces to seek out. Making the collection as complete as possible became an important part of our lives.

After my retirement from the Department of State in 2001, a chance encounter with exhibit designer Ellen Benson from Washington, D.C.'s Bead Museum inspired me to organize my silver collection, which had been gathering dust in locked cases in my home. Together we agreed to assemble the exhibit *Silver Speaks: Traditional Jewelry of the Middle East* from the best of my pieces from five of the countries where I had served: Egypt, Oman (my actual posting was next door in the United Arab Emirates), Saudi Arabia, Syria, and Yemen. As I wrote exhibition captions for the jewelry, I became woefully aware of how limited my information was. I had collected good pieces, but I had not gathered information about the original wearers of the silver and the significance the pieces had in their lives.

The exhibition proved to be a great success and introduced many Americans to the beauty and craftsmanship of Arabic silver jewelry, as well as reigniting in many Arab visitors a renewed interest in the material culture of their countries.

Contacts I made while working on *Silver Speaks* led to an invitation to lecture on

Yemeni silver jewelry at a seminar on Yemeni culture sponsored by the Freer Gallery in Washington in 2002. Dr. Abdulkarim al-Eryani, a special adviser to the president of Yemen, was in attendance and later encouraged me to research Yemeni silver further. Two grants from the American Institute for Yemeni Studies enabled me to study the history of traditional silver jewelry in Yemen during various stays between 2004 and 2007, visits that together totaled over a year.

Yemen, with a greater tradition of silver jewelry than any other Arab country, was a rich repository for research. And while Yemeni society is inherently conservative, its people are quite open to foreigners and interested in their lives. My knowledge of and affection for Yemen, born during our two diplomatic postings there, grew enormously through daily encounters with, for instance, taxi drivers. In my first lengthy stay I lived a long taxi ride across town from the old city where I was conducting my research and I relied on them twice daily to ferry me to and fro. One day, the taxi driver I hailed was a tribesman from the Khawlan area northeast of Sanaa. As we drove together, he asked me details of my life. Where was I from? Was I married? How many children did I have? He told me similar facts about his life. Then he wanted to know what had brought me to Yemen. I told him I had a scholarship to study Yemeni silver jewelry. That really impressed him. He looked at me quizzically in the rear-view mirror and asked, "How old are you?" It is not a question that I always like to answer, but I said, "Sixty-seven." He drew to an abrupt stop on the side of the road and proclaimed to me in a loud, emphatic voice, "You are a *bulbul* [nightingale]! When Yemeni women are your age," he said, "they are all worn out and good for nothing but sitting at home. You must marry a Yemeni and stay with us in Yemen!" Another taxi driver quizzed me about my daughters. He was pleased that two had married and had children, but he was concerned that the eldest had not married. "Don't worry," he said, "I will marry her!"

The boldest interlocutor I encountered proved to be Said, one of my two guides

6. Mahra, April 2005, left to right: Said, a bodyguard, Mubarak, and Abdulla.

across southern Hadramaut to Mahra on the Arabian Sea. One very hot day, after I had interviewed the two silversmiths in Sayhut, I rented a hotel room so that we—Said's partner Mubarak, my government-imposed bodyguard, and my driver Abdulla—could escape the midday heat. To while away the time I passed around the album of family pictures I carried with me in Yemen to demonstrate my healthy family ties. Included was a picture from our most recent family wedding where we had posed with another family close to us. They have two beautiful daughters. Said asked if they were married and with all earnestness declared his intent to marry the younger. I did not take him seriously, of course, but my driver told me later that Said told him he was thinking of taking an American wife. He said this despite the fact that he already had two wives and seven children! I call it Yemeni nerve.

7. Tawila, Mahwit governorate: Sayyid Hussein al-Ghirsi. 'Sayyid' is the title given to a descendant of the Prophet.

Throughout this book I will share other tales of Yemeni boldness, but, more often, stories of their extraordinary kindness and generosity. Mubarak, for example, decided that it was a waste of time and money for my driver, bodyguard, and me to commute an hour to and from a hotel in Shihr before traveling east to Sayhut in Mahra, so he and Said offered us hospitality in their homes. I slept on a thin mattress on the floor of Mubarak's living room and Said took the two men into his house. Before retiring to the family part of his house, Mubarak told me that he would not be far away and that I should call on him in case of need. I rose at 3:30 a.m. to go to the bathroom and then returned to my bed. When Mubarak was serving us breakfast in the morning he said to all assembled, "Marjorie is such a good person. She rose at 3:30 this morning to say her prayers!" I did not disabuse him.

Yemenis take great pride in their heritage and welcome attempts by foreigners to study it. This can have unexpected consequences. Once I was walking from an old house in a section of the old city of Sanaa with which I was not familiar. I asked a man passing by with his family if I was headed in the direction of the *sayla*, the road dividing the old city from the new. He affirmed that I was and then walked alongside me. He asked where I was from and what I was doing in Yemen. I was wearing my big camera around my neck. After I explained that I was researching the traditional silver jewelry of Yemen, he asked if I knew Tawila, a small city on the road to the capital of Mahwit province. I answered that I did. He asked if I had taken a photo of a man wearing a dagger, or *jambiya*, there. I reflected and then remembered that I had photographed a man in Tawila (figure 7) who was wearing a very special *jambiya* made in the distinctive Zaydiya style and in the shape favored by both judges and *sada* (descendants of the Prophet Muhammad). He asserted that Sayyid Hussein al-Ghirsi was waiting for a copy of the picture I took of him! I had been in Tawila at least seven months earlier; it was a two-hour drive from Sanaa. Yemen is a country of twenty-some million, and this man found me in Sanaa and pressed his friend's demand for a

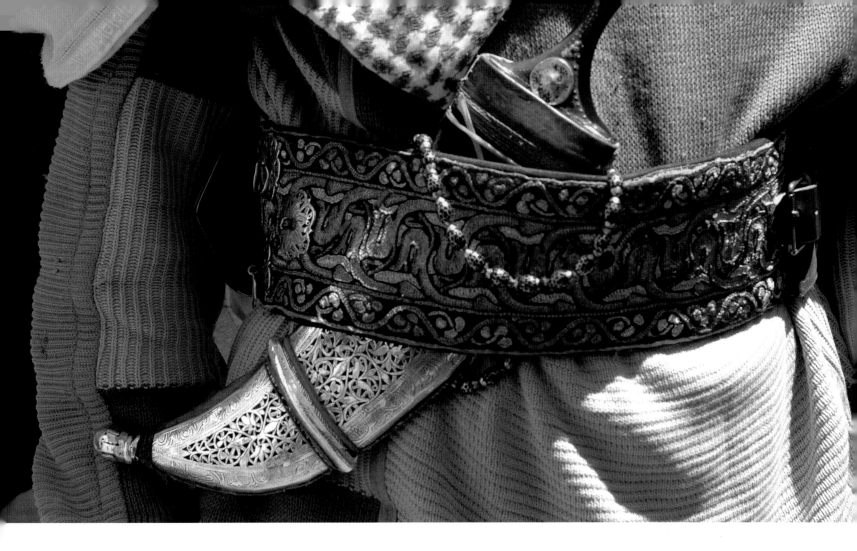

8. Tawila, Mahwit governorate:
Sayyid al-Ghirsi's dagger (*jambiya*),
made in Zaydiya,
photographed May 2005.

photo. After that encounter, I made sure to get the photo to Sayyid Hussein quickly.

Wherever I traveled, silversmiths I approached were ready and willing to talk about their craft. Few before me had asked them about their work and they shared their histories with enthusiasm. Old ladies literally grew in stature as I asked about their wedding jewelry. Not many visitors had previously paid them much attention, then suddenly this foreign researcher was there asking them questions. Their eyes shone.

My findings in this book are based on personal interviews that I conducted in Arabic. Since most women stopped wearing silver in the 1950s, I wanted to interview men and women of at least sixty years of age. Kamal Rubaih, my consultant in Sanaa, could communicate with me in English; my other interviewees spoke only Arabic. The few times I had difficulty understanding a dialect, I found an educated, younger family member to help translate into standard Arabic. As a single woman no longer young, I had extraordinary access to families and their stories.

However, it was often a challenge to be allowed to leave the male silversmiths and silver dealers to join the women in their living section of the house. The men assumed I could gather little useful information from women and that they, the men, knew so much more. But they were wrong. Only women my age and older have firsthand knowledge of how the silver jewelry was used in family and community culture.

In the course of my research I studied the jewelry that tribal and Bedouin (nomadic) women wore and local silversmiths made. This type of jewelry was found all over the Middle East, but none of the countries I studied had quantities of silver comparable to what I found in Yemen. Saluma Awad Huwaydif Bawazir al-Dis from Dis al-Sharqiya on the southern coast of Hadramaut, in figure 9, told me that she had more than ten kilograms (twenty-two pounds) of silver jewelry when she married some fifty years earlier. "There was so much silver jewelry," she said, "there was no worry of theft. Everyone had some."

Now gold has taken the place of silver as the valuable metal and those who have managed to afford a few pieces of gold have to watch it carefully or it will disappear. And, to my immense regret, the old silver is still being melted down to be sold as silver ingot—a tradition traded for cash. Most of the women I interviewed, women of limited means, have sold their silver jewelry at low prices to traveling merchants. When I began my study I was sure that Bedouin women still wore silver jewelry. With my local Yemeni guide Said, I traveled forty-five kilometers inland to Mishqas,

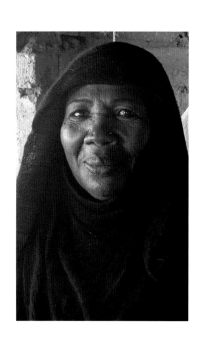

9. Dis al-Sharqiya:

Saluma Awad Huwaydif Bawazir al-Dis,

April 2005.

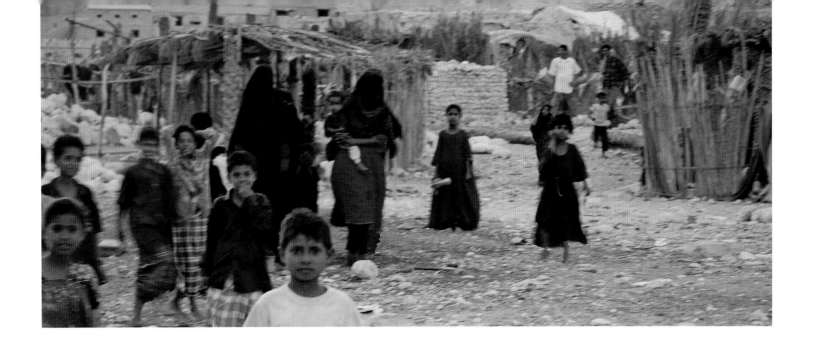

10. Bedouin women and children in the interior of southern Hadramaut. April 2005.

east of the fishing village of al-Qusayyar on the southern coast of Hadramaut, to interview them. I visited three households and then spoke to a group of thirty or so women gathered outside a local market (fig. 10). They did not have one piece of silver jewelry among them! This unfortunately proved the rule in most of my encounters with both Bedouin and tribal women.

My hope is that this study will contribute to an appreciation of the economic and social importance of silver in Yemeni society before 1970 and create increased demand for these exquisite pieces of traditional silver jewelry before the craft disappears entirely. I also want to share with a wider world my impressions of an extraordinarily humorous, hard-working, and deserving people.

In this book I have not said much about the silversmiths themselves, the men—and sometimes women—who made this wonderful jewelry. I will tell their stories in a second volume.

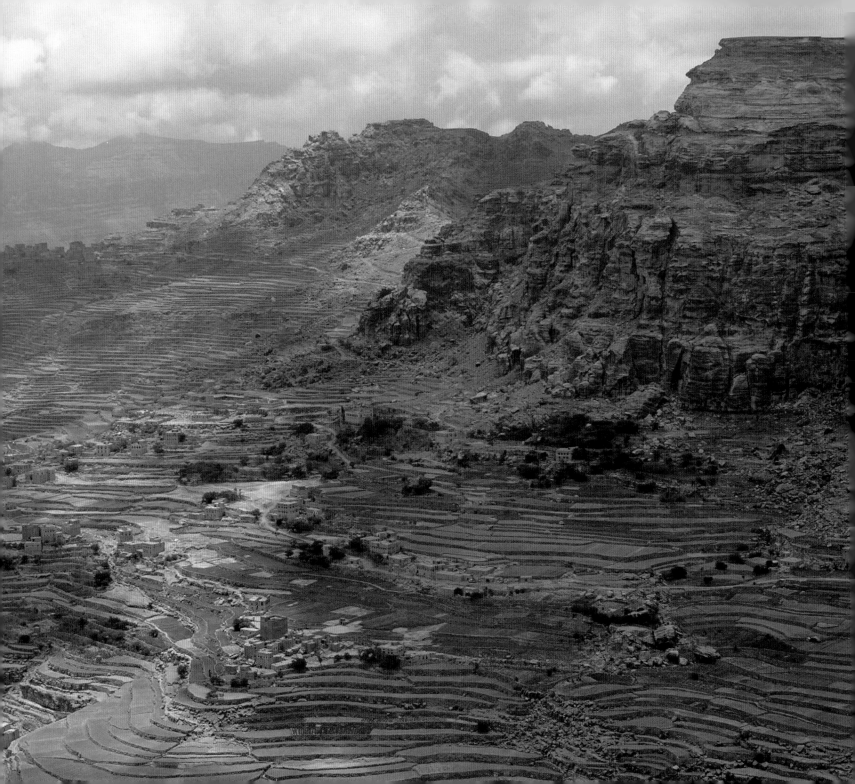

—— 2 ——

The Timeliness of This Study

11. Bukur, Mahwit governorate: a wadi (canyon) reputedly as deep as the Grand Canyon in the United States, photographed as the clouds roll up from the Red Sea, April 2005.

As Yemen is an agricultural country, its life was determined by water, specifically the harvesting and storage of rainfall by the millions of terraces built up and down the mountainsides. For thousands of years the monsoons and the mountains, together with the formidable energy of the Yemeni people, created wealth. The strategic location of the port of Aden along the Red Sea–Indian Ocean sea route made trade important as well. Thus, throughout its long history, Yemen has been the seat of extraordinary kingdoms and empires, rich in learning, elaborate social customs, and enterprise. From the time of the legendary Queen of Saba' (Sheba in western parlance) and earlier, these civilizations produced complicated social and physical structures that have long attracted scholars eager to study and document their accomplishments.

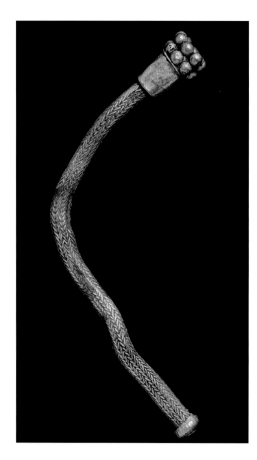

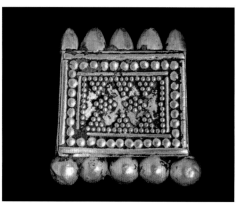

Along with its remarkable history, glorious monuments, and impressive physical beauty, Yemen created a uniquely beautiful architecture, a complicated and intriguing social structure, and exquisite, labor-intensive handicrafts. Of all the crafts—building, textile and basket weaving, leather working, embroidery, and woodcarving and carpentry, none is more beautiful and distinctly Yemeni than traditional silver jewelry.

For centuries, gold and silver jewelry was produced throughout Yemen by Jewish and Muslim silversmiths, with remarkable continuity in design and techniques. The earliest evidence we have of the craft comes from the time of the Queen of Sheba, as shown in figures 12 and 13 from the British Museum. The loop-in-loop technique in the chain in figure 12 and the fine granulation and beadwork visible in the rectangular amulet in figure 13 are some of the same elements you will see in many of the twentieth-century pieces in this book. Figure 14, for example, is a mid-twentieth-century loop-in-loop belt, hand-woven by a woman in Hadramaut. Granulation, or *shadhraat*, is a process that joins small, usually round, balls, or granules, to a base, as in figure 15.

Filigree, or *shabk*, as in the box in figure 16, is a form of delicate wirework. It began to appear in Yemeni silver jewelry in the late nineteenth century and was perfected by Harun Bawsani, an important Yemeni Jewish silversmith in the early twentieth century.

In at least the last fifty to 150 years, the period of my study, these three techniques were used in a number of jewelry centers in both the Imamic kingdom of the north and the British protectorate of Aden in the south. From fifty to seventy years ago, when the price of silver fell in value and the price of gold increased dramatically, women's taste turned from traditional silver jewelry to gold pieces, many of them imported from abroad. This trend was perhaps accelerated, especially in North Yemen, by the departure of most of the Yemeni Jewish silversmiths to Israel in 1949, but also by the influx of Yemeni workers into Saudi Arabia when the price of oil spiked

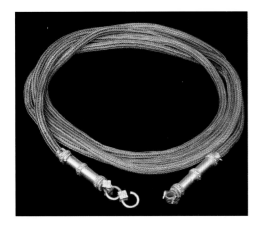

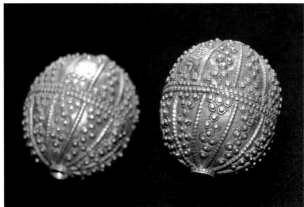

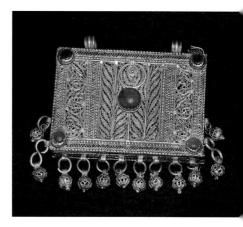

in the 1970s. There they were exposed to new and different fashions, as well as attractive modern appliances, which could prove more useful than traditional jewelry.

Most of the silversmiths I interviewed were in their seventies or eighties and retired. Those in their sixties were near retirement. Their sons had, for the most part, taken up other livelihoods. The women who had worn the silver were in their sixties and older. In ten years or so it will be almost impossible to gather their stories.

Currently there are pockets of young men in Yemen who make new light silver jewelry using machines. I found them in Aden, Ataq, Shabwa, Shihr, and Sayyun. There are also some in Sanaa and Taiz. I wrote about the young silversmiths who still use traditional techniques in my article, "The Enduring Craft of Yemeni Silver."

I have included, where I can, a transliteration of the Arabic term used to describe the piece of jewelry. You will note that different terms are used in different parts of Yemen.

Due to space limitations, this volume is confined to the jewelry and costumes worn by Yemeni women in the twentieth century. The twenty or so pieces of jewelry in the Ransom collection from the nineteenth century and earlier will appear in a special chapter in a second volume, which will be devoted to the men—and sometimes women—who made the jewelry.

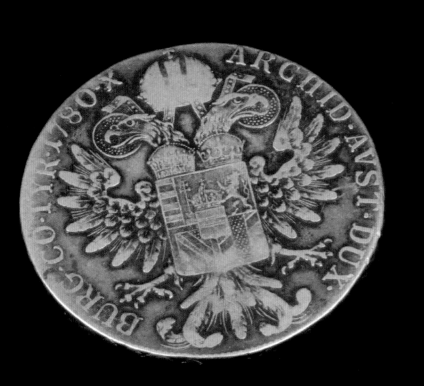
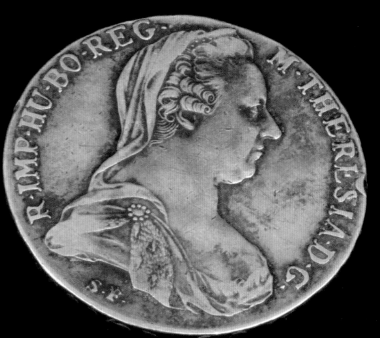

—— 3 ——

The Source of Silver

THE MARIA THERESA THALER

A question often asked when I lecture about Middle Eastern silver jewelry is where the silver for the jewelry came from. In the biblical story of the visit of the Queen of Sheba to Solomon, somewhere between the twelfth and tenth centuries BC, as related in I Kings 10:22, there is mention of the queen taking silver and gold and other commodities from Ophir, or Yemen, which would seem to indicate that there was silver in Yemen then. In the tenth century AD, the Yemeni scholar Hassan al-Hamdani wrote about the silver mine al-Radrad in Wadi Harib Nihm, close to Sanaa; supposedly it was operated by Persians from before Islam to the early Middle Ages.[1] There were silver mines throughout Asia Minor, in Iran, in what is now Afghanistan, and in eastern Turkmenistan. There was heavy trade in silver coins across the silk route, some of which went into jewelry. But when I began my research

in Yemen I quickly learned that while jewelry was sometimes made from old, broken, recycled pieces, it almost always came from melted-down Maria Theresa thalers, like those in figure 17.

The Maria Theresa thaler (MT) was minted in Austria after the first year of the reign of the Habsburg empress, Maria Theresa (r. 1740–80). When she died, a new coin was struck in the image of the new ruler, but it was not accepted in Yemen, where the Maria Theresa thaler had become, in effect, the local currency due to the expansion of trade with Europe, based on the export of two important Yemeni crops: coffee, which grew in the mountains, and indigo, which grew in the flatlands. Thus, for more than two hundred years, MTs have borne the date 1780, comprised 83.3 percent silver, and weighed 28.0668 grams. The engraving on the edge of the coin made it difficult for anyone in the exchange chain to shave off a bit of the silver and also made it more difficult to counterfeit. Called 'French riyal' in local parlance, the MT is still found in Yemeni silver shops. There is a story that circulates about Imam Yahya, the second-to-last royal ruler of Yemen, who had a tax collector who collected taxes from the citizens in MTs. This tax collector got the idea of shaving a small amount of silver from each coin to enhance his income. Unfortunately for him, the imam knew what the weight of each MT should be and weighed the coins coming into his treasury. When they were found to be light, the tax collector lost his life, or so it is rumored.

In Yemen, silver coins served as a savings bank for many people, especially Bedouin and tribesmen. They were the key element in the marriage contract. (In Islam, the groom pays for the right to marry his bride.) *Milak* is the engagement contract drawn up by the groom and the father of the bride before the Muslim religious leader, the imam, and two witnesses. This contract is more important than the wedding ceremony that takes place much later, for it is when the groom gives the *mahr*, or bride price. The bride's father usually spent a percentage of the *mahr* for

silver jewelry, which, according to Muslim law, became a woman's personal wealth—her right according to custom and tradition. The jewelry declared her status as a married woman of property. The fact that silver jewelry was sold by weight enabled women to use it as their portable bank account. A woman always knew the value of the pieces she owned. She sold her silver in case of need, but often bought additional pieces when she had the means. It serves as her insurance throughout her lifetime and ideally the decisions of how to use it are hers. What was left when she died was often used to pay for her burial.

The jeweler would use the percentage and quantity of silver that fitted the needs and ability of his customer to pay to craft the new bride's jewelry. When a higher percentage of silver than the 83.3 percent found in the thaler was desired, the silversmith could turn to the Saudi riyal, seen in figure 18, which was roughly 93 percent pure, or the equivalent of sterling silver. My pieces from the nineteenth century and earlier were usually made in 50 percent silver, called *nisfi*, or half. When the pieces were made in 83 percent silver or higher they were deemed special. At the beginning of the twentieth century most fine pieces were made in 83 percent silver or higher. Bedouin and tribeswomen in remote areas often bought pieces of low silver content, or nickel, as they were what they could afford.

Bedouin savings were traditionally in livestock and silver jewelry. Both were used for commerce. Thus, nomadic women's dress and jewelry were essentially richer and more differentiated than their urban counterparts. Perhaps it was partially because a nomadic woman did not veil in those days, and others could view her jewelry. Also, the nomadic economy was risky. Nomads needed readily salable, valuable, and easily transportable reserves of capital. In urban settings, the acquisition of landed property or participation in promising commercial ventures were always more attractive.

18. Saudi riyals, front and back.

---- *4* ----

Regional Styles of Yemeni Jewelry and Costumes

19. Swaiq, near Zabid in Tihama, hosts

a weekly market for the area.

Present-day Yemen extends from the Red Sea to the border of Oman in the east, and from the border of Saudi Arabia in the north to the Gulf of Aden in the south. From the ninth century until the mid-twentieth century, North Yemen was ruled by imams, descendants of the Prophet Muhammad, known in Yemen as *sada* or *ashraf*. A revolution in 1962 overthrew the imamate and established a democratic republic. The southern and eastern parts of Yemen were occupied by the British from 1839 until 1967, when the People's Democratic Republic of Yemen (PDRY) was formed. In 1990, the two Yemens were united into the Republic of Yemen.

The jewelry in my period of study—from the mid-nineteenth century to the early 1960s—reflects the past political separation, illustrated in the map on pp. 24–25. The jewelry of the north was influenced by ideas introduced during the second Turkish

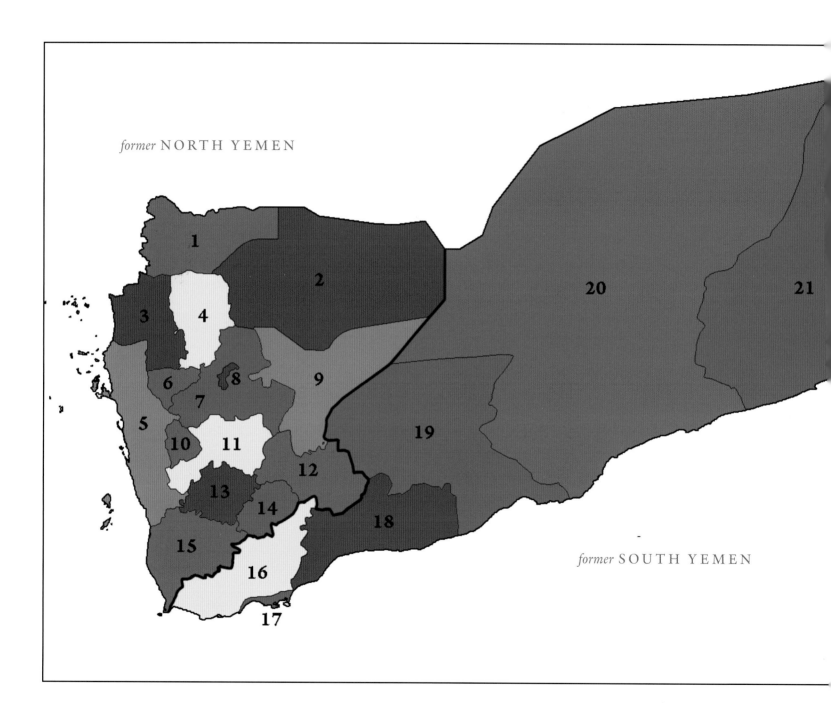

former NORTH YEMEN

former SOUTH YEMEN

FORMER NORTH YEMEN
(Yemen Arab Republic)

GOVERNORATE	CAPITAL CITY	KEY
Amran	Amran	4
Dali'	Dali'	14
al-Bayda	al-Bayda	12
Hudayda	Hudayda	5
al-Jawf	al-Jawf	2
Mahwit	Mahwit	6
Amanat al-Asima	Sanaa	7
Dhamar	Dhamar	11
Hajja	Hajja	3
Ibb	Ibb	13
Marib	Marib	9
Rayma	Rayma	10
Saada	Saada	1
Sanaa	Sanaa	8
Taiz	Taiz	15

FORMER SOUTH YEMEN
(People's Democratic Republic of Yemen)

GOVERNORATE	CAPITAL CITY	KEY
Aden	Aden	17
Abyan	Zinjibar	18
Mahra	al-Ghayda	21
Hadramaut (includes Socotra)	Mukalla	20
Lahij	Lahij	16
Shabwa	Ataq	19

occupation, 1876–1918; the southern part of Yemen looked east and the jewelry shows Indian influence. Thus, I have divided the book into sections dealing in general with jewelry from the north and from the south. Within these two divisions, I have grouped several subdivisions in order to introduce to the reader the large variety of regional styles in Yemeni traditional silver jewelry.

THE NORTH

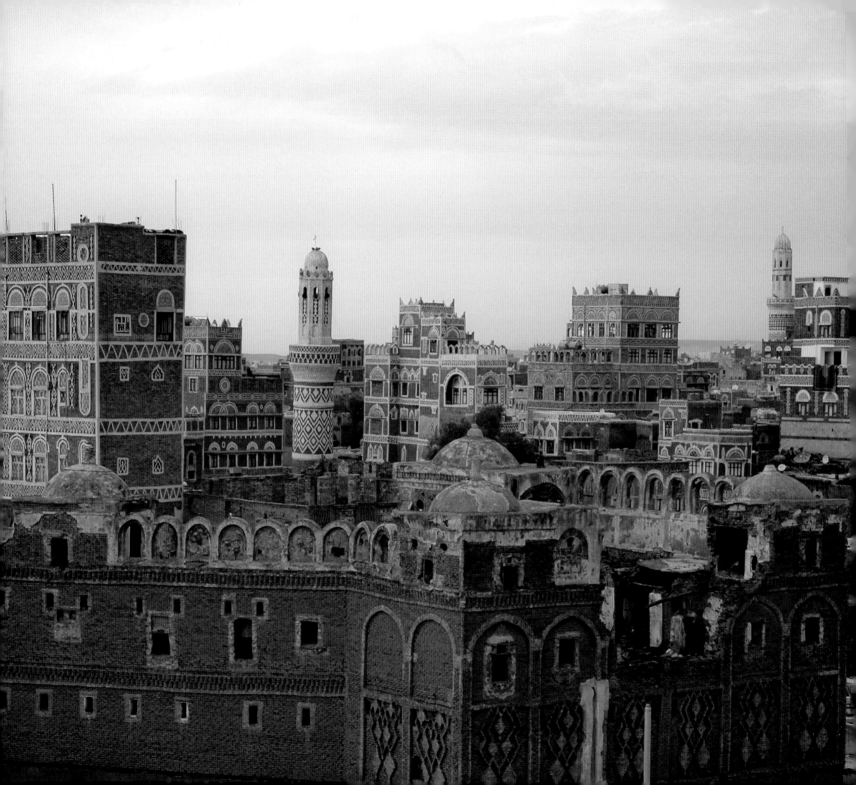

— 5 —

The Northern Mountains

SANAA, SAADA, AMRAN, HARAZ, MAHWIT, JABAL MILHAN, AND HAJJA

20. Caravanserai Muhammad bin al-Hassan bin al-Qasim, or Dar al-Mal (House of Money), on a rainy day. Merchants stored their caches of silver here in times long past as it was a secure repository, May 2005.

SANAA

Sanaa, the capital of Yemen, is one of the oldest cities in the world and one of the best-preserved traditional Islamic cities in the Arabian Peninsula. It is also the highest capital city in the Middle East, situated at 2,195 meters (7,200 feet) above sea level. Seated on major trade routes that date back centuries, it has as many as forty distinct markets and several ancient caravanserais that housed visiting caravans, their animals, and their wares. The old city of Sanaa is a vibrant, lively place where artisans practice their crafts and people from across the modern city come to shop. Extended families inhabit large, old buildings and often live upstairs over street-level shops.

In the heart of the old city is the salt market, or Suq al-Milh, where the silver market, or Suq al-Fidhdha, is located. It is where I lived for most of my time in Yemen and did much of my research. Silver dealers and silversmiths opened their homes to me as they shared valuable information about their craft.

21. Old Sanaa: the silver market, June 2005.

Mornings in the market are the purview of men and the occasional foreigner, as shown in figure 21. But the women come out to do their shopping for jewelry in the afternoon, after they have finished lunch preparations and cleanup. In figure 22, two women are bargaining over coral. I could not get close enough to determine whether they were buying or selling—either is possible. The woman on the left wears a striped head covering that was originally made in Sanaa by the family of Abd al-Ghani al-Thulayya. Now cheap Chinese copies are sold in the market. This covering is worn by older women in Sanaa and the nearby countryside.

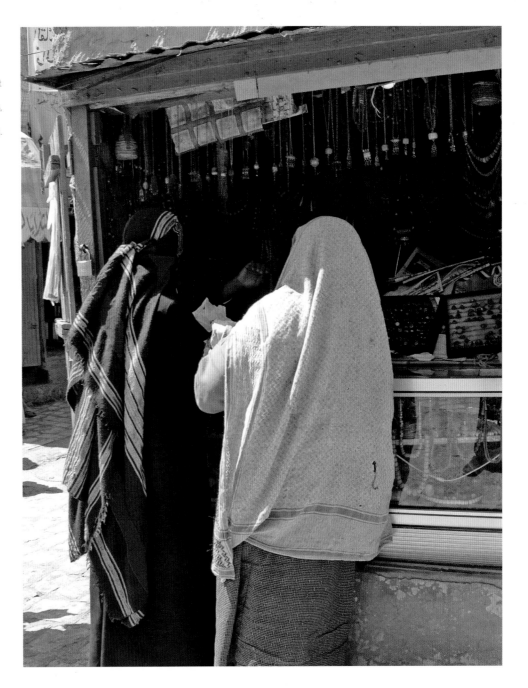

22. Old Sanaa: women at Abd al-Salam Hamud al-Harithi's shop, June 2005.

23. Sanaa: outer garment *(sitara)*, headpiece *(ras maghmuq)*, tie-dyed cotton face veil *(maghmuq)*, and Indian silk dress, the House of Folklore, January 2009.

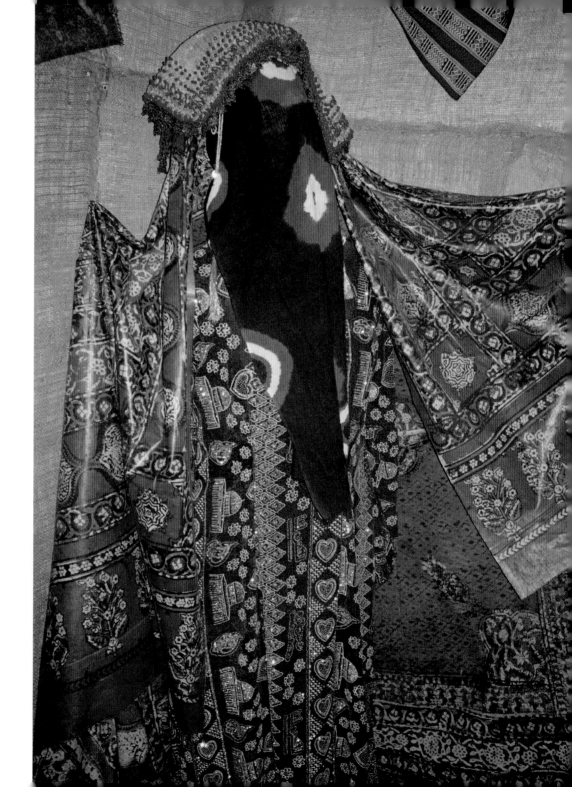

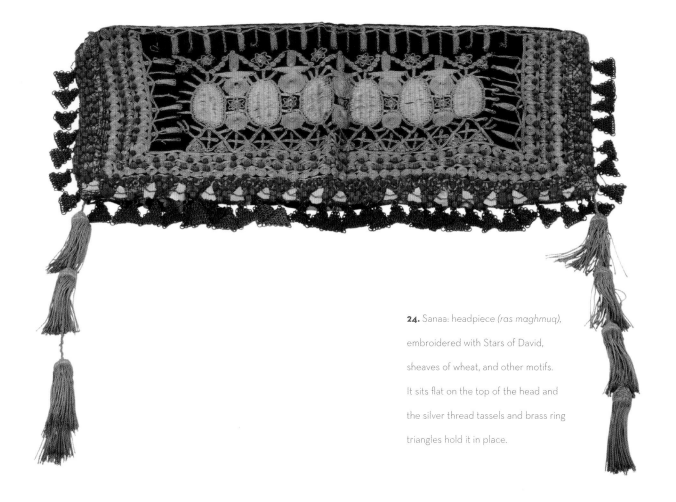

24. Sanaa: headpiece *(ras maghmuq)*, embroidered with Stars of David, sheaves of wheat, and other motifs. It sits flat on the top of the head and the silver thread tassels and brass ring triangles hold it in place.

A traditional Sanaani woman wore a popular outer garment (fig. 23), a face veil, with large eye motifs to repel the evil eye and an embroidered headpiece over a silk dress (fig. 24). The outer garment was originally made in Indonesia and later in India.

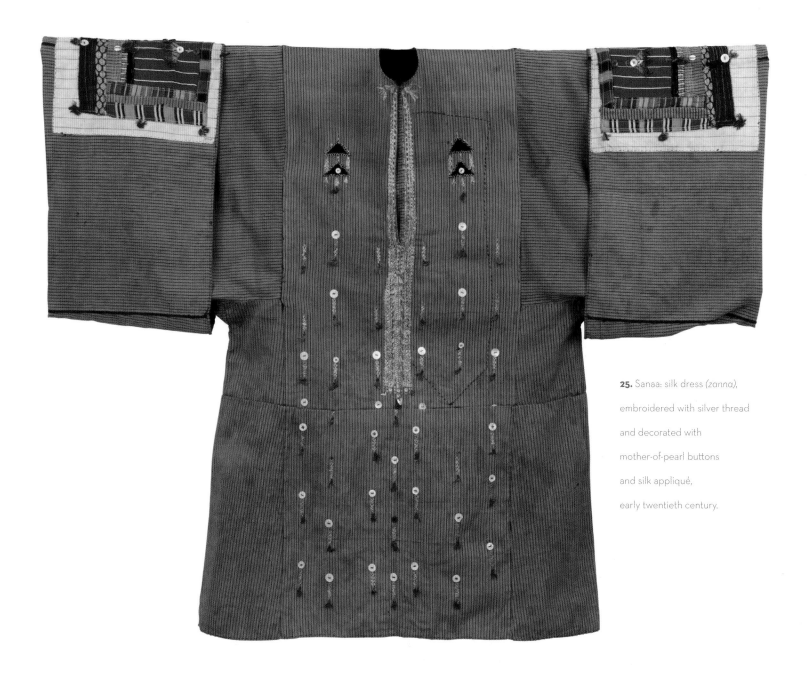

25. Sanaa: silk dress *(zanna),*
embroidered with silver thread
and decorated with
mother-of-pearl buttons
and silk appliqué,
early twentieth century.

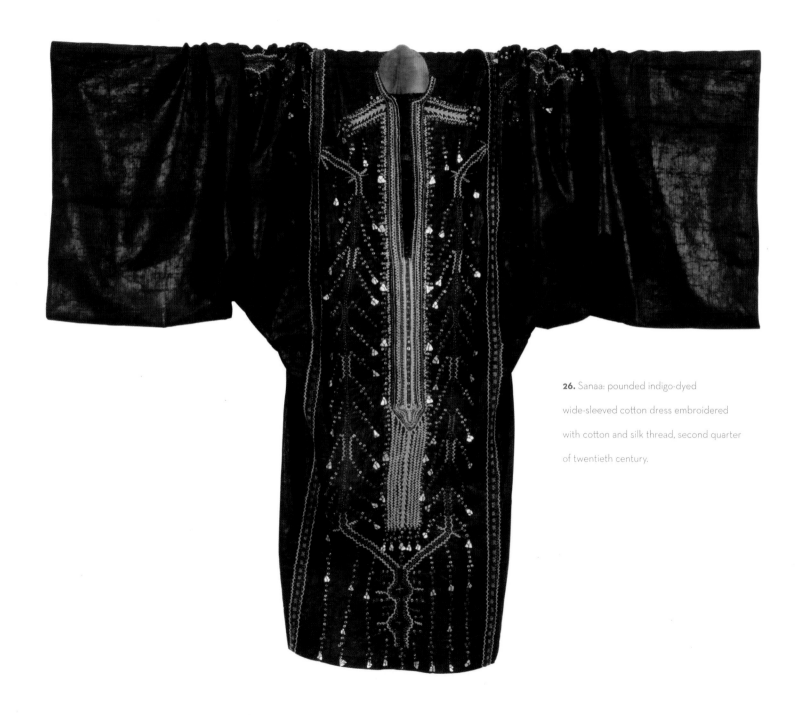

26. Sanaa: pounded indigo-dyed wide-sleeved cotton dress embroidered with cotton and silk thread, second quarter of twentieth century.

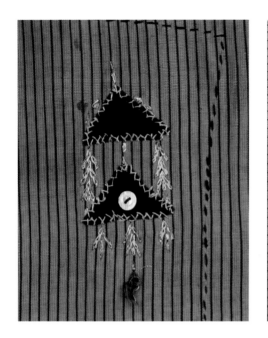

27. Dress front detail of figure 25 showing couched embroidery in silver thread, as well as amuletic triangles.

28. Sleeve detail of figure 25: mix of Syrian striped and Indian brocade fabrics; an amuletic triangle and cowrie shell form the decorative patch.

The wedding dress in figure 25 dates from the early twentieth century and is an example of the fine couched silver thread embroidery used at that time; figure 27 shows the work in detail. Thick silver thread is laid on the fabric in a pattern and is then attached to the fabric by finer thread of the same color. The material is a silk and cotton Syrian fabric; additional pieces were used to embellish the sleeves. Cowrie shells, mother-of-pearl buttons, and triangular shapes are used in the overall decoration of the dress. The frontispiece of the book displays the headdress and the array of jewelry a Sanaa woman would wear for her wedding.[2]

Figure 26 shows an indigo-dyed embroidered cotton dress decorated with mother-of-pearl triangles and brass mandrels.

The most delicate work in traditional silver jewelry was done by Jewish silversmiths in Sanaa and other centers in the northern mountains. Making fine silver

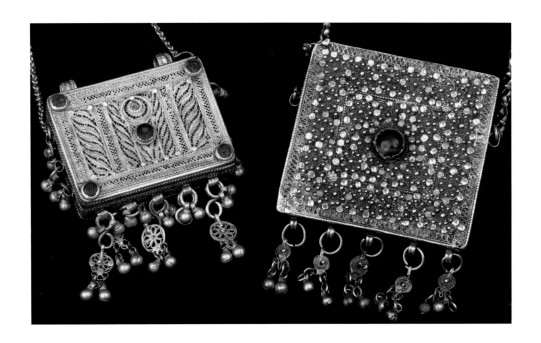

29. Sanaa: on left: gilded silver filigree box *(mahfaza),* 6 x 4 cm, signed by Harun Bawsani; on right: Badihi-style gilded amulet box *(mahfaza),* 7 cm, a gift from Ambassador Yahya al-Arishi to the author.

jewelry is an old tradition, as detailed in chapter 2. Although most Jews left Yemen in the late 1940s in Operation Magic Carpet, which took Jews from Aden to Israel, silver dealers to this day will use as their best sales pitch that the piece is *shughl yahudi,* or Jewish work. Two prominent silversmiths put their mark on special styles at the beginning of the twentieth century. Harun Bawsani (1890–1949) and his offspring and followers mastered the Bawsani style, which used silver wire to fashion intricate arabesque filigree designs. Yahya Badihi, working a bit later, specialized in intricate granulation.

Two examples that clearly contrast the work of the two design schools of Yemeni Jewish work—Bawsani and Badihi—are the amuletic boxes in figure 29; both are adorned with Yemeni agate stones. The box on the left is signed by Bawsani; the box on the right with its intricate granulation was done in the Badihi style.

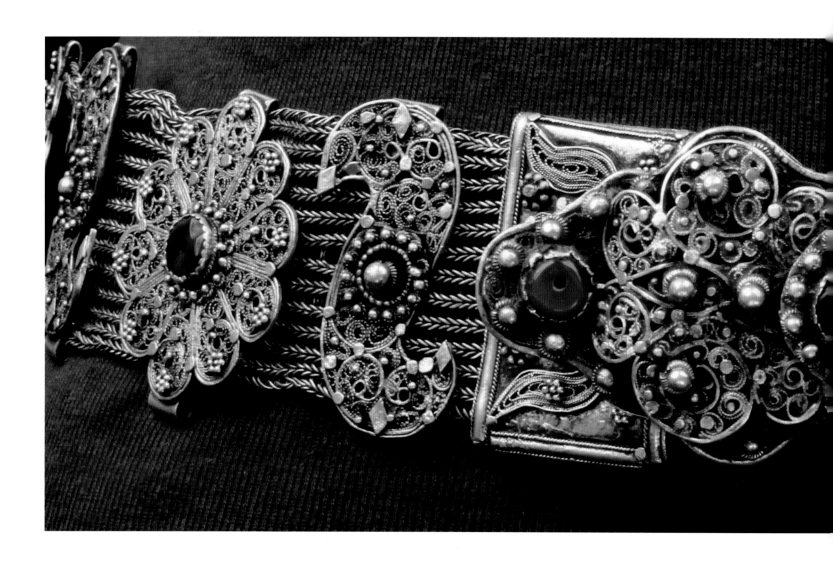

30. Sanaa: silver belt with agate stones, 82 cm, signed by Harun Bawsani.

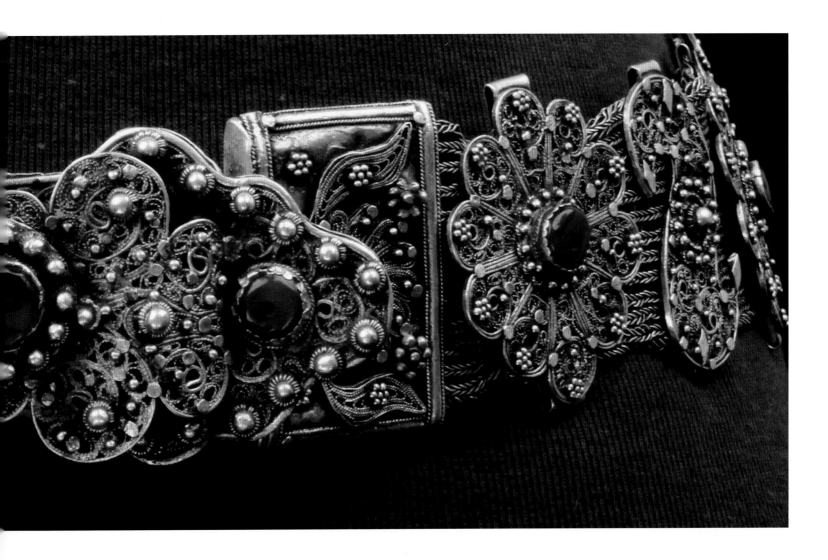

There are other Bawsani pieces in the collection, some signed and others perhaps done by followers of the Bawsani school. The belt has agate stones and a whale and flower motif (fig. 30), or *hut wa zuhra*, in filigree pieces mounted on a finely woven belt strap; it is signed by master craftsman Harun Bawsani. The whale and flower motif appeared in many pieces of jewelry, but I could not find out what it signified.

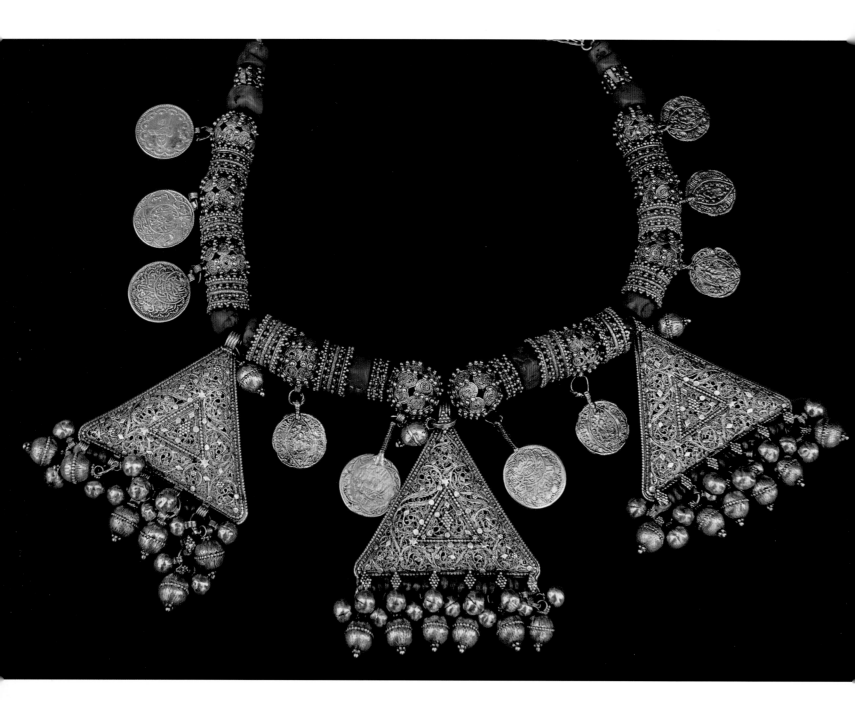

31. Sanaa: gilded filigree necklace, 50 cm.

Many pieces of fine silver were signed with the artist's signature stamp. But the work of master craftsmen was recognizable in their time and it was not necessarily considered important or valuable to have a piece signed. Some purchasers preferred unsigned pieces so that others would not know where to order copies.

The three filigree triangles of the rare necklace shown in figure 31 were most likely made by Harun Bawsani, but the piece is not signed. The hollow 7-cm triangles are two-sided and made of fine filigree and granulation, with arabesque designs. The larger beads are of finely wrapped wire. The necklace, except for the dangles, is gilded, and the coral chunks appear old. (It is impossible to document the age of pieces of jewelry exactly, but there is a consensus among silver dealers that the finest filigree and granulation were done at the beginning of the twentieth century. Wear and color do not help in this calculation, for they are affected by the amount the owner wears them.) It is unusual to see such fine work in a necklace for women, as this quality of work was usually reserved for men's daggers. Most of the bracelets shown in figures 32, 33, and 34 were made in the Bawsani style in the early twentieth century.

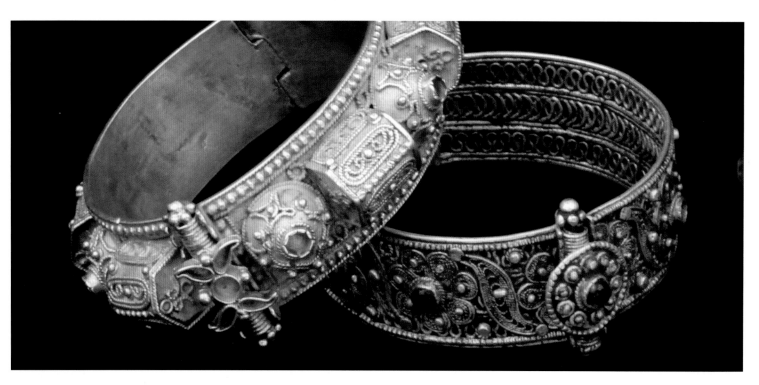

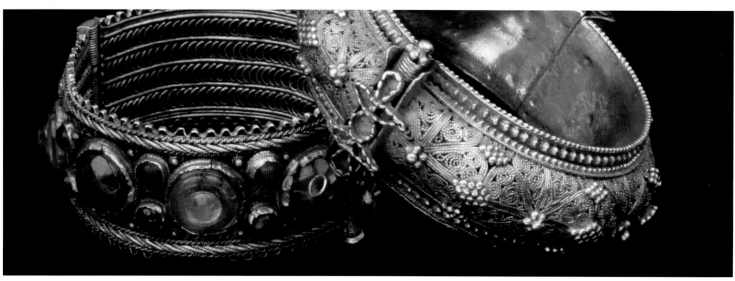

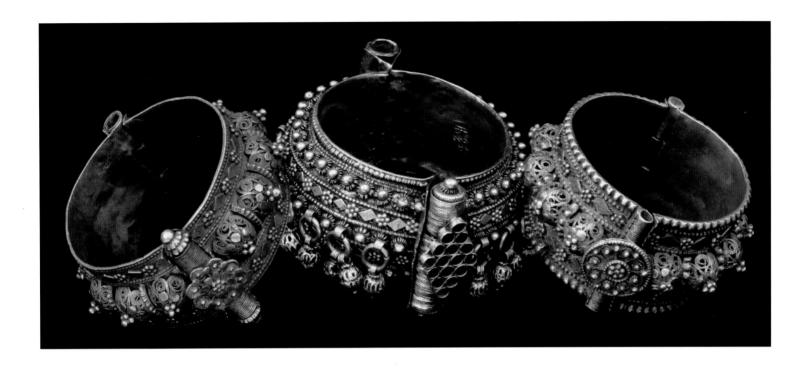

32. *(left, top)* Sanaa: left to right: gilded bracelet *(qubur)*, one of a pair, 5.5 cm, worn by Jewish women; gilded Bawsani bracelet, 5.5 cm, with flower and whale motif, has two signatures of Shamwil Sirri. The *qubur* bracelet, which dates from the nineteenth century, actually predates Bawsani. Other such *qubur* bracelets, made later, were considered Bawsani work.

33. *(left, bottom)* Sanaa: gilded silver Bawsani bracelet *(tafiya)*, 5.5 cm, signed by Yusuf Kuhin; Bawsani bracelet *(shumayla)*, one of a pair, 9 cm, with fine filigree.

34. *(above)* Sanaa: left to right: Bawsani gilded bracelet *(tafiya muqabbaba)*, one of a pair, 8.5 cm, signed by Nahhas Iraqi; Badihi-style gilded bracelet *(tafiya)*, one of a pair, 5.5 cm, signed by Sulayman Qara; bracelet *(shumayla)*, 5.2 cm, signed by Ibrahim Bawsani and dated 1911. The last was dipped in *harad*, a mixture of turmeric and a special resin called *tulkayat har*, and worn mainly in the Khawlan Sanaa area, northeast of Sanaa.

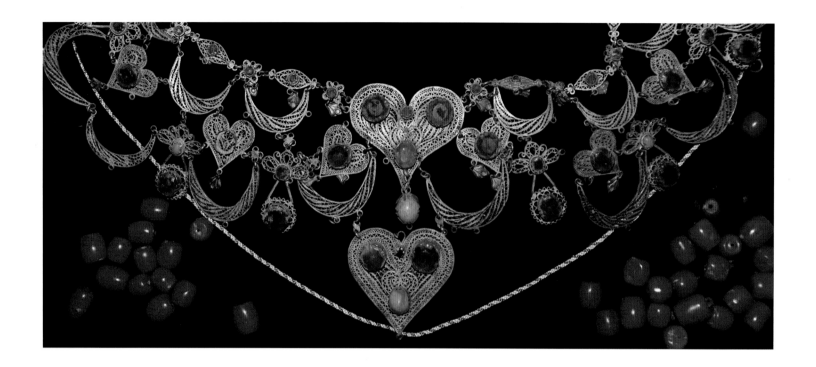

35. Taiz National Museum: Ottoman necklace *(abu hilal),* made by a Jewish silversmith, probably at the end of the nineteenth century, February 2005. *Abu hilal* refers to the crescent shapes in the necklace, which were a frequent motif in Ottoman jewelry.

36. Sanaa: above: gilded bird necklace *(labba tayyur),* 55 cm, work of Yusuf al-Abyad; below: gilded necklace, 47 cm.

The Ottoman necklace in figure 35 is on display in the National Museum in Taiz. When the Turks occupied Sanaa at the turn of the twentieth century, they were good customers of the silversmiths. In fact, the fine Yemeni filigree of the early twentieth century seen in figure 36 may well have been inspired by pieces that the Turks brought to the silversmiths to copy; in that period, most new pieces were made in 83 percent silver or higher, rather than the 50 percent, or *nisfi,* prevalent in most Mansuri pieces, the jewelry of the nineteenth century, and earlier. Such light and intricate necklaces as in figure 36 were most likely made in the 1930s and 1940s by Jewish silversmiths Yahya al-Abyad and his son Maysha and were worn by ruling family members or rich merchant families. If not, they were made by Jewish silversmiths who worked in the Bawsani style.

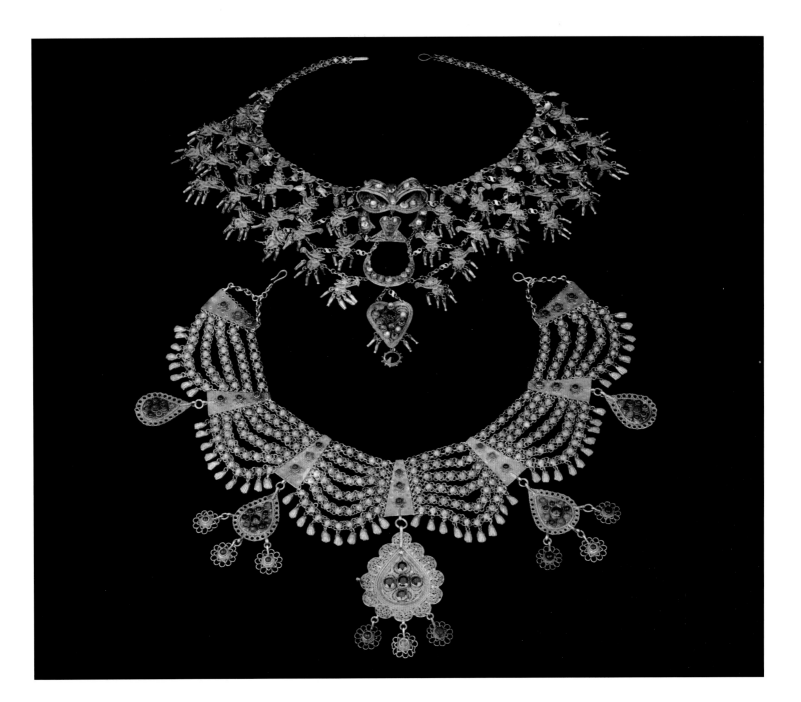

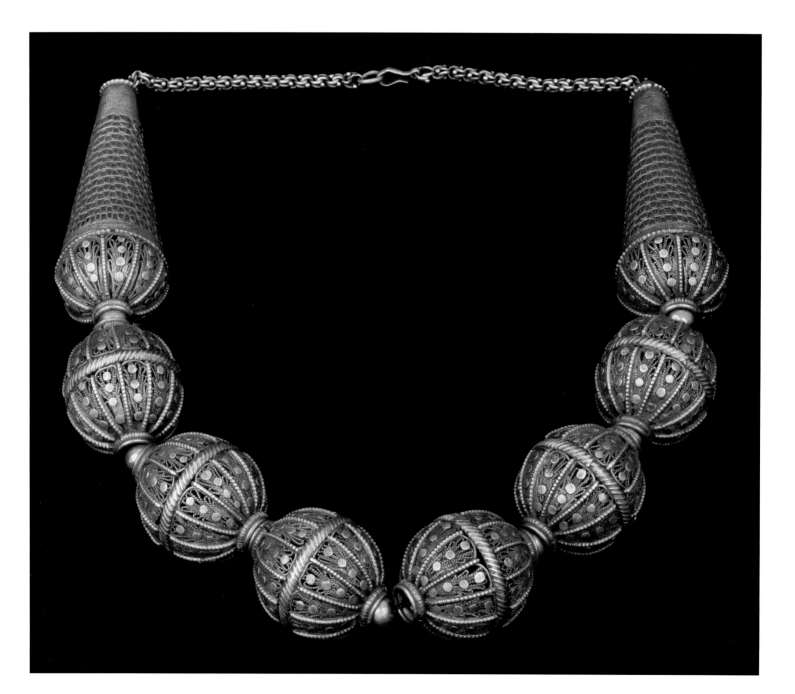

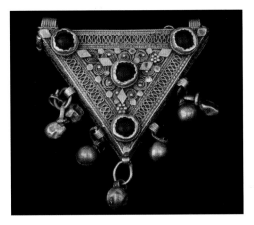

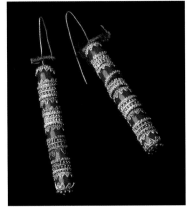

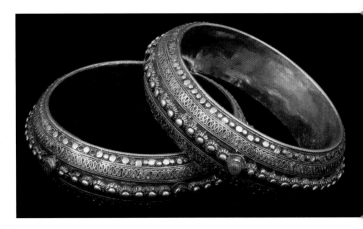

37. *(opposite)* Sanaa: Badihi necklace *(duqqa)*, 39 cm, signed by Yusuf Salih.

38. *(top left)* Sanaa: gilded triangular box *(mahfaza)*, with red glass stones, 6 cm, signed by Yahya Badihi.

39. *(top center)* Sanaa: gilded hairpieces *(maratiq)*, 13 cm.

40. *(top right)* Sanaa: silver bracelets *(ma'dhad)*, 6.5 cm, signed by Hayim 'Amriya, late nineteenth century.

Three different types of containers were used as amulet cases: the triangle in figure 38, the square or rectangular container in figure 29, and the cylinder in figure 50 in the section on Saada. The wearer often kept a verse from the Qur'an or a prayer from a holy man inside. If the container was large, a woman might carry some coins, such as Maria Theresa thalers, or her wedding contract. Once in a large amulet I found a clump of fine white hair. I imagined it to be the hair of a holy man, but it could have been part of a ritual to repel the evil eye.

An excellent example of Bawsani-style work is the necklace in figure 37 signed by Yusuf Salih.

The headpieces in figure 39 have fine granulation on the *tut* (mulberry) beads, which places them in the Badihi school. The Sanaa bride would have worn them only at her wedding. Because of their color, the red ceramic beads had the amuletic, protective value of coral. The bracelets in figure 40 also are done in a Badihi style.

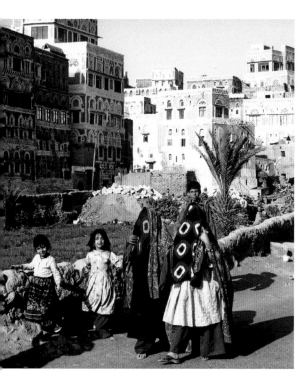

41. Sanaa: the old city, 1983.

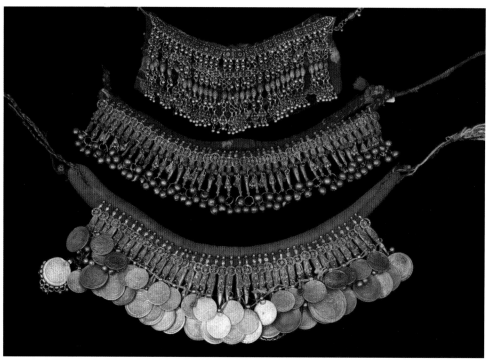

Yahya Salih was a well-known Sanaani Jewish silversmith at the beginning of the twentieth century; he specialized in Sanaani bridal jewelry as seen in figure 42. The top necklace was worn by well-to-do women in Sanaa on special occasions. It was almost always backed with cloth, to protect the piece as well as the fancy garment on which it was worn. The bottom two necklaces were assembled on padded cloth and worn around the neck.

Figure 43 displays a necklace worn by Jewish women on festive occasions. It has fifteen strands of faceted solid beads and *tut* beads and weighs 1006 grams. The beads are original and the cone ends are newly made.[3]

The two rings in figure 44 are excellent examples of fine Bawsani work.

42. *(opposite)* Sanaa: top: silver two-faced
necklace *(labba)*, 22.5 cm.
The two-sided pieces look cast,
but they are pounded in a form
called a *damgha*;
middle: necklace *(labba mazamir)*,
34 cm, signed by Yahya Salih;
bottom: gilded necklace,
40 cm, signed by Yahya Salih.

43. *(top)* Sanaa: necklace
(ma'naqa), 54 cm.
The triangular ends are called *turraf*;
they are handmade and closely
resemble the original

44. *(bottom)* Sanaa: left to right:
ring with coral cabochon, 2.5 cm;
ring with coral cabochons, 3.5 cm.

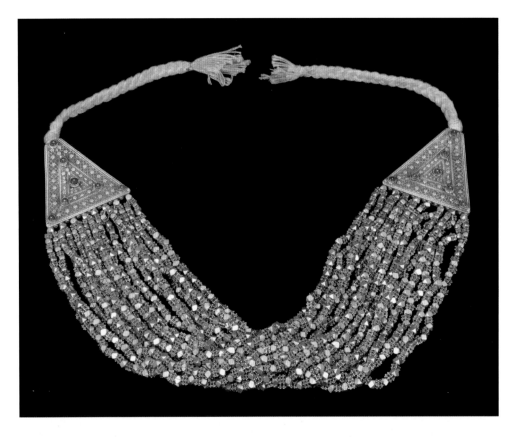

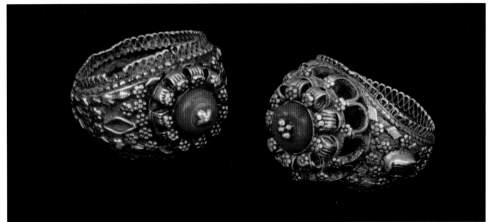

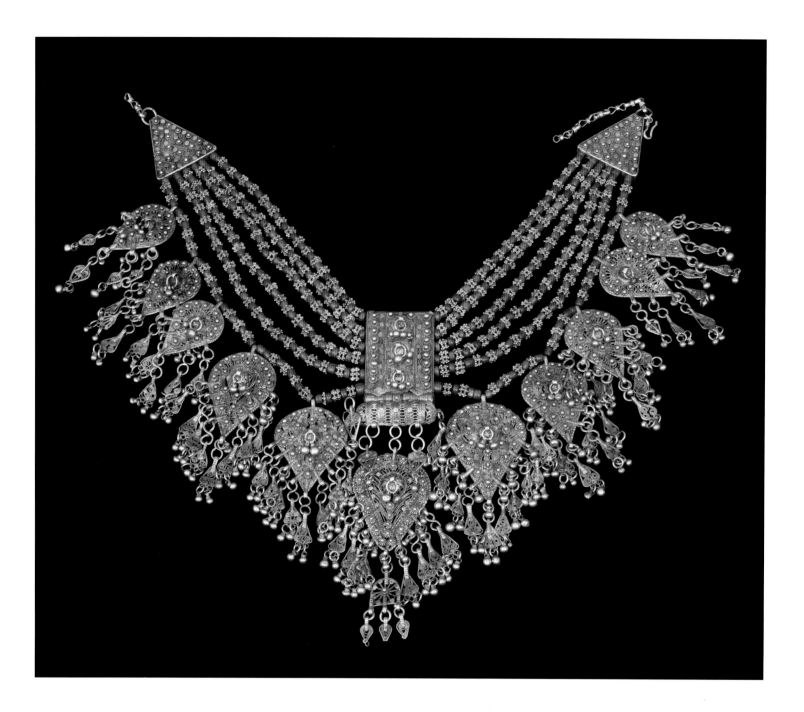

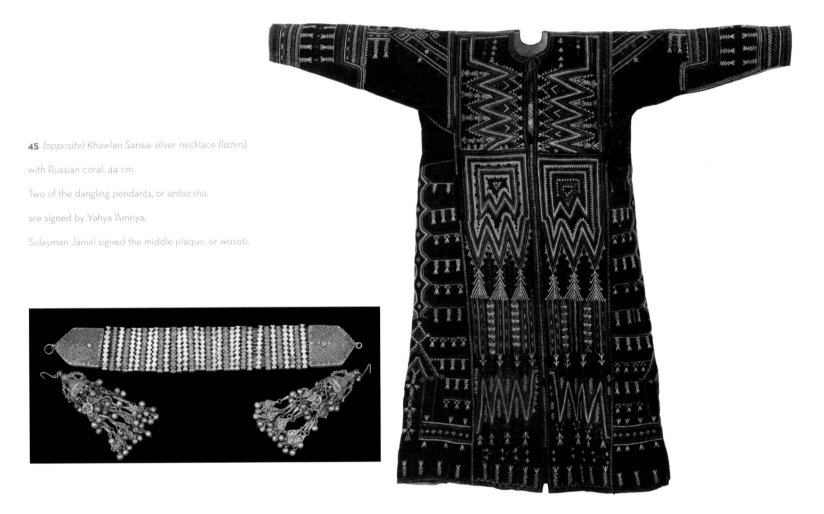

45. *(opposite)* Khawlan Sanaa: silver necklace *(lazim)*, with Russian coral. 44 cm.

Two of the dangling pendants, or *anbarsha*,

are signed by Yahya 'Amriya;

Sulayman Jamal signed the middle plaque, or *wasati*.

46. Khawlan Sanaa: silver headpiece *('isaba)*,

33.5 cm; earrings *(mashaqir mutawwaj)*, 16 cm.

47. Khawlan Sanaa: indigo-dyed cotton dress with

silk and silver embroidery, early twentieth century.

KHAWLAN SANAA

Khawlan Sanaa is a tribal area northeast of Sanaa where silver jewelry is still worn by some tribeswomen, perhaps because their shaykhs insisted that silver jewelry be part of the marriage payment. Figure 45 is a heavy, intricate necklace with old Russian coral. The Khawlanis are also renowned for their fine embroidery (fig. 47). The earrings in figure 46 were dipped in turmeric paste and worn next to a sweet-smelling herb such as rue or basil in the headdress.

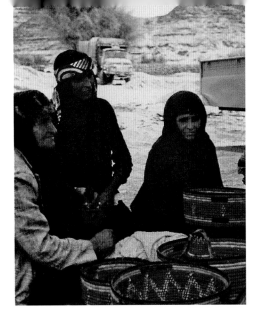

SAADA

The one time I was able to visit Saada was in 1977 on a trip from Jeddah to Sanaa with
diplomatic colleagues. We were introduced to the *zabur* type of mud architecture
as we crossed Asir, a mountainous area in the south of Saudi Arabia. (*Zabur* involves
pressed layers of mud or clay, a technique used primarily in Yemen's north and north-
east). We had a flat tire as we entered Saada and were forced to stop. Because I had
heard about the conservatism of this northernmost city, I looked around our imme-
diate neighborhood with some trepidation. I was standing with another American
woman when, much to our surprise, the ground-floor door of the nearest house
opened and a Saada woman gestured to us, inviting us to drink tea. I was heart-
broken when my companion told me that we could not take the time, because the
leader of our group was determined to press on to Sanaa. The city has beckoned to
me ever since. When I conducted my research in 2004–2007, there was a civil war.
I tried to get permission to travel north during lulls in the fighting, but the permit
never came.

50. Saada town: amulet *(hirz)*, 32 cm,

with Bawsani beads and

Badihi spacer beads

(tut mukhattam),

and Bawsani dangles.

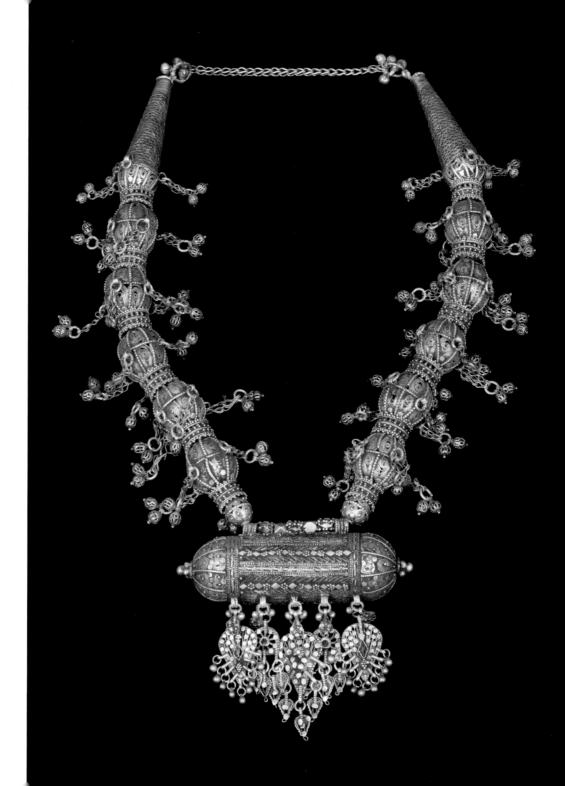

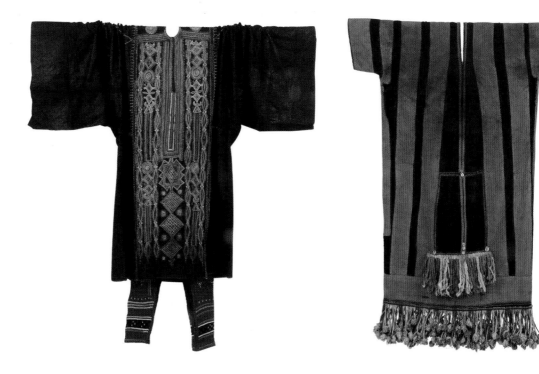

51. Khawlan Saada: heavily
embroidered, indigo-dyed dress,
first half of twentieth century;
silk-embroidered pantaloons,
mid-twentieth century.

52. Khawlan Saada: indigo-
and *harad*-dyed linen, first
quarter of twentieth century.

Saada was important in the history of Yemen as the city where Zaydi Shi'ism was introduced to Yemen. Zaydi imams ruled major parts of Yemen's highlands from the tenth century until 1962, when North Yemen became the Yemen Arab Republic. For centuries, Saada has been an important social, religious, and commercial town for the northern part of the country. Jewish silversmiths were a significant part of the market, making silver jewelry, weaving baskets, and doing woodwork and other crafts. They worked in the town of Saada and several other centers across the governorate. I met three Saada Jewish silversmiths briefly in Sanaa and was fortunate in finding a number of Jewish-made pieces that display their skills beautifully. The amulet in figure 50 combines intricate filigree and granulation.

Another skill that was highly developed in Saada was embroidery. Khawlan Saada produced the costumes seen in figures 51 and 52.

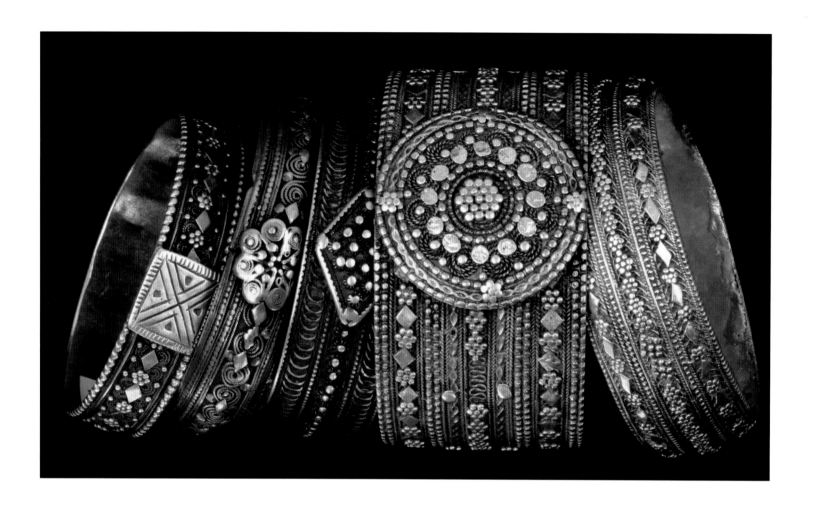

Small communities of Jewish silversmiths worked in different locations in the Saada region. Where I could, I have identified them and their specific jewelry style. Mashraq Saada was one such area that stands out. In figure 53, the two bracelets on the right are good examples of Mashraqi Badihi-style work with its fine granulation. The medallion in the largest bracelet closely resembles the medallion on the woman's headdress in figure 54.

53. *(opposite)* Saada governorate: left to right:

bracelet *(bilzaqi)*, one of a pair, 7 cm;

bracelet *(swara)*, 8 cm;

bilzaqi, one of a pair, 7.5 cm,

dated 1912 and signed by Ibrahim Bawsani;

upper-arm bracelet *(damlaj)*, one of a pair, 8 x 4.5 cm,

possibly the work of the Muslim silversmith

Abdulla bin Mir'i; *bilzaqi*, one of a pair, 7 cm.

54. Northern mountains of Yemen:

woman bedecked in her silver jewelry, 1977.

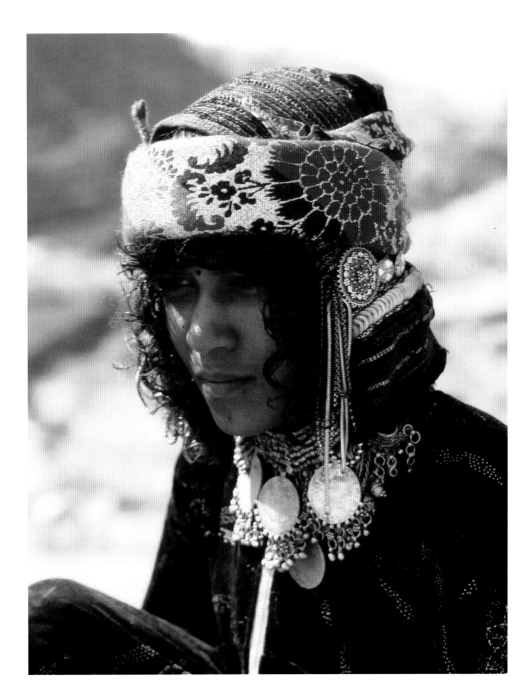

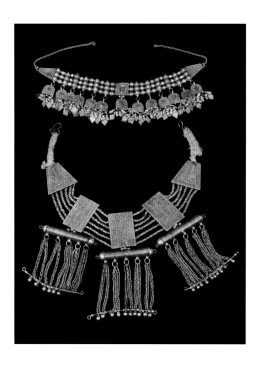

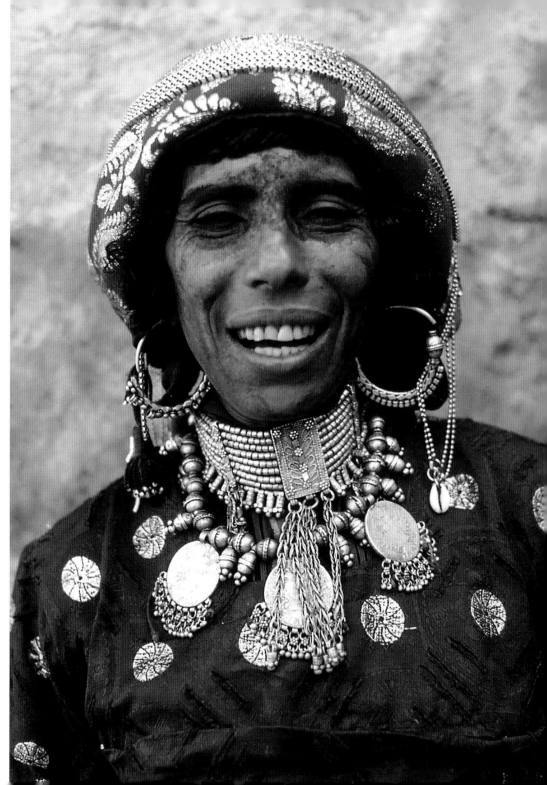

55. Saada Mashraq: top:

partially gilded necklace, 28 cm,

signed by Yahya Mashraqi;

bottom: necklace (*lazim*), 32 cm.

56. Northern mountains: a woman wears

the juice of pulverized leaves as a cosmetic

and for protection from the sun, 1977.

Figure 55 shows two more pieces of jewelry from the Mashraq area. The top gilded piece is signed by Yahya Mashraqi. His necklace is similar to pieces made in Bur'a, but the signature seems to place it in Mashraq. The bottom necklace is called a *lazim*, a piece made all over the northern mountains and considered in some areas to be an obligatory part of the bride's attire. The word *lazim* means something that is essential—the bride must wear one when she marries—and it also means something that clings, as this necklace does to the chest. This *lazim* has a distinctive design made only in Mashraq. The woman in figure 56 wears another type of *lazim*. Figure 57 shows a dress that is typical of Saada with its dense indigo dye and its elaborate couched silver embroidery. The sleeve pattern of embroidery is also typical of Saada.

The Mashraqi silversmiths even produced intricate nickel bracelets for young girls (fig. 58), which were worn by both Jews and Muslims. They also made the special amulet and hair ornament in figure 59. The amulet was worn for special occasions, but the hair ornament was used only by Jewish women, who wore it down their backs with braided hair.

58. Saada Mashraq: left to right: hinged bracelet *(miska biwarda)*, 6.5 cm; *miska biwarda*, 5.3 cm; hinged bracelet *(swara)*, 5.5 cm.

59. Saada Mashraq: left: amulet *(hirz bihunaysha)*, 9.5 cm; right: hair ornament *(sha'r madhfur)*, with three glass cabochons, 42.5 cm, worn down the back with braided hair by Jewish brides.

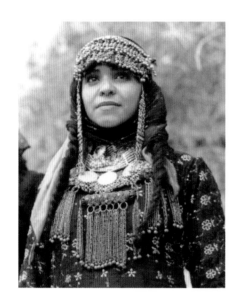

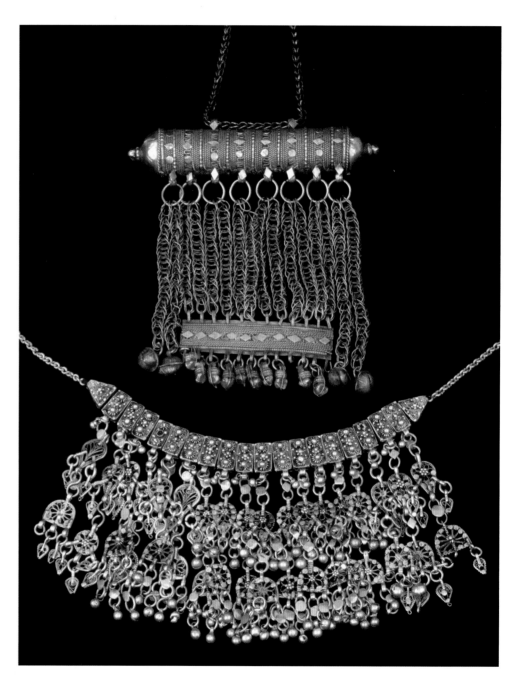

60. Saada: married woman wearing a headpiece

and amulet similar to the pieces in figure 61.

61. Saada: top: amulet *(hirz)*, 14 cm,

the work of Abdulla bin Mir'i, in Saada al-Talh;

bottom: necklace *(labba)*, 20 cm,

has an unreadable signature, gift from the late

Honorable Abd al-Aziz Abd al-Ghani to the author.

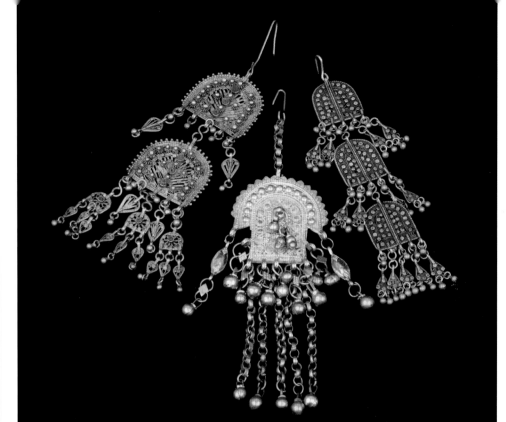

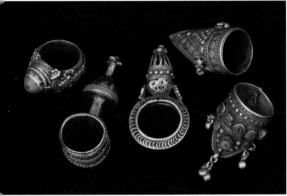

62. Saada governorate: left to right:

ring (khatim), with coral bead, 3.5 cm;

ring, 5.3 cm; ring, 5 cm; ring, 4.8 cm;

ring, with coral bead cabochons, 3 cm.

63. Saada town: left to right:

Bawsani-style hair ornaments, called *mashaqir*

or *shanun*, 15.5 cm; *mashaqir*, 18 cm;

Badihi-style *mashaqir*, 18 cm. Each is one of a pair.

In figure 60, a married woman wears jewelry for a festive occasion. Her headpiece is worn as Muslim women wore it, across her forehead; Jewish women wore it under their chins. Such pieces, called *labba*, were made and worn in different regions from Hajja and Saada in the north to Ibb and Taiz in the south. Her amulet, shown in figure 61 above the *labba*, and made by the well-known Muslim silversmith bin Mir'i, is from al-Talh in the Saada region.

The Saada silversmiths made sophisticated hair ornaments for city dwellers (fig. 63), as well as a variety of rings for all customers (fig. 62). Saada was the source of most of the high, pointed Yemeni rings.

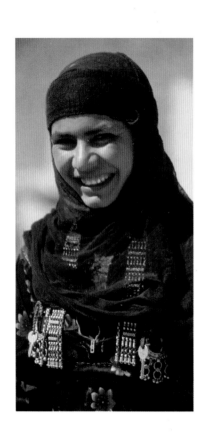

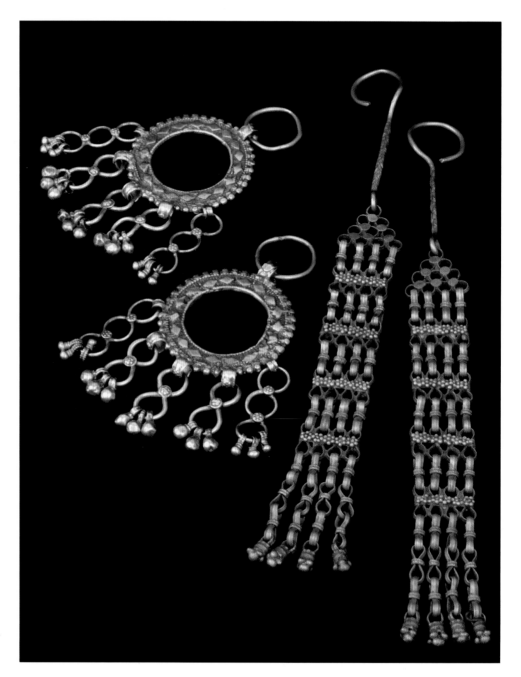

64. Saada vicinity: married Jewish woman, 1973.

65. Saada vicinity: left to right: hair ornaments (*mashaqir*), 10 cm; hair ornaments, 27 x 2.5 cm.

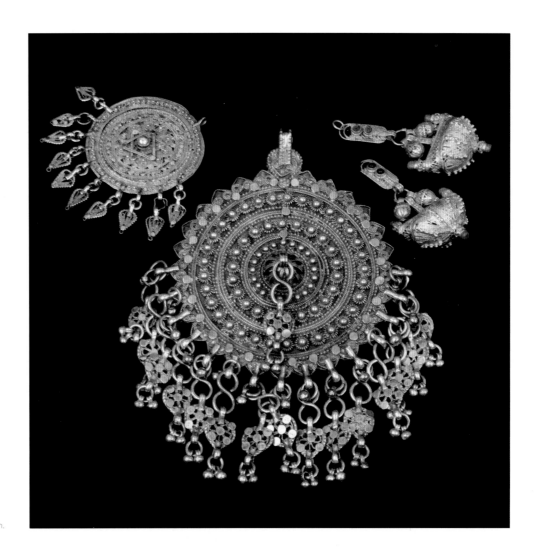

66. Saada vicinity: left to right:

gilded amulet *(anbarsha)*, 4.8 cm;

silver *anbarsha* medallion, also called *warda*, 9.4 cm;

gilded pendants *(zanabil)*, with coral cabochons, 6 cm.

In the early 1970s, a married Jewish woman posed wearing distinctive hair orna-
ments alongside her household keys (fig. 64). When dressing for special occasions,
Jewish women wore intricate items on their bonnets (fig. 66), such as appear below in
the section on Haraz.

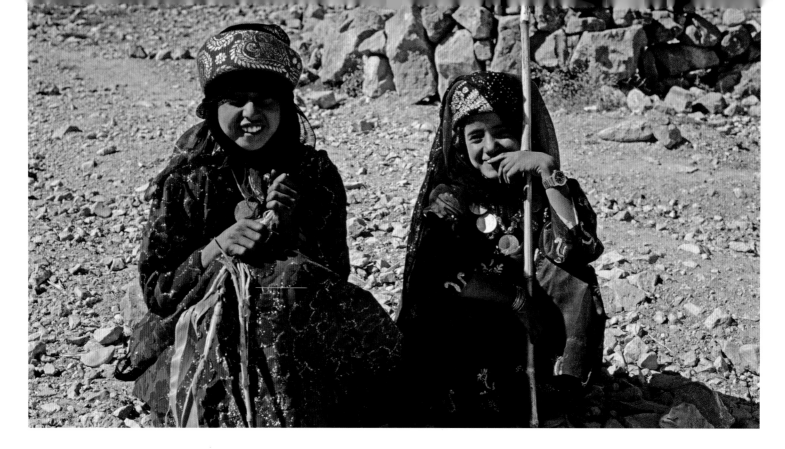

67. Amran: girls dressed for
a religious celebration, 1978.

68. Amran: typical houses
with stone foundations and
mud construction above,
March 2006.

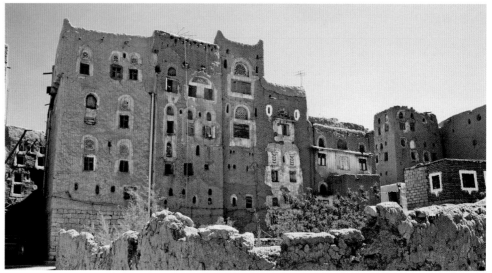

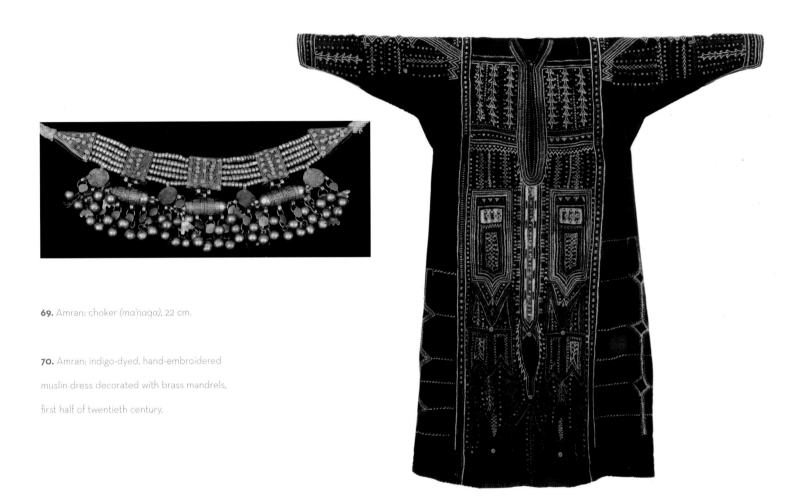

69. Amran: choker (*ma'naqa*), 22 cm.

70. Amran: indigo-dyed, hand-embroidered muslin dress decorated with brass mandrels, first half of twentieth century.

AMRAN

North of Sanaa on the road to Saada, Amran is an old fortified town whose houses often have stone foundations and upper floors of mud construction. In figure 67, the young girls are dressed in their best for a religious feast. In the past they would have worn a choker, such as that shown in figure 69. The houses are more akin to tribal houses to the east than to those in Saada, and the embroidered dresses of Amran (fig. 70) resemble the dresses of the Khawlan Sanaa.

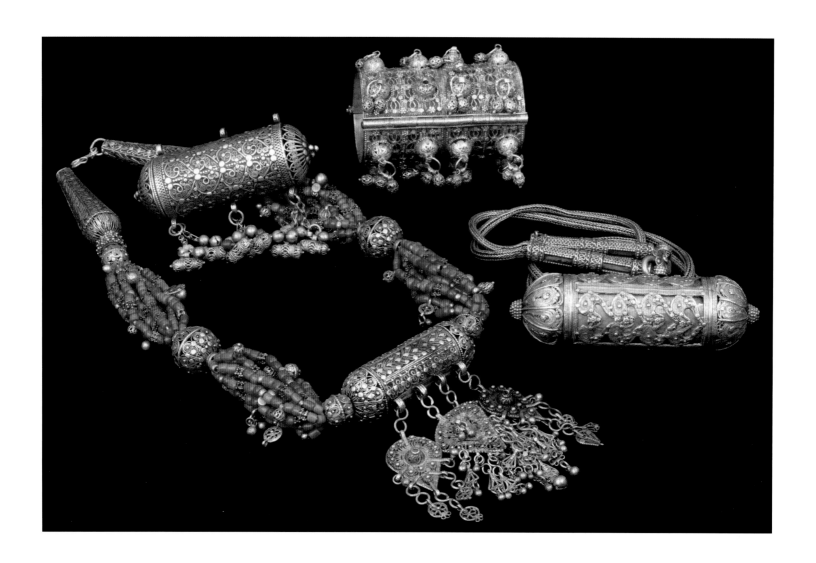

71. Haraz: left to right: coral necklace *('aqd marjan),* 69 cm; amulet *(hirz),* 11 cm; hinged bracelet, one of a pair, 9.5 cm; *hirz,* 14 cm, signed by Shamwil Sirri, made originally for judges, but now reputedly worn by female descendants of the Prophet. The ends of the chain are from Rayma or Bur'a.

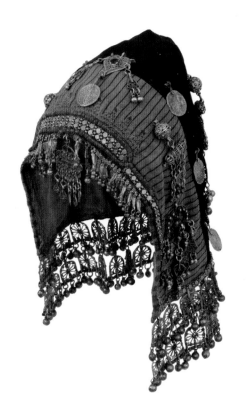

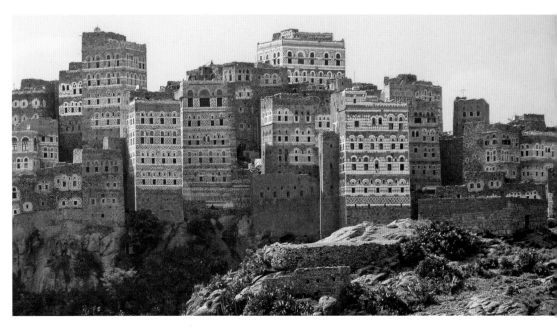

72. Haraz: black cotton and Syrian striped silk bonnet (*gargush*), 30 x 36 cm. The small, grain-like silver dangles (*'aqrat*) that hang from the hood over the face were worn only by Jewish women.

73. Hajjara, Haraz, June 2005.

HARAZ

Haraz is a mountainous area west of Sanaa on the road to Tihama and the Red Sea. A picturesque city, Hajjara (fig. 73) is perched on a mountaintop just west of Manakha, the main market center in Haraz. It had a small community of Jewish silversmiths whose jewelry was similar to that made in Sanaa. Sadly, as in many other locales, when the Jewish silversmiths vacated, they took their skills with them, and no silverwork is done there today. In this area, a coral necklace like that in figure 71 was always worn by the bride on her wedding day. The bonnet, commonly known as a *gargush*, was worn by both Jews and Muslims, but this particular one (fig. 72) would have been worn by a Jewish woman because only they wore the small *'aqrat*—grain-shaped pendants that hang over the forehead.

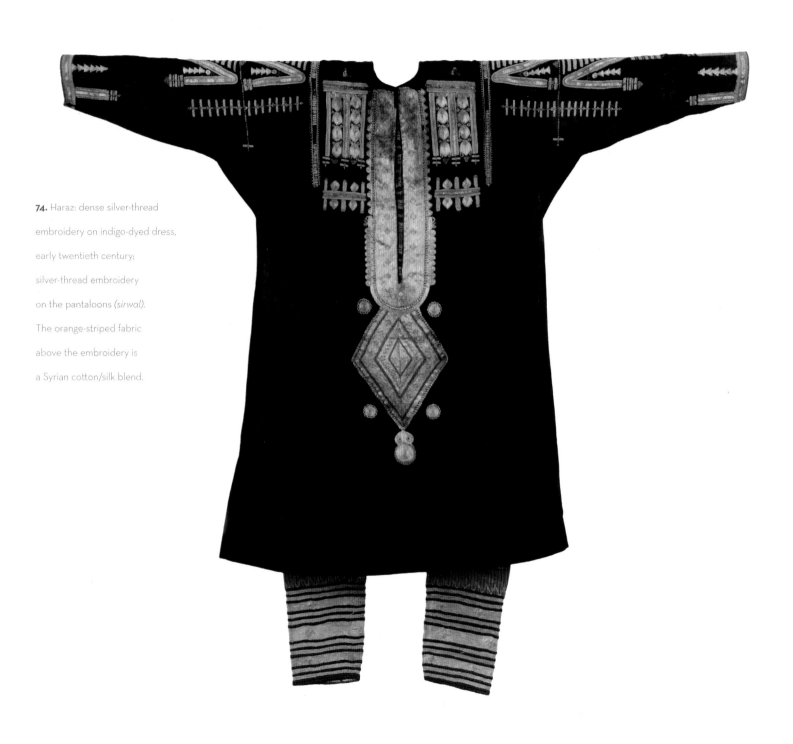

74. Haraz: dense silver-thread embroidery on indigo-dyed dress, early twentieth century; silver-thread embroidery on the pantaloons (*sirwal*). The orange-striped fabric above the embroidery is a Syrian cotton/silk blend.

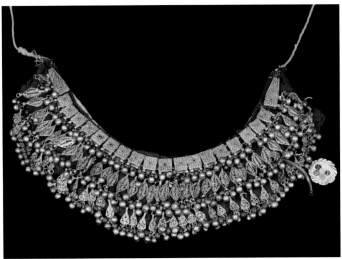
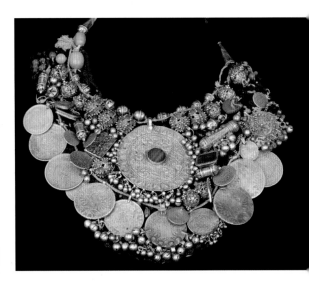

75. *(top left)* Manakha, Haraz: indigo-dyed cotton bonnet *(gargush)*, 65 x 44 cm, densely decorated with tiny Red Sea shells.

76. *(top center)* Haraz: Bawsani gilded necklace *(labba)*, 41 cm. Chain on right is part of a watch chain and the metal pendant is Isma'ili with the names "Allah," "Muhammad," "Ali," "Hassan," "Hussein," and "Fatima." The chain and the pendant were added about twenty-five years ago, but the necklace is a hundred years old.

77. Haraz: *(top right)* chest piece (labba), 27 cm.

The dress in figure 74 is densely embroidered and has similarly embroidered pantaloons. Figure 76 is a necklace that was worn more often but not exclusively by Jewish women. The odd medallion on the bottom right is an inexpensive modern talisman; the chain is also much newer than the necklace, which dates from the late nineteenth or early twentieth century.

There was little information available about the shell-covered bonnet or hood shown in figure 75 other than that it comes from the Haraz region. The chest piece in figure 77 has a large, elaborately incised central medallion of gilded silver that is probably Iranian in origin, an engraved, bezeled carnelian stone, four Maria Theresa thalers, and an Indian rupee coin dated 1801. The engraving in the carnelian is in Iranian style and spells out "Allah," "Muhammad," "Ali," "Hussein," "Hassan," and "Fatima." It probably was worn by an Isma'ili woman, as the Isma'ilis are Shi'a who have lived in Haraz for centuries.

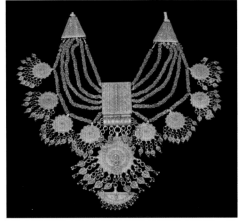

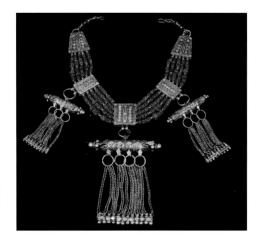

78. *(opposite)* Mahwit City, November 2004.

79. *(top left)* Mahwit governorate: older woman carrying a bundle wrapped in Chinese newspaper beneath her head covering, 1980.

80. *(top center)* Mahwit: necklace *(lazim shatta)*, 44 cm.

81. *(top right)* Awam village, Mahwit governorate: coral necklace *(lazim)*, 33 cm.

MAHWIT

Mahwit is a long, narrow governorate that comprises tall, dramatic, terraced mountains as well as areas that descend to the Tihama plain, the strip roughly forty miles wide that extends north–south along the Red Sea. Mahwit was known especially for the necklace called *lazim*, mentioned before in the section on Saada. One from Mahwit City is shown in figure 80 and one from Awam village in figure 81. Jewish silversmiths worked in both of these places.

In 2005, when I attended a wedding in Mahwit, I spoke to the women about marriage customs. There the bride wears different outfits for the seven days of the wedding. She has to wear the *lazim* on the day she wears traditional clothing. But she no longer has to own it. She either borrows it from her family, which holds one for this purpose, or she rents it from a silver shop. If she receives new jewelry for her wedding, it is most likely gold.

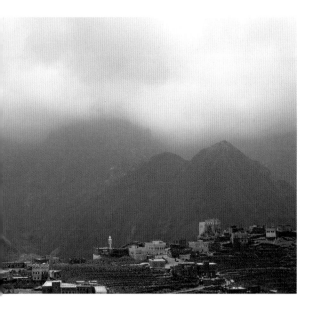

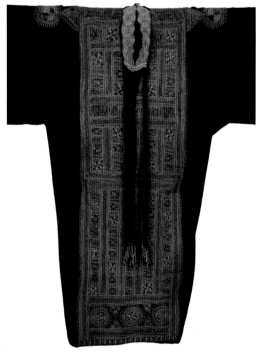

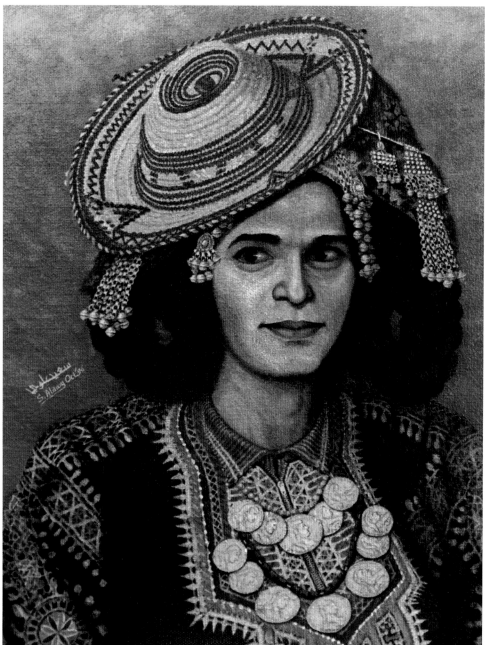

85. Hinged bracelet, 5.5 cm, one of a pair worn in Jabal Milhan, but made in the Taiz area; middle: al-Dhahiyy: upper-arm bracelet (*kumali* or *damlaj*), 14 cm, made by master craftsman Ibrahim al-Mahdi; al-Dhahiyy: hair ornament, 15 cm, with twisted chain called *mabrum*; Saada: hair ornament, 6 x 4.6 cm, work of Abdulla Gathban, both hair pieces are one of a pair; bottom: Mahwit: headpiece (*ma'saba*), 37 cm.

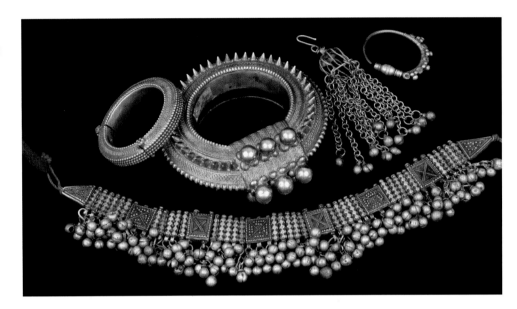

82. *(top left)* Jabal Milhan, seen from Adhra' in Mahwit governorate, April 2006.

83. *(bottom left)* Jabal Milhan: Eighty-year-old embroidered piece sewn onto twenty- to thirty-year-old cotton rayon. The embroidery has been rubbed with *harad*, headpiece of black cotton braid and red, yellow, and white silk hand embroidery.

84. Oil painting of Jabal Milhan woman by Said Alani, October 1966.

JABAL MILHAN

Jabal Milhan (Milhan mountain) (fig. 82) was known for its coffee and its hospitality. The women, as personified in a painting by a Yemeni artist,[4] wore heavily embroidered costumes, decorated straw hats, and vast amounts of silver jewelry.[5]

86. Hajja: beaded belts *(hizam)*, 112 cm.

87. Hajja: bracelet with coral cabochon, 8 cm;

necklace, 50 cm.

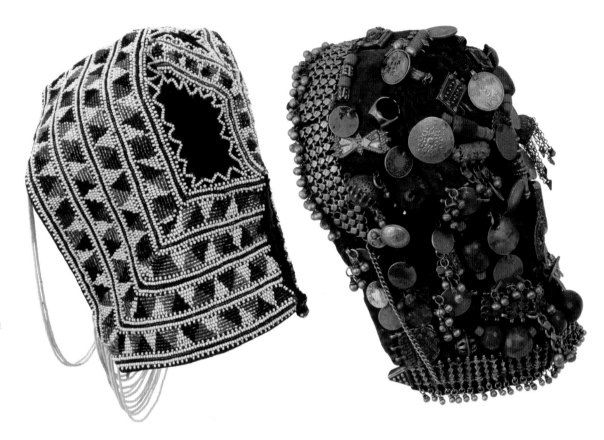

88. Hajja: beaded bonnet *(gargush)*.

89. Hajja: cotton bonnet *(gargush)*.

HAJJA GOVERNORATE

Hajja produced elaborate beadwork, seen in the cap and three belts in figures 86 and 88, as well as distinctive jewelry (fig. 87), with a special flower motif. The owner of the distinctive cap in figure 89 added various elements to make her own creation: two nickel coins dated AH 1372 (AD 1952), bits of silver jewelry, several composite beads, seven amber beads, a French military button, and a Yemeni or Ethiopian choker across the bottom. They are mounted on black machine-made cotton; the items are nickel or low-quality silver and scrap pieces from worn-out items.

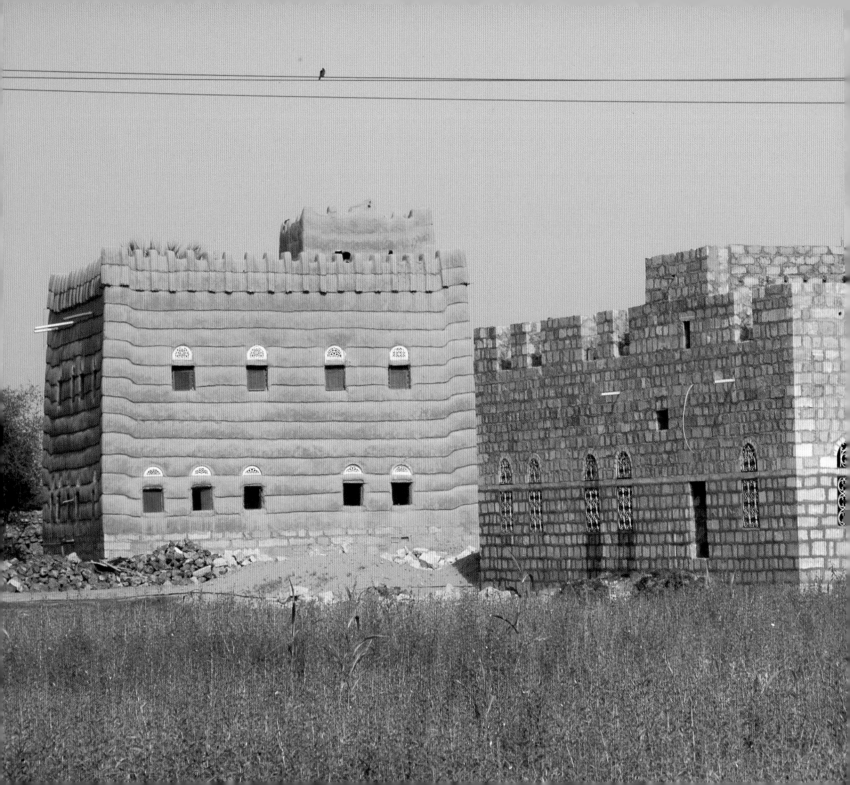

—————— 6 ——————

Marib and the Jawf

Descending east from the mountain highlands, we come to Marib and the Jawf, which are governorates richer in antiquities than in natural resources. Most occupants are tribesmen who raise flocks of sheep or goats for meat, wool, and leather. They bought their jewelry from craftsmen in Habban, al-Bayda, and sometimes Saada. The silversmiths or their *dalala*s (traders) traveled distances of 150 to three hundred kilometers to sell them their wares.

Abda, from Juba in the Marib governorate (fig. 93), posed in her wedding finery, which included a headscarf woven in silk some decades ago in Bayt al-Faqih in Tihama, a headpiece made in Habban, and a leather belt adorned with Maria Theresa thalers.

In Juba, I was approached on the street by a young man who wanted to sell a

90. Marib governorate: at left, a traditional mud structure built with the *zabur* technique, alongside a modern Yemeni stone house, June 2005.

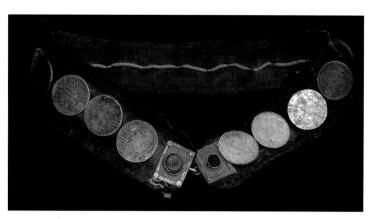

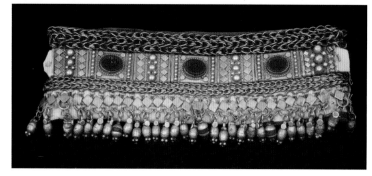

91. Juba, Marib governorate: Abda's belt *(hunaysha)*, June 2005.

92. Juba, Marib governorate: headdress *(ma'saba)*, 48 cm.

93. Juba, Marib governorate: Abda, a tribeswoman, wearing her wedding attire, June 2005.

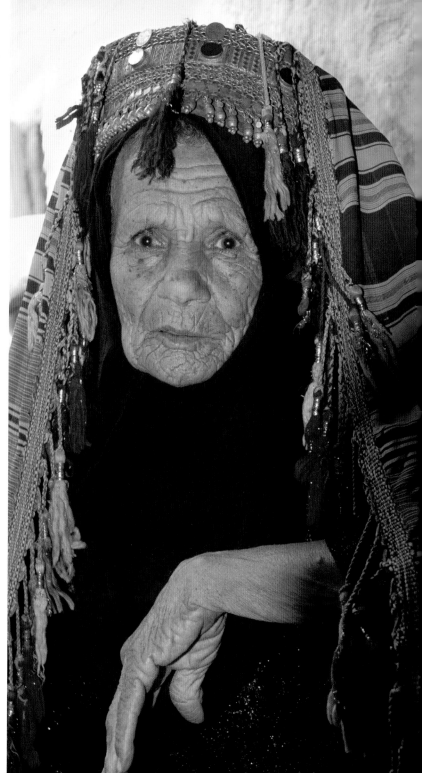

headdress, which appeared to me to be virtually the same headdress as Abda's. I was not interested as I already had one in the collection, but just as he began his sales pitch, his mother came out of a house behind us. It was hers. "Don't take less than ten thousand riyals," she said (about $38.00). After that clear documentation, I had to buy it.

Figure 95 shows an old embroidered Marib dress that repeats the jagged design of the roof of many *zabur* houses in the area. In another Juba residence, Bakhita (fig. 94) showed off a silver buckle—all that remained of her wedding jewelry.

94. Juba, Marib governorate: Bakhita, June 2005.

95. Marib governorate: hand-embroidered, indigo-dyed cotton dress, early twentieth century.

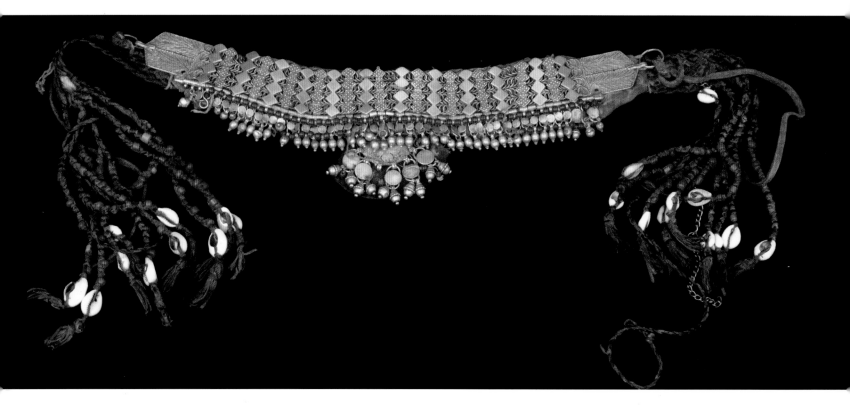

96. Marib governorate: leather headpiece (*ma'saba shaddadi*), 42 cm, made in Habban.

97. Marib and the Jawf: headpieces (*nuna*), 8 cm. The coin on the right is a Maria Theresa thaler; the coin on the left is an Italian coin issued in the nineteenth century for use in Eritrea.

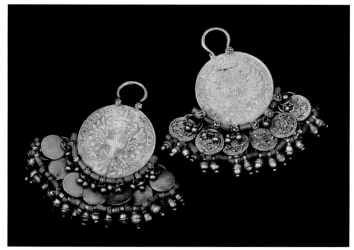

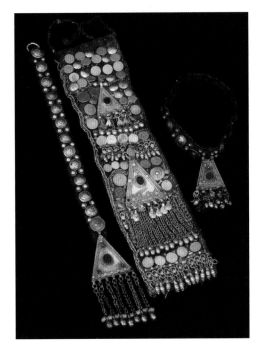

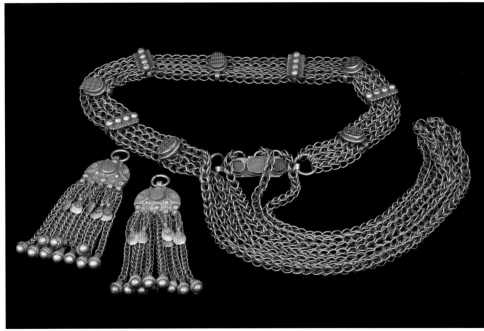

98. Marib governorate: left to right: leather headpiece *(alam)*, 56.5 cm; black cotton headpiece, 51 cm; leather circlet, 14.5 cm.

99. The Jawf: nickel belt *(hanaysha mufassasa),* 85 cm, made in al-Bayda; hairpieces, 15 cm, made in Habban.

The Marib headpieces in figure 98 contain old silver pieces sewn on leather or cloth. Jewish silversmiths visited Marib yearly and stayed for several weeks to fill orders. The tribesmen bought the silver, and the silversmiths then sewed the pieces onto leather or cloth. Made for a tiny head, the circlet measures only 14.5 cm in diameter. The long, narrow hairpiece indicates that the wearer is married and is worn on one side of the head; it has coral-colored composition beads interspersed with silver pieces. The largest piece in figure 98 hung down the back. These three pieces were made in al-Bayda or Saada. The colorful belt in figure 99 was made in al-Bayda for the Jawf; the more complex hairpieces (bottom left in figure 99) were made in Habban, to the southeast, as was the one in figure 96. A *nuna*, or coin medallion, is visible in figure 96; the back of one and the front of another can be seen in figure 97. The coin

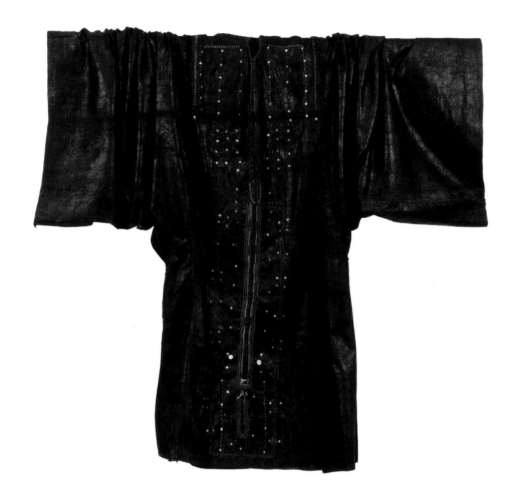

100. Harib, Marib governorate:
indigo-dyed cotton dress,
first half of twentieth century.

101. Wadi Bayhan: upper-arm
bracelet *(swara abu mahafith)*,
27 cm.

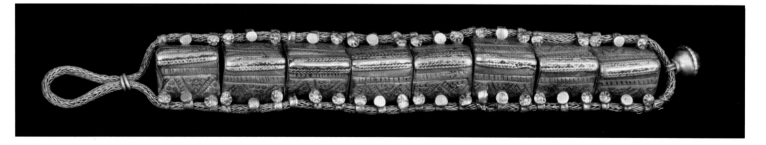

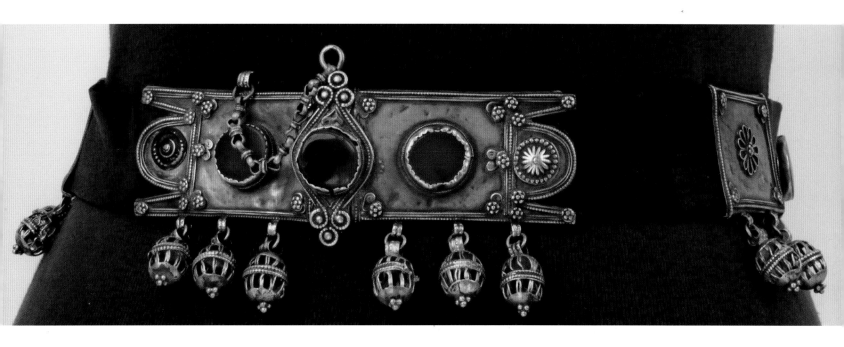

102. Wadi Bayhan: leather belt with silver pieces, 92 cm.

on the right is the back of an old Maria Theresa thaler, dated 1772; the coin on the left was made by Italians for their colony in Eritrea. It looks like the thaler but was not as widely distributed. In the *nuna*s the two-headed eagle of the thaler faced outward, but both sides were used prominently in other pieces of jewelry. Women from Marib, whom I met in a Sanaa shop, identified the dress in figure 100 as from Harib, which is in Marib governorate just before crossing into Wadi Bayhan in the Shabwa governorate. Harib had its own indigo-producing and dyeing industry, of which this dress is a good example.

Yemeni Jewish silversmiths in Wadi Bayhan in Shabwa province, about a hundred kilometers from Marib, made the items in figures 101 and 102, worn in Marib, as well as in Yafi' and Dali' in southern Yemen.

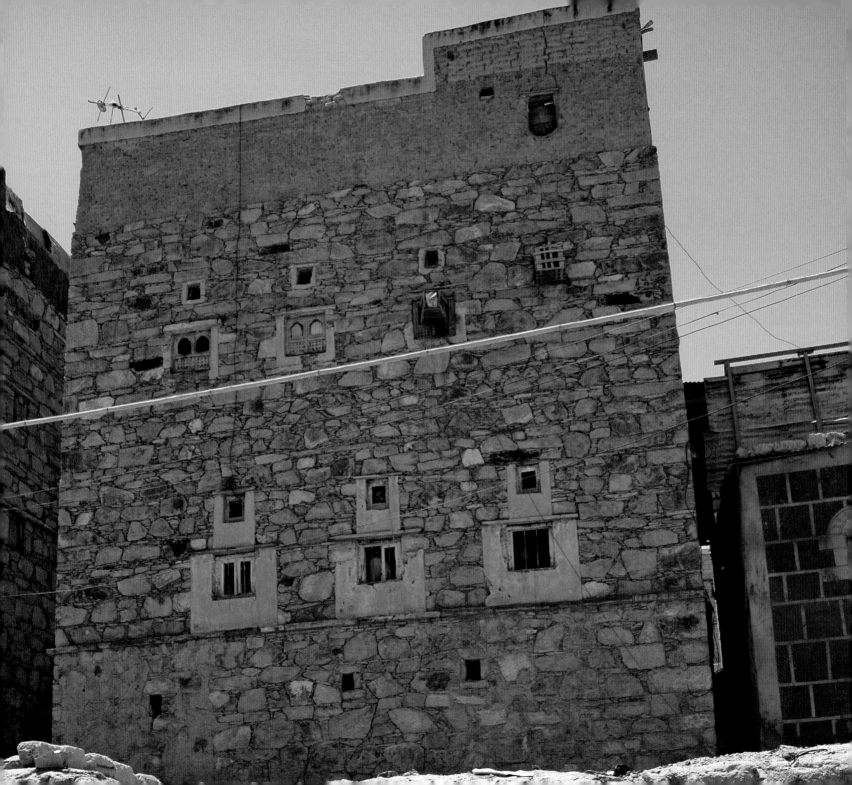

—— 7 ——

Al-Bayda

103. Al-Bayda: the stone house
built in 1945 for master silversmith
Ahmad Bahashwan, June 2005.

The al-Bayda governorate is located southeast of Sanaa on the old border between North and South Yemen. It was part of the Yemen Arab Republic before the two Yemens united in 1990, but had many ties to the south. Certainly in the case of jewelry, it was a bridge for silversmiths who moved across the border to and from Aden. Al-Bayda shares a certain architecture with governorates further east, especially Yafi'.[6] The house shown in figure 103 was built for master silversmith Abdullah Ashur Bahashwan in 1945 and reflects that influence.

The silversmiths in al-Bayda worked primarily to provide jewelry to Marib and the Jawf. When there was an active community of Jews living in al-Bayda, before the late 1940s, the Jewish craftsmen would travel north seasonally to sell their wares. My contact in al-Bayda, Abdullah Ashur Bahashwan, did not have examples of Jewish

104. *(opposite, left)* Al-Bayda: headpiece (*'isaba*), 40 cm, work of Ahmad Bahashwan. Coral beads were added later.

105. *(opposite, right)* Al-Bayda: jewelry in the shop of Abdullah Ashur Bahashwan, June 2005.

106. *(right)* Al-Bayda: high-grade silver amulet (*hirz*), 32 x 12 cm; silver bracelets (*awaliq mutall*), 6 cm, lined with leather. The dyed string holds the leather in place. The three pieces are the work of Ahmad Bahashwan.

107. *(below)* Al-Bayda: bracelets (*tafayat*), 5 cm.

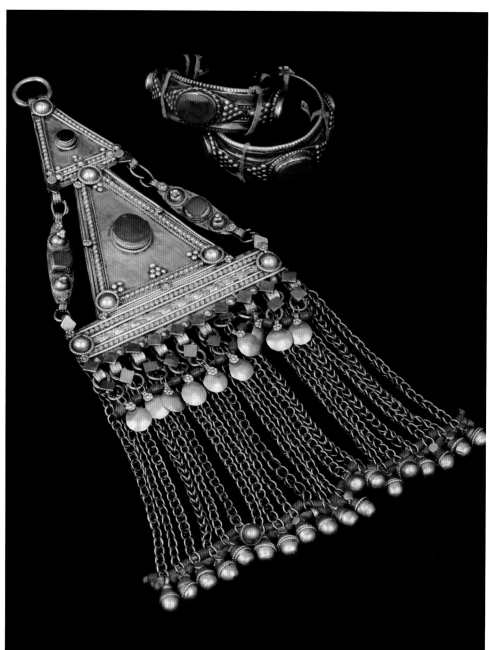

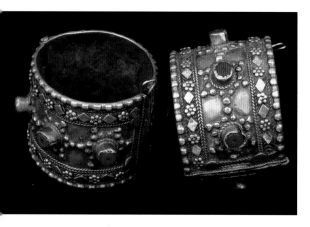

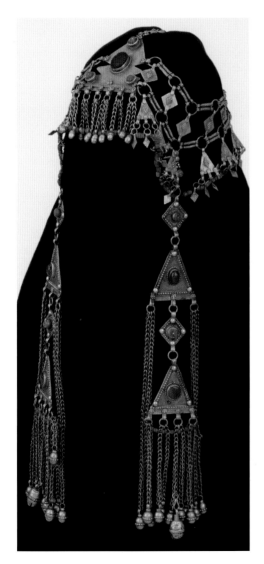

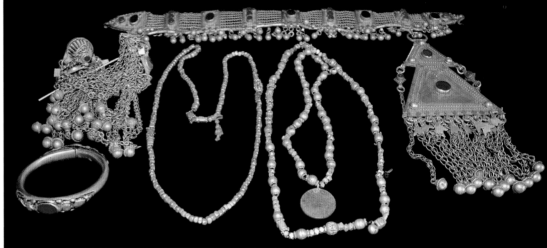

work, but showed me the pieces prepared in al-Bayda for Marib and the Jawf (fig.105). Such jewelry was also worn in Saudi Arabia. Red cabochons were the centerpieces of most pieces made for this area. Red is a sign of good health; for women, it reputedly provided protection from bleeding, especially during childbirth.

The finest pieces I have seen from al-Bayda are the two in figure 106 made by Ahmad Bahashwan, Abdullah Ashur's uncle. The unusual headpiece in figure 104 is also his work. The hinged bracelets in figure 107 are most probably from al-Bayda. The Star of David design in the placement of granules around the bezels and the general quality indicate Jewish work and the design is similar to Jewish jewelry produced in Ibb, to the west of al-Bayda, in the same period.

Much of the jewelry in al-Bayda was produced in nickel, reflecting the limited means of the customers, but the quality of the work remained high despite the cheaper metal.

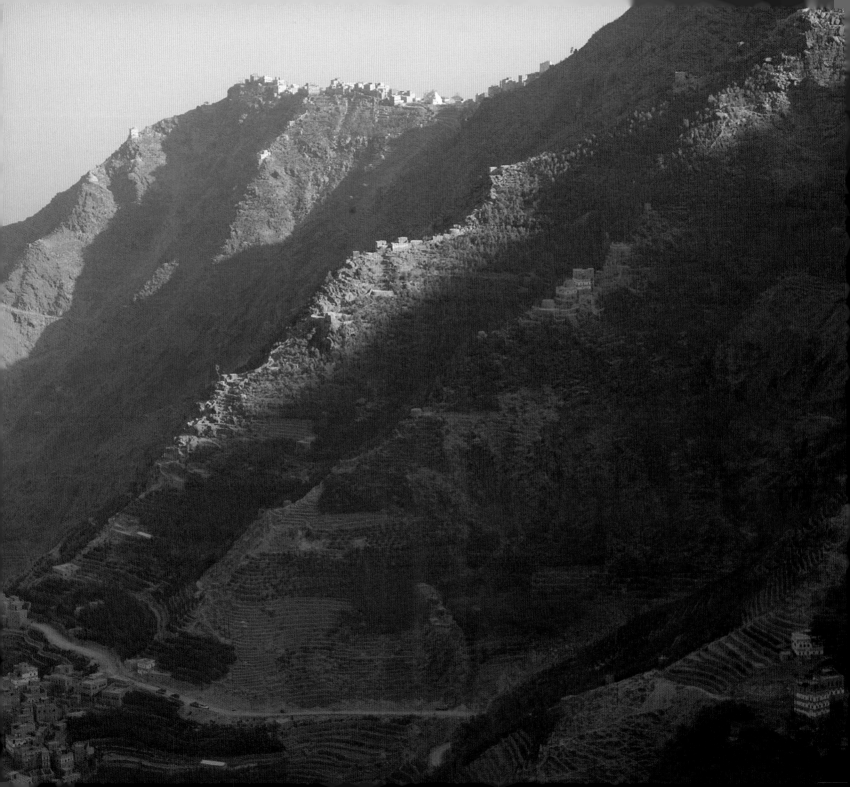

——— 8 ———

Mountains near the Red Sea

BUR'A, RAYMA, AND WASAB

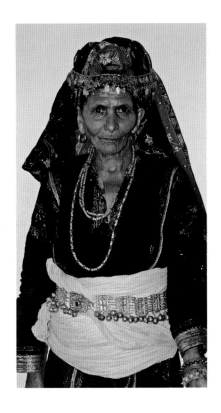

108. Ruqab, Bur'a: the village is on the left
crest of the mountain, February 2006.

109. Ruqab, Bur'a: Miriam, aged seventy,
February 2006.

When we visited Bur'a in Hudayda governorate, one of the mountain ranges that descend into Tihama, there were no rooms to rent, so we put a tent on the school roof, far below our final destination of Ruqab, seen in figure 108 on the upper left. This mountaintop settlement was once home to five families of Jewish silversmiths. Highly accomplished in their craft, they held closely the secrets of their techniques. Today, no one in the village works with silver. The hike up to Ruqab was tough. I shared a steep stone staircase with donkeys that galloped up and down carrying provisions. Once there, I interviewed a blacksmith who had worked many years for the silversmiths. A thoughtful schoolteacher on assignment in Ruqab invited me to his house to see pieces he had collected and to photograph Miriam, a woman of the village, wearing them (fig. 109).

110. Bur'a region: embroidered dress, silver thread overlay, red, blue, and off-white thread on black cotton, third quarter of twentieth century.

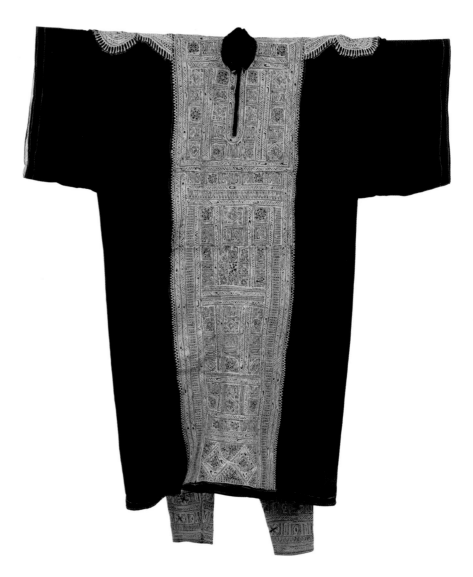

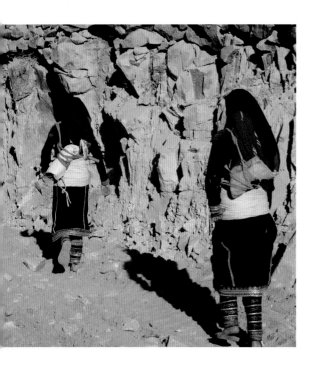

111. Bur'a: women going to get firewood, February 2006.

The embroidery of Bur'a (fig. 110) resembles that of Jabal Milhan to the north in Mahwit governorate. The women wear cummerbunds just like Miriam's when they go to gather wood (fig. 111). The cummerbunds support their backs as they carry heavy loads.

112. Bur'a: gilded necklace, 33 cm.

The necklace in figure 112 features shapes of palm trees and almonds, such as those found in Hadrami jewelry, but also in other Bur'a jewelry. In fact, the Bur'a jewelry so closely resembles that of Wadi Daw'an that I had to check repeatedly with my sources to be sure I was attributing the jewelry to the right locale. This resemblance is probably the result of coffee trade, since the coffee of Bur'a was consumed by the people of Hadramaut.

113. Bur'a: left to right: gilded necklace (*tayyar*), 64 cm; gilded silver pendant and silver chain, 7 cm; partially gilded silver headpiece (*mushqir*), 24 cm.

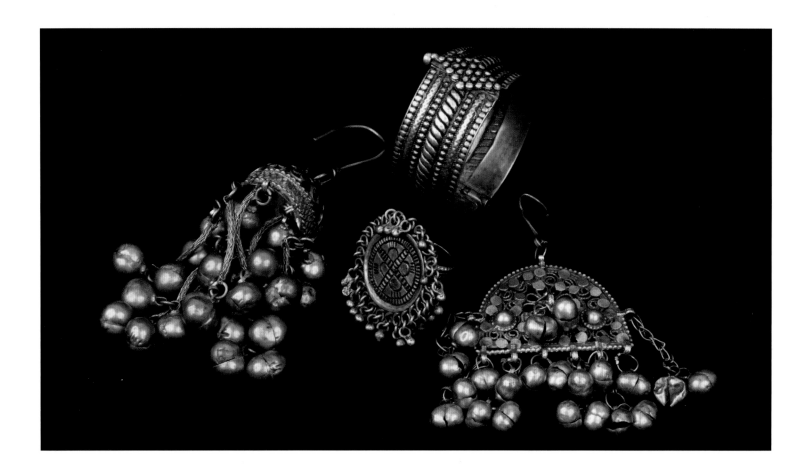

114. Bur'a: left to right:

headpiece (*mushqir*), 16 cm;

ring, 4 cm; earring, 13 cm;

top middle: hinged bracelet, 6 cm.

Each is one of a pair.

Like their cousins in Hadramaut, the women of Bur'a loved to dance, and their jewelry made noise. The cylinder on the right in figure 113 was worn under the headdress on the side of the face, usually alongside green herbs such as basil or rue, for dancing at celebrations such as an engagement or the birth of a child. The long necklace on the left was worn resting on the hip. The headpieces in figure 114, as well as the ring, all make noise for dancing. The hinged bracelet has a bold, strong design.

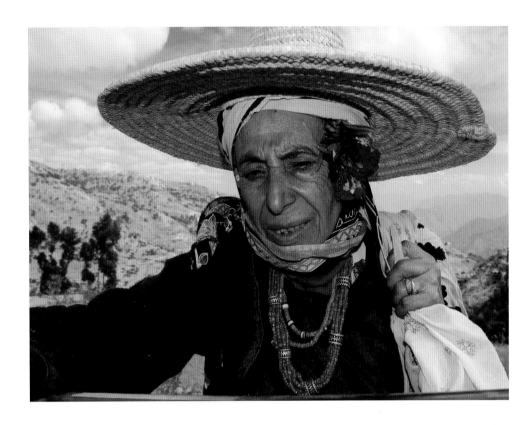

115. Rayma, February 2005.

116. Rayma: coral trader (*dalala*), February 2005.

RAYMA GOVERNORATE

As I rode up the track from Bayt al-Faqih on the coast to Kuzma, the capital of Rayma in the mountains, I met a woman who traded coral. She said she had seen me several months before in Taiz trying to photograph women selling qat (*catha edulus*, the mild stimulant chewed by many Yemenis). She was right, but what a coincidence! Now that taste and needs have changed, the Rayma families are selling their coral. The large necklace the woman wears in figure 116 has multiple strands of old Russian coral and intricate *tut* beads made years ago by a Jewish silversmith. Notice the flowers and sweet-smelling herbs she has tucked in her headdress.

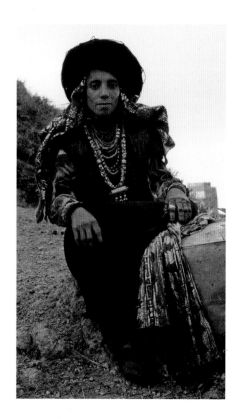

117. Rayma: woman dressed for a religious festival, 1980.

118. Rayma: coral necklace (*'aqd marjan*), with silver amulet, 32 cm; headdress of flattened chain (*makhalaf*).

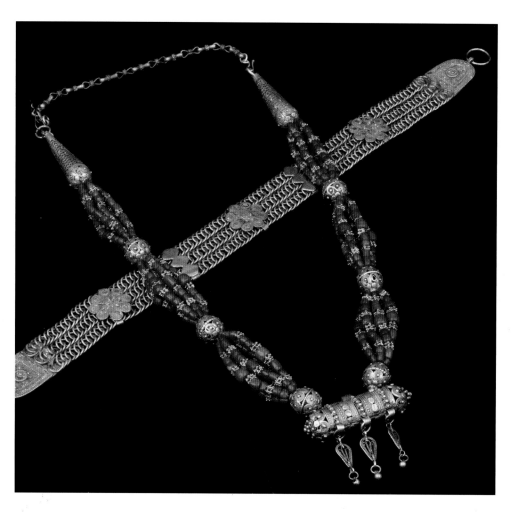

The coral necklace, figure 118, is a special necklace given to a woman after she gives birth for the first time, whether the child is male or female. It was worn throughout the northern mountains of Yemen. The woman from Rayma in figure 117 wears an elaborate example. She could have worn as well the headdress found in figure 118. There was a community of Jewish silversmiths in Rayma; their work, seen in figures 119 and 120, gives testimony to their skill. Figure 119 was worn like a

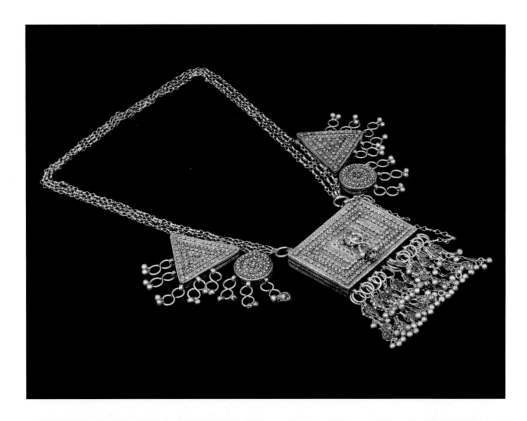

119. Rayma: large necklace *(tayyar)*, 92 cm.

120. Rayma: necklace *(labba 'agrat)*, 23 cm.

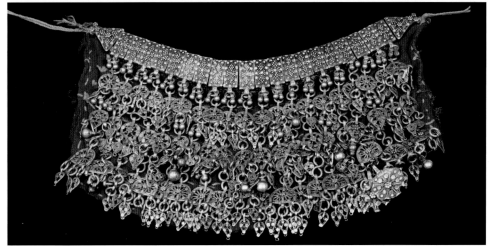

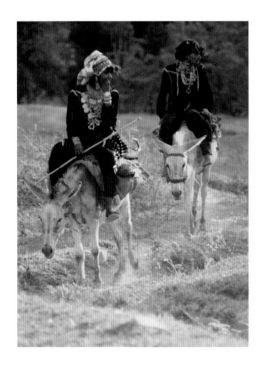

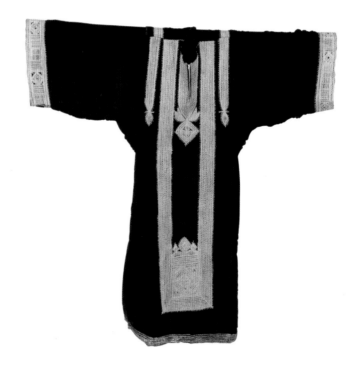

121. Rayma: women on donkeys
dressed for a celebration, 1980.

122. Rayma: silver and silk thread
couched embroidery on velvet dress,
first half of twentieth century.

bandoleer, across one shoulder and hip, and has very fine granulation. Similar bandoleer-like pieces were worn in Hajja governorate and in nearby Bur'a. Figure 122 is a traditional dress of Rayma, and figure 121 shows Rayma women on a feast day astride their donkeys in their holiday splendor.

A woman I met in Wasab Safil told me that she considers her Rayma necklace (fig. 124) her most important piece of jewelry. She received it when she wed and wore it all her life for special occasions like weddings or religious feasts.

The young woman in figure 123 wears her wedding dowry, with at least thirteen strands of coral, and gold earrings. She wears wool braids to enhance her headdress and a large granulated amulet hangs over one ear. Her hands are worn from hard work, but her smile reflects her pride in her appearance on her feast day. In figure 125, recycled pieces of jewelry are displayed on an old dress front.

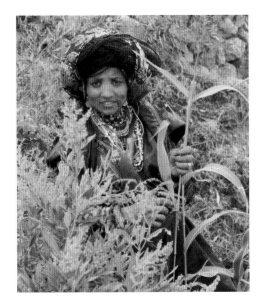

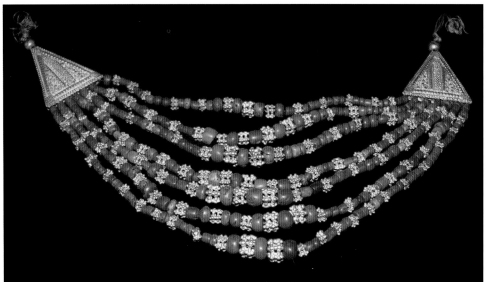

123. Rayma: woman dressed in her celebratory best, 1980.

124. Wasab Safil: coral wedding necklace, February 2006.

125. Rayma: indigo-dyed, hand-loomed cotton dress front.

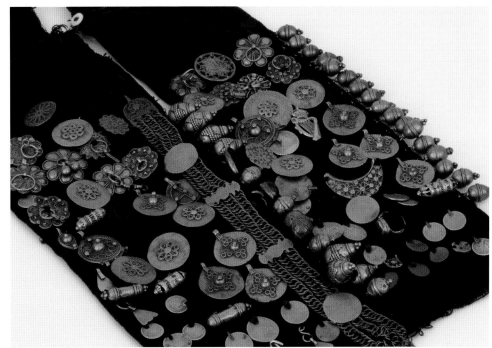

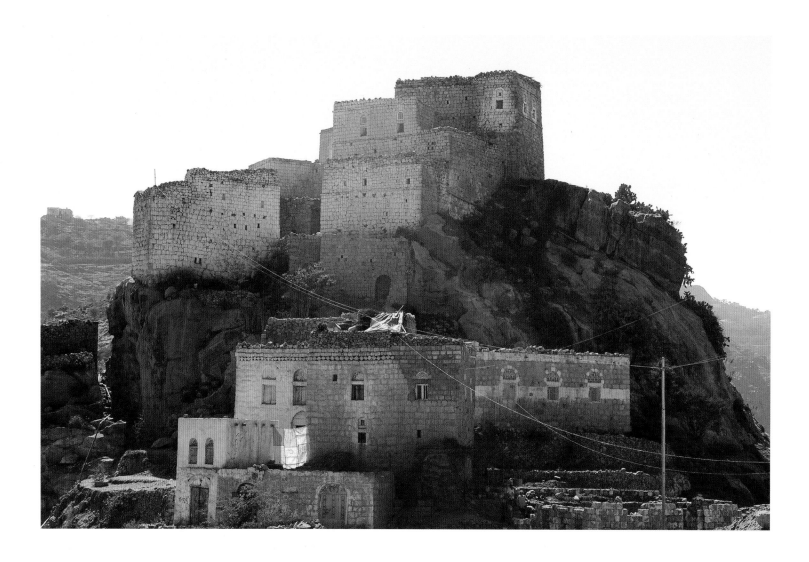

126. Dan, Wasab Ali, February 2006.

WASAB

Part of the Dhamar governorate, Wasab is another mountain range that springs up out of Tihama. When I visited in 2006, Wasab had no paved roads or electricity and was an area even my much-traveled driver Abd al-Rahman al-Sabri had not visited. I was searching for jewelry made by the Arifi silversmith family, who worked throughout northern Yemen and in Saudi Arabia's western coastal towns: Najran, Jeddah, and Mecca. Because they were from the Wasab region, the Arifi silversmiths were nicknamed Wasabi.

We set out from Bajil, a Tihama city at the base of the mountains, and started to climb—and climb. We had a late start and it was getting dark as we approached Dan (fig. 126), the main center of Wasab Ali (Upper Wasab). Abd al-Rahman had asked several landowners as we approached Dan if we could camp on their property, as we knew there would be no hotels. No one would allow us. We got preliminary agreement from some lower-level employees to camp in the compound of a telephone company, but the big boss denied us. Someone appeared in Dan's main square to offer me a room with no bathroom. That was not helpful, so I refused. It was completely dark when we started to put up our tent in the flattest space we could find. I thought to myself that I had never experienced such inhospitality in Yemen. Then, suddenly and without warning, a man with a kind face stepped forward from the darkness and told us that the *mudir* (local administrator) of Dan wanted to meet me.

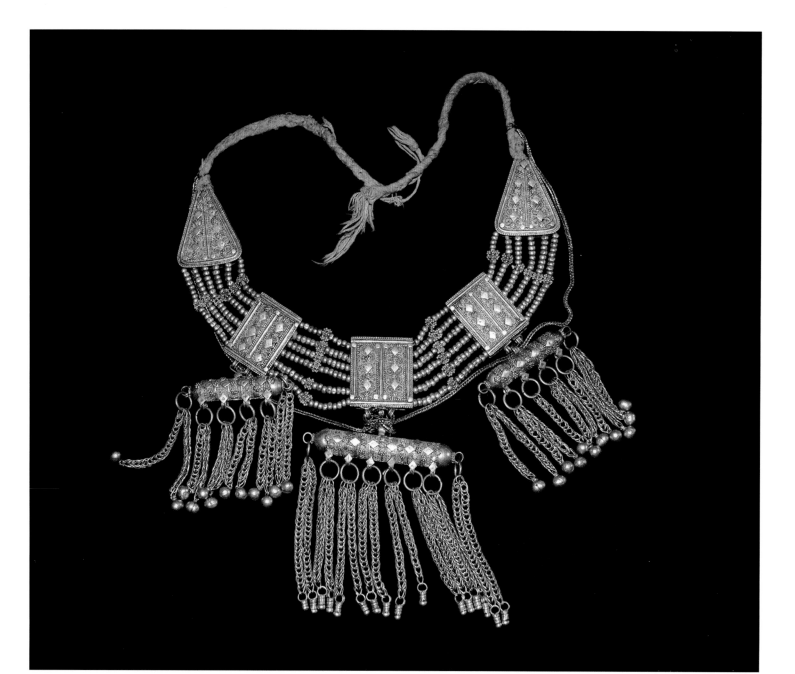

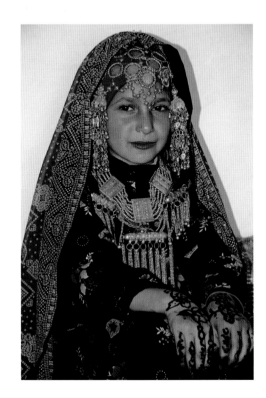

127. Dan, Wasab Ali: necklace *(lazim),*
February 2006.

128. Dan, Wasab Ali: young girl in wedding finery,
February 2006.

I grabbed my heavy portfolio of photos of silver jewelry from the Wasab area and went off in the dark, clutching my tiny flashlight and clambering up the rocky path. After an interminable hike, we came to an open door from which light poured forth. The *mudir*, who hailed from the Jawf governorate, greeted me and invited me into a room with at least thirty local notables; he seated me next to him on a raised dais. Before I had a chance to say anything, a man at the back of the room cried out in a loud voice that I had come to steal their ancient manuscripts! I understood exactly what he was saying and responded that I had no manuscripts in my possession. Furthermore, I could not read manuscripts and I sought none from anywhere. The *mudir* then asked me to explain what my purpose in Dan was. I replied that I had a research grant to study the traditional silver jewelry of Yemen. No one had done this study, the craftsmen were disappearing, and I wanted to document this unique, beautiful handicraft before it was too late. When I showed the *mudir* my portfolio of pictures of Wasabi jewelry, he took a perfunctory look and then sent the note-book around the room so the men assembled could see with their own eyes what my research involved. Then he picked up the phone and called the governor of Dhamar to inform him that he had an American woman with him who wanted to research Yemeni silver jewelry. My heart was in my throat! But when he got off the phone, he announced to all assembled that the governor had said that what I was doing was wonderful and that it was good for Yemen. Furthermore, the governor had instructed him to give me all the assistance he could. He then offered us food and lodging.

The next day I was instructed by the *mudir*'s office to go to a lady of the village who had researched local culture. She proudly showed me her wedding silver, including the necklace, or *lazim* (fig. 127), given by her grandfather to her grandmother eighty years earlier. She dressed her daughter in her wedding jewelry; her hands were deco-rated with henna or, in this case, *khadhab*, a different but similar substance.

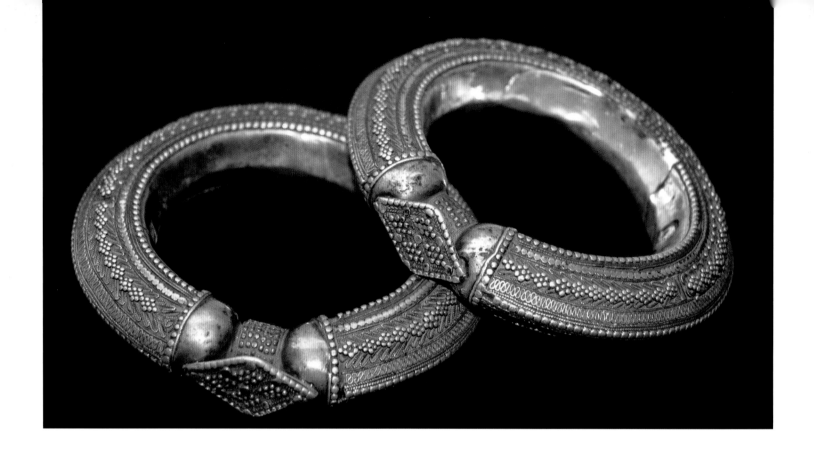

129. Bani Arif, Wasab Safil:

upper-arm bracelets,

made by Hassan al-Arifi,

February 2006.

The next morning, even before we had had breakfast, I was told that the *mudir* had decided to escort me to Wasab Safil (lower Wasab), with a stop for a picnic by a waterfall. We were off quickly to Suq al-Ahad (the Sunday market), the municipal center of Wasab Safil.

I had no idea what I would find on this journey to Wasab. None of my Sanaa sources knew anything about silversmiths there. I knew no one and had no phone numbers to call, so it was a true adventure. They told me in Wasab Ali that they had had Jewish silversmiths in the distant past, but no one presently worked silver. They advised me to look for the Arifi family in Wasab Safil. So, after I attended a lunch

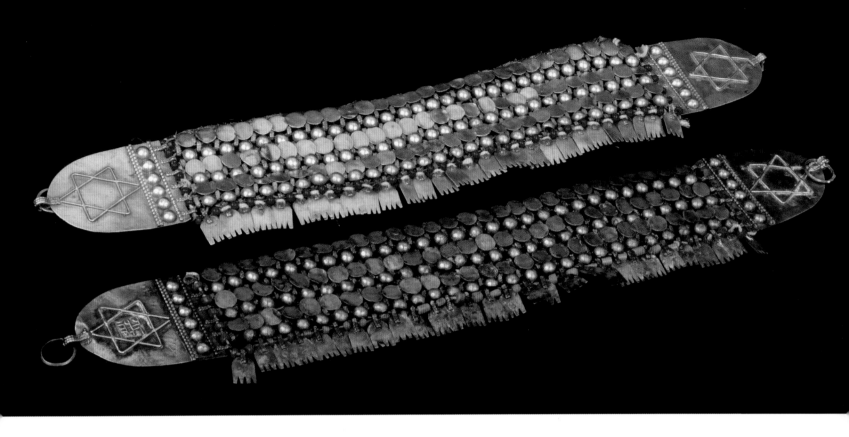

130. Bani Arif, Wasab Safil: two headpieces
(*ma'saba*), 35.5 cm, both by Abdullah Ghalib al-Arifi,
one with signature and one without.
Flat dangles edge the bottom; flat silver buttons
and bead halves are soldered onto a mesh of linked
circlets, and coral and composition beads are
incorporated along the bottom and one side.

in Suq al-Ahad hosted by the *mudir*, I set off with my driver to find silversmiths. We
stopped at a small cigarette shop by the side of the road to ask directions. The
four distinguished gentlemen standing in the sun by the shop turned out to be
retired silversmiths! One, Hassan, was a member of the al-Arifi clan and a wonderful
craftsman; he brought the examples of his work in figure 129 for me to photograph.

We proceeded to Bani Arif, the village of the Arifis, where we were directed to
the workshop of the brothers Abdullah Ghalib and Muhammad bin Ghalib al-Arifi.
I was astonished to discover that one of my favorite pieces—an *'isaba*, or headpiece
(fig. 130)—worn all over the north of Yemen, was Abdullah's creation. I had always

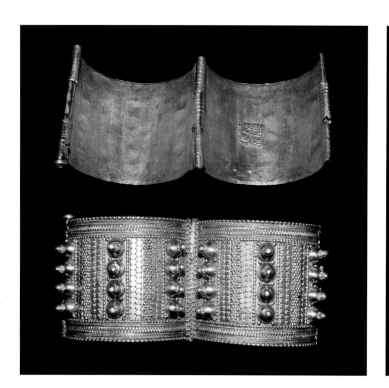

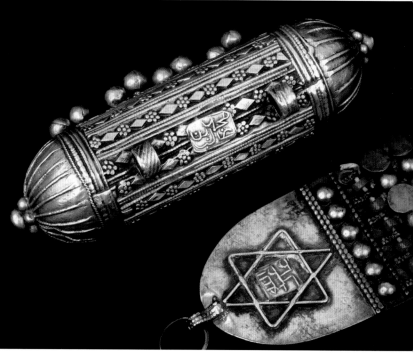

131. Bani Arif, Wasab Safil: bracelets, signed by Abdullah Ghalib al-Arifi.

132. Bani Arif: amulet (*hirz*), 12 cm, signed by Muhammad bin Ghalib (al-Arifi). The headpiece, the same as in figure 8.24, is signed Abdullah Ghalib al-Arifi.

wondered where bracelets such as those in figure 133 were from and I now have direct documentation. These pieces, which bear Abdullah Ghalib's signature, have distinctive bosses and granulation. Muhammad bin Ghalib's work, seen in the amulet in figure 132, is also well known. I already had several examples in my collection but had not realized he was from the al-Arifi family, as he and Abdullah do not sign their full names (note their two clear signatures on the amulet and the headpiece in figure 132). These two gentlemen may be the best surviving silversmiths of their generation and are little known outside their remote location.

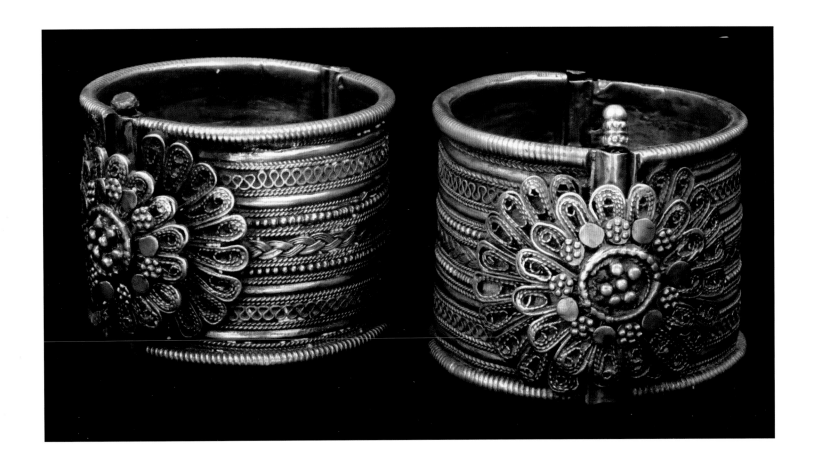

133. Dhamar City: hinged bracelets *(tafayat)*, braided silver wire and a double rosette, 20.5 cm.

The bracelets in figure 133 were hard to document. Many of my sources suggested Dhamar, which is the capital of the province where Wasab is located. They posited that it was just a local design, but I saw it in both Sanaa and Taiz. The rosette design is unusual, but the pressed bands of silver resemble work from Ibb, south of Dhamar City. I have good documentation for the Dhamar necklace in figure 134. It came from a Sayyid family in Dhamar who had owned it from the time of purchase two generations earlier. The style is unusual; it is the only time I have seen such coral wrapping on barley beads. It is clearly Jewish work.

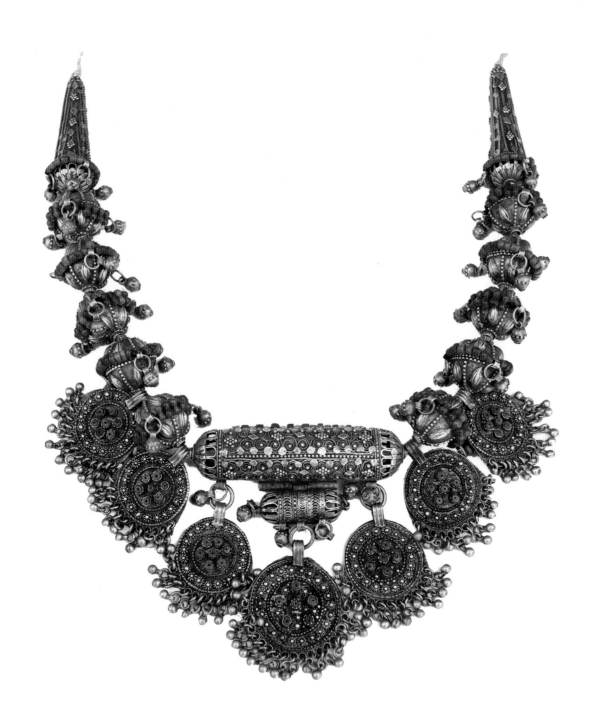

134. Dhamar City: necklace *('aqd)*, with Russian coral beads, 57 cm. The coral beads on six of the ten silver barley beads are cut to look like two beads.

135. Wasab Safil: top: necklace *(mariyya musaddasa)*, 48 cm, with glass and small coral beads. Wasab Ali: bottom: necklace, also called *sambusa* or *sharikh*, 41 cm, with glass beads.

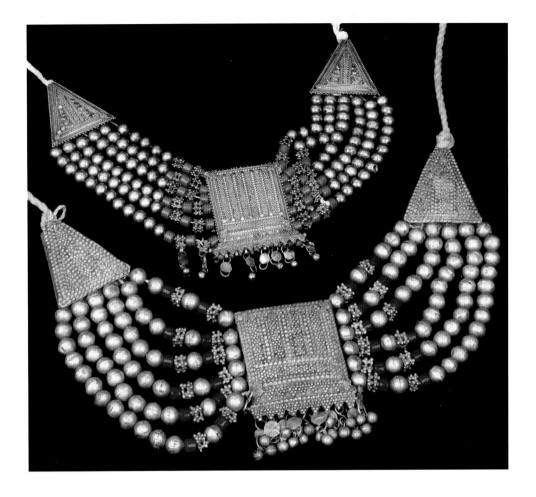

There are several older pieces in my collection that were made by Wasabi silversmiths in various locations. The necklaces in figure 135 were worn every day as well as for special celebrations. The lower piece was made in Wasab Ali, probably by a Jewish silversmith. The upper necklace, a finer piece, was made by an Arifi in Wasab Safil. Notice the smooth, round silver beads on both pieces. Wasabi silversmiths are famous for them.

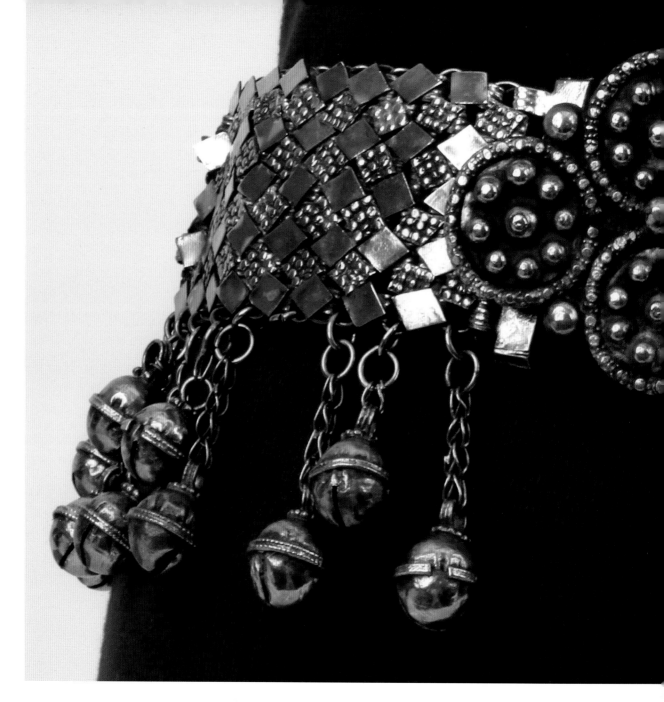

136. Wasab Safil: belt, 81 cm.

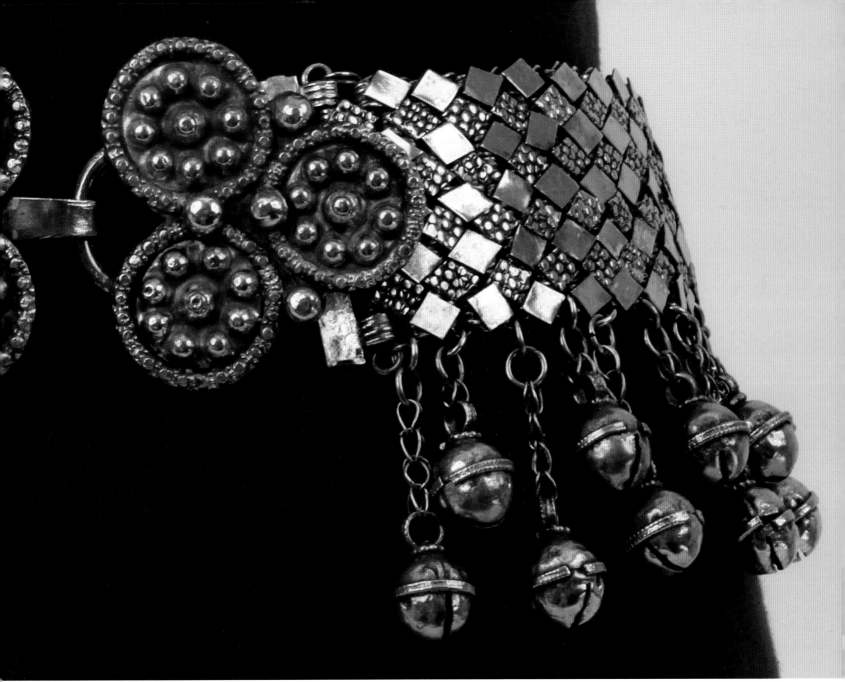

137. Wasab: mulberry *(tut)* beads made
by a Wasabi silversmith in Taiz;
on left and right, silver beads with faux granulation;
amber-colored composition beads on right
were probably made in Czechoslovakia
or Germany in the first quarter
of the twentieth century.

138. Najran, Saudi Arabia: necklace *(lazim),*
34 cm, mid-twentieth century.

The belt in figure 136 has hammered diamond shapes that simulate more complex granulation. Figure 137 contrasts the faux granulation with the fine granulation in the *tut* beads; both are signs of Wasabi work.

The necklaces in figures 138 and 139, to the best of my knowledge, were made in Najran, Saudi Arabia, by Wasabi silversmiths for customers in the Asir and Hijaz areas of western Saudi Arabia. At the time these pieces were made, Najran was part of Yemen. The crown in figure 140 has Wasabi features and was probably made in Jeddah for a special customer. I saw a crown like it in gold or gilded silver in a now out-of-print and unavailable Saudi publication; it was flat, not bent to the shape of

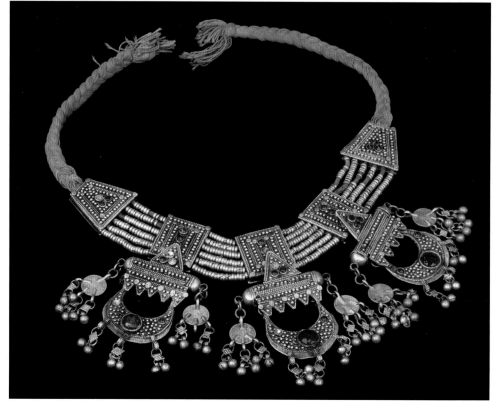

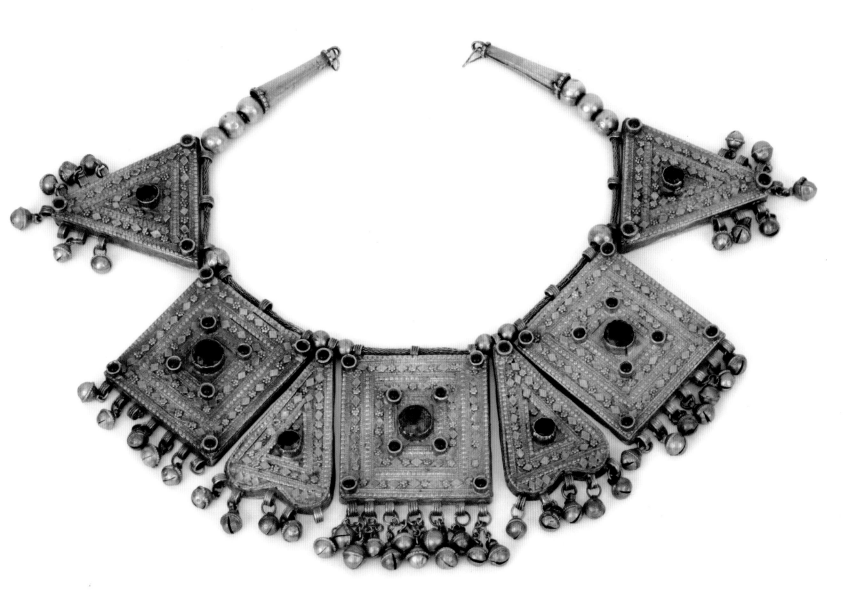

139. Najran, Saudi Arabia: necklace *(lazim)*, 62 cm,
early twentieth century.

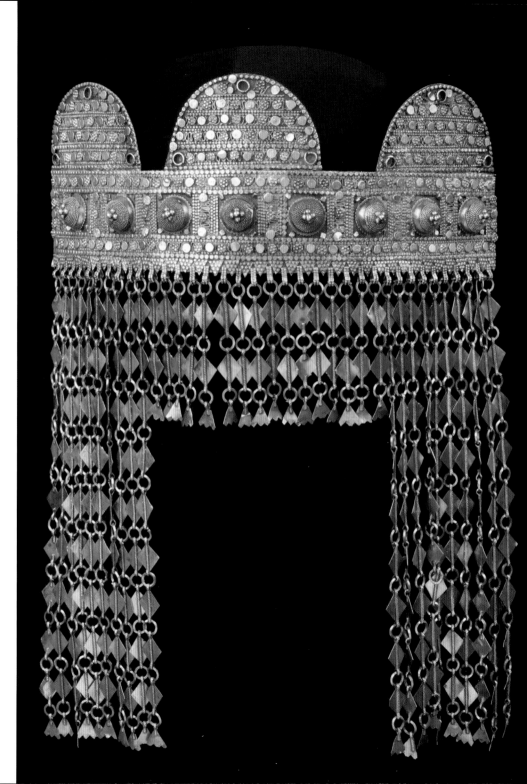

140. Crown *(taj)*, 32 cm,
made in Jeddah by a
Wasabi silversmith.

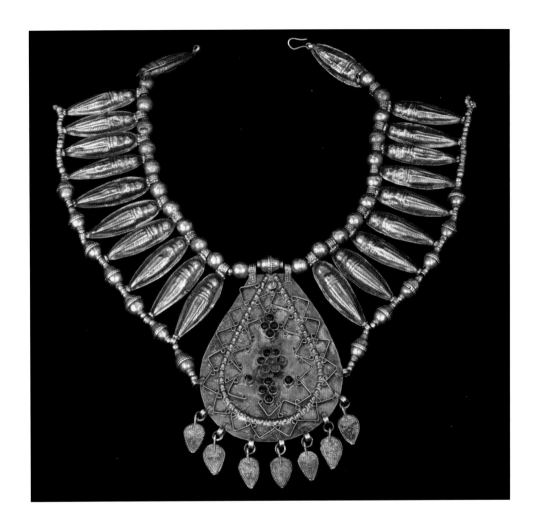

141. Najran, Saudi Arabia: gilded necklace, 40 cm, work of a Wasabi silversmith.

the head like this one. The piece in figure 141 is a mystery. My contacts insisted it was made in Najran by a Wasabi silversmith. I have seen more than one like it but did not find other jewelry that resembled it anywhere in Yemen.[7]

—— 9 ——

The Southern Mountains

TAIZ, HUGARIYA, AND IBB

Taiz is the most populous city in Yemen and the trading center for the southern part of the country. Jabal Sabir is the high mountain overlooking the city. The women of Jabal Sabir, seen in figures 142 and 143, are renowned as independent traders.[8] Theirs is the only region I know of in Yemen where women own land and sell their produce—they walk down the mountain to Taiz daily to sell their crop of qat leaves. Thus, in the period my study covers, from the mid-nineteenth to the third quarter of the twentieth century, Jabal Sabir brides drew some of the largest bride prices. They wore the particular pieces of jewelry seen in figure 144.

In the first half of the twentieth century, processed amber beads like those in figure 145 were popular in the Taiz area. Figure 146 shows examples of the bracelets Jewish and Muslim silversmiths in the Taiz area made to meet the preferences of

142. Jabal Sabir women going home from the fields to make lunch for the family, June 2006.

143. Jabal Sabir, Taiz: Sabir woman, oil on canvas painting, work of Said Alani, 1995.

144. Jabal Sabir, Taiz; top to bottom: necklace of dangles *(namanim abu shathra),* mulberry *(tut)* divider beads, black and white cut agate beads *(jaza'),* and two coral-colored glass beads *(mirj)* 38 cm; six-strand silver necklace *(hunaysha),* 39 cm; necklace of German *jaza',* 2.65 cm; silver choker *(tanj),* 27 cm.

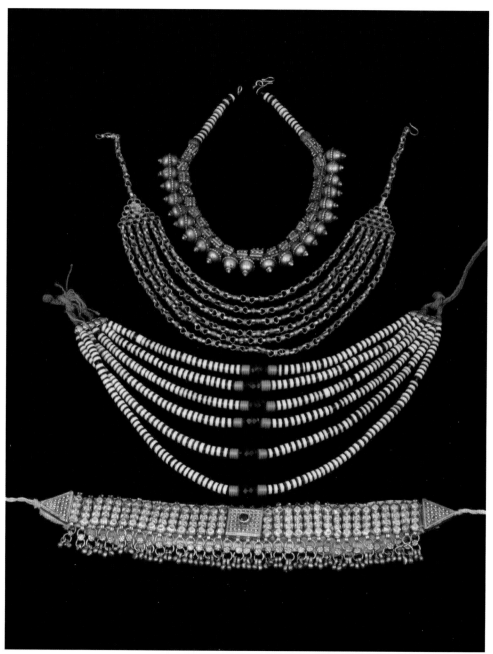

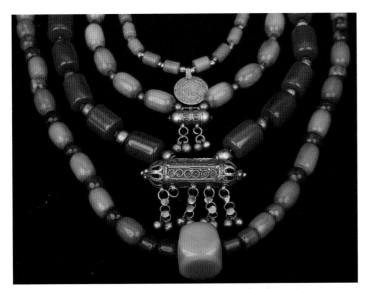

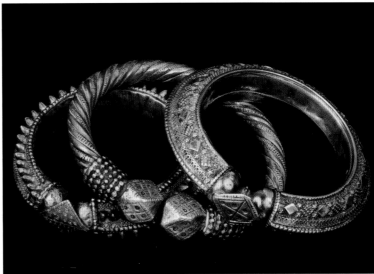

145. Taiz governorate: top to bottom: processed amber necklace, 38 cm, with Imam Ahmad coin, dated AH 1327 (AD 1909); necklace of what Yemenis call Hadrami amber, 55 cm; necklace of amber-colored glass beads, 45 cm; necklace of amber composition and brown tiger-eye beads, so-called Jabal Sabir amber, which was considered a treatment for illness.

146. Taiz: left to right: upper-arm bracelet (*ma'adhid musannan*), 11 cm; heavy high-grade twisted silver upper arm bracelet, 10.5 cm; upper-arm bracelet, 11.5 cm. Each is one of a pair.

specific local communities and Tihama. The necklaces in figure 147 were made by Jewish artisans. The bottom piece has a mix of coral and composition beads, faceted solid beads and small *tut* beads, a Badihi plaque, and Bawsani ends. The largest coin, a Maria Theresa thaler, is dated 1765. As they were usually dated 1780, this is an early coin. A Saudi coin is dated 1886 and the Indian rupees are dated from the first decade of the twentieth century. Both necklaces were produced for the al-Qubayta area south of Taiz.

Ahmad Sam'i, a Muslim silversmith in Taiz, who worked after the departure of the Jewish artisans in the late 1940s, gave me two examples of his work when I visited him in 2004. You can see in figure 148 that his work is fine. The hinged bracelet and the headpiece are made of low-grade silver, but that was almost always the case for the *labba* necklaces, which needed the strength of additional base metal.

Indian glass bracelets (fig. 149) were widely worn in the Tihama area and the southern mountains of North Yemen as early as the second quarter of the twentieth

147. Taiz: top: necklace (*mariyya*), 28 cm,

bottom: necklace, 48 cm, has

a Badihi plaque and Bawsani ends.

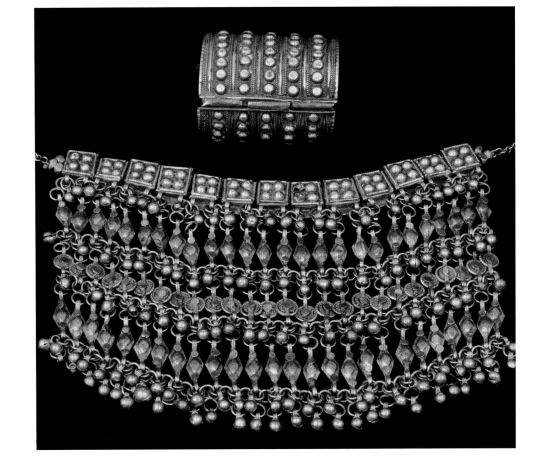

148. Taiz: hinged bracelet, 7 cm; necklace *(labba)*, 22 cm, both the work of Ahmad Sam'i.

century. Ali Sa'idi, a Yemeni friend from Ibb province, told a story about the bracelets. When he was twelve years old, he was transporting goods on a camel for his father, a merchant. He saw a wild dog—Yemen was full of them when he was a boy. They roamed freely and were a nuisance. He threw a stone at it. He missed the dog and instead struck the mouth of a woman passing by and broke her front tooth. He was very frightened, thinking that she would be angry at him. Instead, she cried out in a loud voice, "Thank God, you did not break my glass bracelets!" She was afraid

149 Taiz and Tihama: Indian glass bracelets *(balaziq)*, 7.5 to 8.5 cm,

worn north to Ibb and all over Tihama, early twentieth century.

150 Taiz: young women wearing Indian glass bracelets on their upper arms, ca. 1965.

that would bring the evil eye upon her. You can see in the Graf photograph in figure 150 that both upper arms of the young Taiz women are full of glass bracelets.[9] It is a puzzle how women got them on and how they avoided breaking them.

The dresses and pantaloons from the Taiz area, figures 151 and 152, have remarkably bright embroidery.

151. Taiz area: black cotton dress with
silk hand embroidery, worn in Misra,
in the eastern part of Jabal Sabir,
mid-twentieth century;
pantaloons of hand-woven cotton,
hand-embroidered with silk/cotton thread.

152. Taiz area: black cotton dress heavily embroidered with silk and cotton thread, first half of twentieth century; hand-embroidered pantaloons.

HUGARIYA AND TURBA

Turba is an important marketing center in the middle of the Hugariya region south of Taiz. It also had a community of Jewish silversmiths; an example of their work appears in figure 155. One can see local tastes in costume in figure 154.

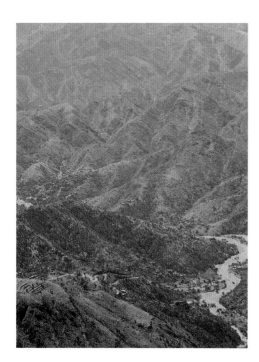

153. *(above)* Turba, Taiz governorate: view south toward Aden, October 2004.

154. *(right)* Turba, Taiz governate: embroidered black dress from Azaiz Hugariya, between Turba and Misra.

155. *(opposite)* Turba, Taiz governate: necklace *(lazim)*, 37 cm, with coral and *tut* beads, as well as chunks of coral in cabochons on the central medallion.

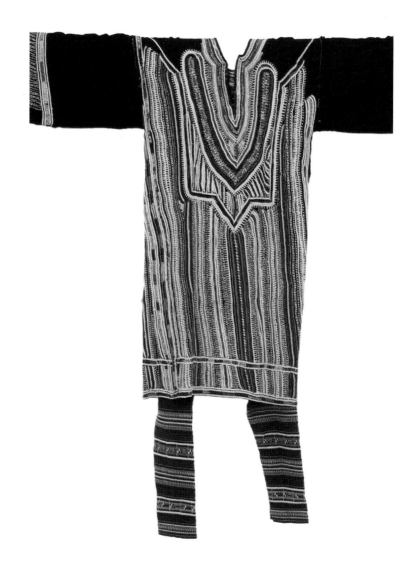

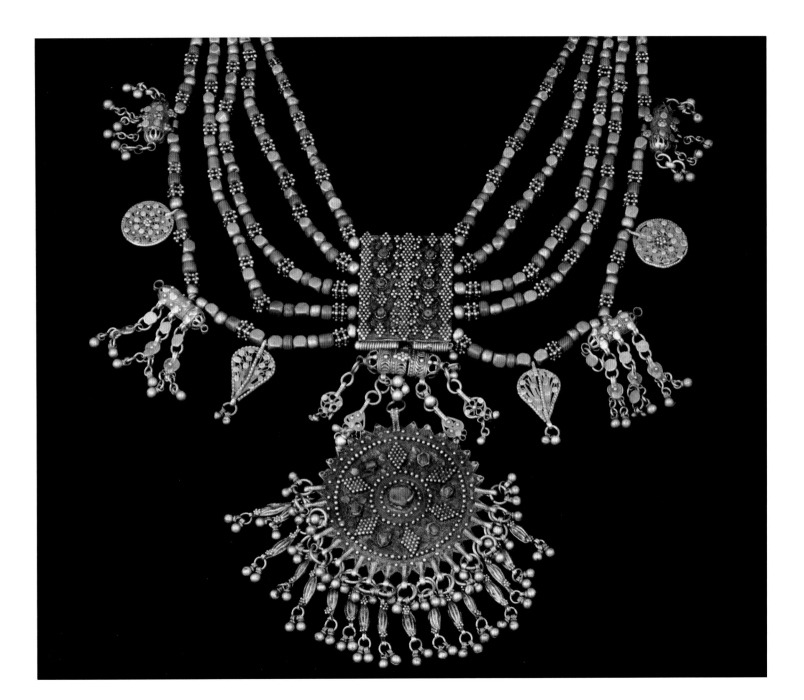

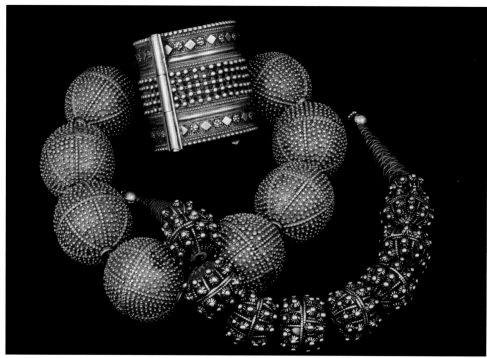

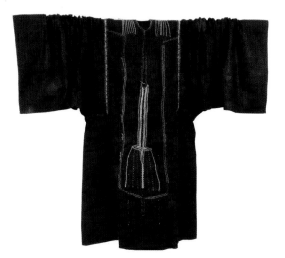

156. Ibb: old door with Stars of David, October 2004.

157. Ibb: left to right: beads *(qahhat)*, 12.3 cm, unique examples, perhaps done as a special order; necklace *('aqd)*, 33 cm; bracelet *(tafiya)*, one of a pair, 5.3 x 5.9 cm. .

158. Ibb: indigo-dyed dress with hand embroidery.

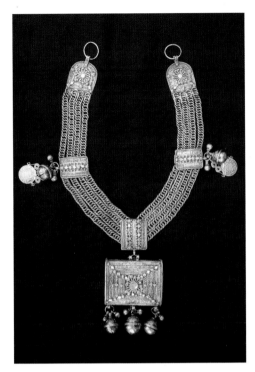

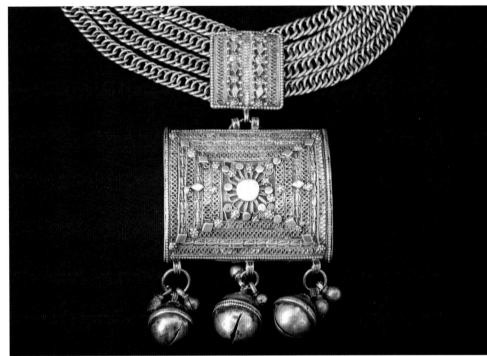

159. Ibb: necklace, 59 cm, a gift from Ali Sa'idi to the author, the same Ali Sa'idi of the story on pp. 123-25 about glass bracelets.

160. Detail of Ibb necklace in fig. 159.

IBB

Ibb, a governorate just north of Taiz, had Jewish silversmiths and other craftsmen and is known for its old doors. The Star of David on the door in figure 156 indicates that it may be the work of a Jewish carpenter. As can be seen in figure 157, the jewelry of Ibb had a distinctive style. The necklace in figure 159 was a gift to me from Ali Sa'idi from the Ibb governorate, who told me that his mother wore it. The dress in figure 158 has a straightforward design and may have been worn as everyday attire.

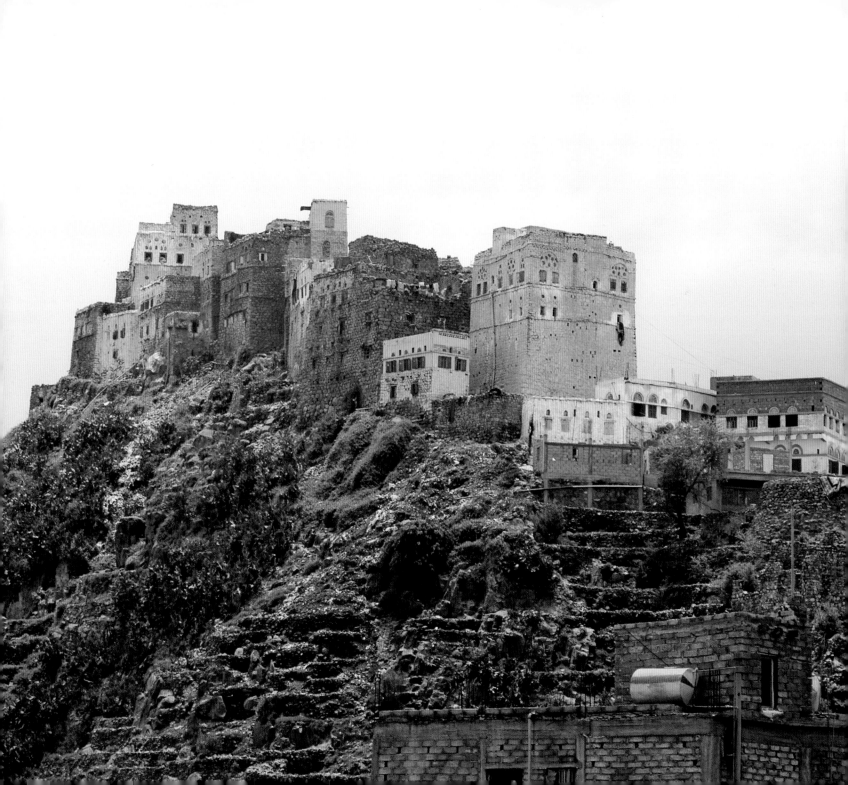

—— 10 ——

The Northern Tihama Coastal Plain

ADHRA', HAWATIM AL-TUR, AL-DHAHIYY, AND ZAYDIYA

In the spring of 2006 I traveled from Mahwit City, west of Sanaa, to Adhra' to talk to artisans who worked in tin and low-grade silver, to Hawatim al-Tur to research the history of Abdullah Ghathban, a well-known Muslim silversmith who worked in the mid-twentieth century, and to al-Dhahiyy, the largest center for making silver jewelry in Tihama. On another trip, I visited nearby Zaydiya, a city known for a distinctive type of silver work.

ADHRA'

While interviewing silversmiths in Adhra', I met Lam'a (fig. 162), who was wearing the lovely pair of bracelets in figure 163. Her son urged her to sell them, but when I asked her preference it was clear that she wanted to keep them—and keep them she did.

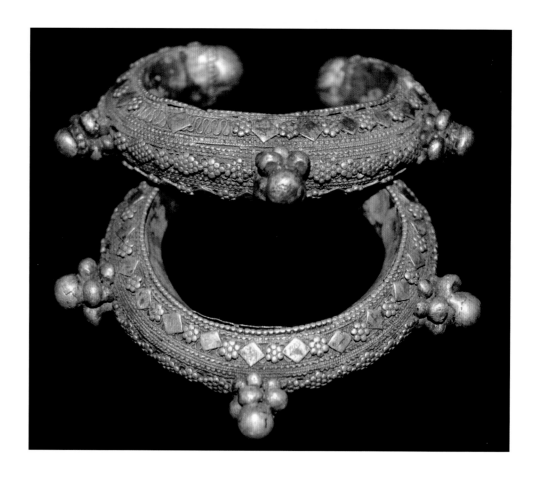

162. Adhra': Lam'a and her bracelets, April 2006.

163. Adhra': Lam'a's bracelets, made in Wasab, April 2006.

164. Hawatim al-Tur, April 2006.

HAWATIM AL-TUR

In Hawatim al-Tur, where the mountains descend to the Tihaman coastal plain, I found sources who had known the jeweler Abdulla Ghathban, who made jewelry that was worn widely in northern Tihama and nearby mountains. A couple showed off their wedding jewelry, and she was wearing Ghathban bracelets. There are several other examples in the Ransom collection, some of which are seen in figure 167. Figure 166 shows a northern Tihama dress.

165. Hawatim al-Tur: couple showing off the family jewelry, April 2006.

166. Northern Tihama: black cotton dress, embroidered with cotton, silver, and silk thread, mid-twentieth century.

167. (opposite) Northern Tihama: top, left to right: bracelet (swara), one of a pair, 6.5 cm; bracelet, 9 cm; bracelet, one of a pair, 9 cm; bottom, left to right: ring, 2.5 cm; top earring (akhras), 5 cm; lower earring with dangles, 5 cm; top earring, 6 cm, and bottom earring, 8.5 cm. Each earring is one of a pair. All items are the work of the late Abdulla Ghadban.

Roughly an hour's drive north of Hudayda, al-Dhahiyy was the largest silver-making enclave in the Tihama area. It once boasted fifty craftsmen. When I first visited in 2005, it had fifteen silversmiths, but when I returned in 2007, the number had dwindled to seven. My principal contact had been reduced to selling gold.

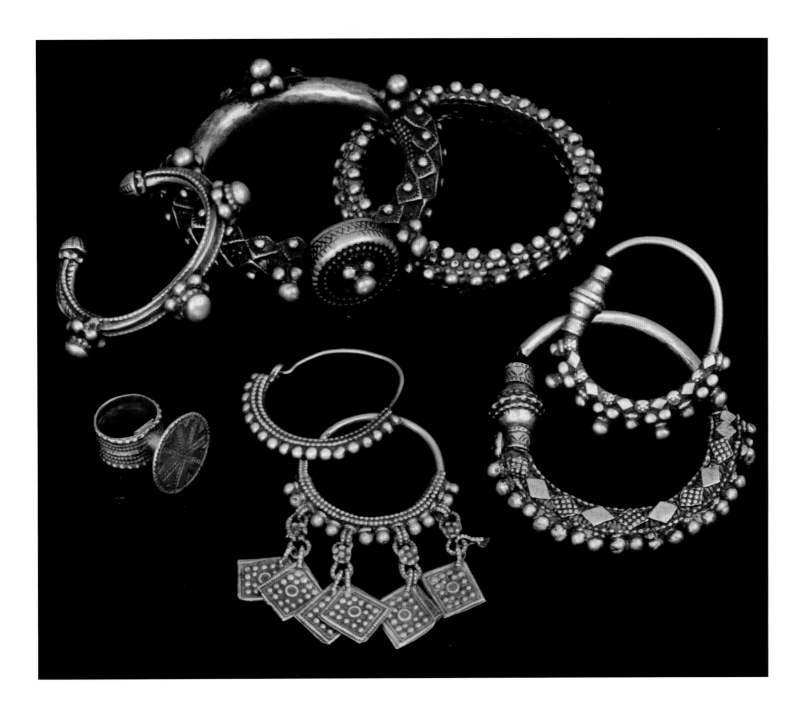

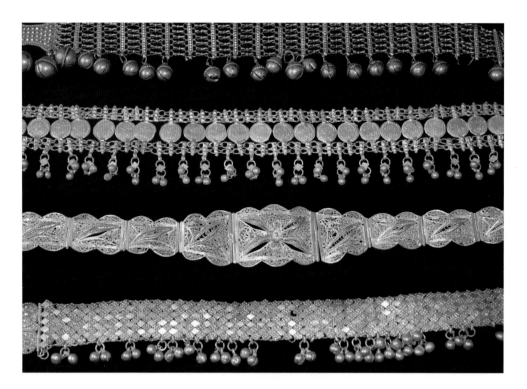

168. Al-Dhahiyy: belts found in Muhammad Sarim's workshop, February 2005.

169. Al-Dhahiyy: left to right: beads worn as an upper-arm bracelet, one of a pair, 9.5 cm; amulet (*mahfaza shams*), 7 cm.

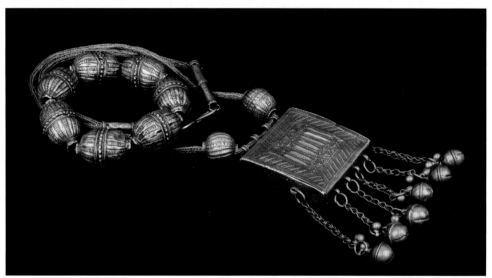

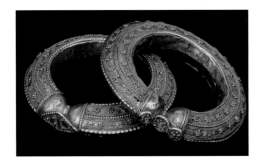

170. Al-Dhahiyy: bracelets (*ma'adhid*), 13 cm, work of Abdo Ibrahim Kuhayyil.

171. Al-Dhahiyy: left to right: bracelet (*muzabraqa musannana*), one of a pair, 9 cm, work of Ali Wahhan; bracelet (*dablul*), one of a pair, 7 cm, women saw different faces in the polished surfaces of this particular bracelet; bracelet (*musammat*), 9 cm; bottom: bracelet (*kark*), 12.5 cm, work of Hassan Abdullah, who died in 1955; bracelet (*dhimna*), 19 cm, made for girls and worn before and after marriage, the silversmith stamped ten small pieces of silver and soldered them inside.

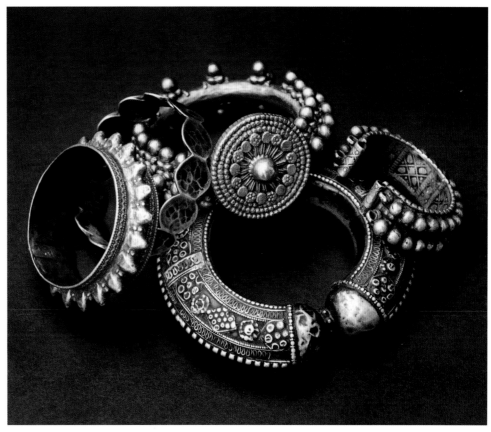

AL-DHAHIYY

The belts in figure 168 show the variety of silver jewelry traditionally made in al-Dhahiyy. Figure 169 has examples of the beads made there. My main source of information in al-Dhahiyy is Abdo Ibrahim Kuhayyil and his work can be seen in figure 170. Some of the pieces in figure 171, such as the *dablul* and the *dhimna* bracelets, are unique to al-Dhahiyy; the others resemble work done in other parts of northern Yemen.

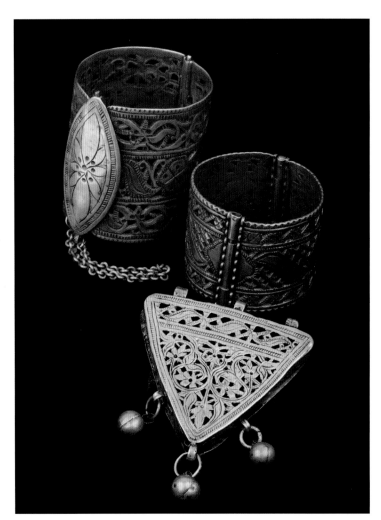

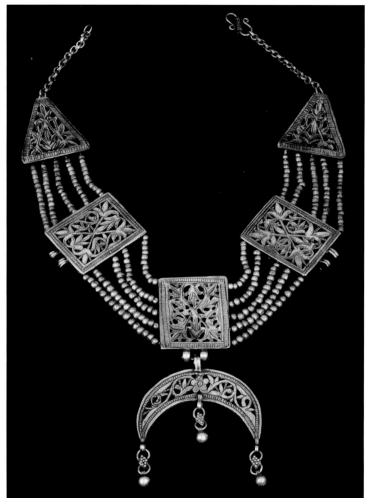

172. Zaydiya: top: hinged bracelet, 6 cm; middle: hinged bracelet, one of a pair, 5 x 4 cm; bottom: triangular high-grade silver amulet, 6.5 x 9 cm.

173. Zaydiya: necklace with cutout *(takhrim)* work, 32 cm.

ZAYDIYA

Zaydiya is a small city near al-Dhahiyy in Tihama known for a special style of pierced silver work *(takhrim)*. Silversmiths named Bland and Darwish made mostly jewelry for men, such as dagger cases and swords. It is thought that the Blands had at least one Indian craftsman in their family because of the Indian influence in the technique and style of the silver and the name Bland, which does not sound Yemeni. The amulet and bracelets in figure 172 are good examples of this work. Figure 173 shows a favorite necklace of mine. The two end pieces and the middle plaque were made by a young silversmith in Taiz. The two middle plaques and the crescent are eighty or more years old.

The costume in figure 174, worn in Zaydiya today, resembles that worn thirty-five years ago (fig. 175). It is most suitable for the hot climate and carries on old embroidery themes of the past.

174. Zaydiya: contemporary black dress with machine embroidery.

175. Zaydiya: a woman in local costume, 1978.

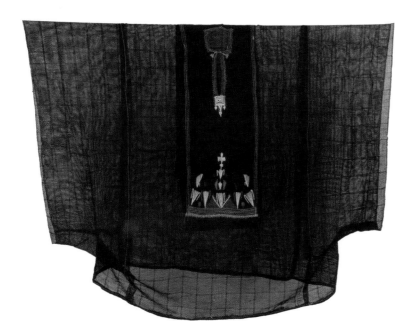

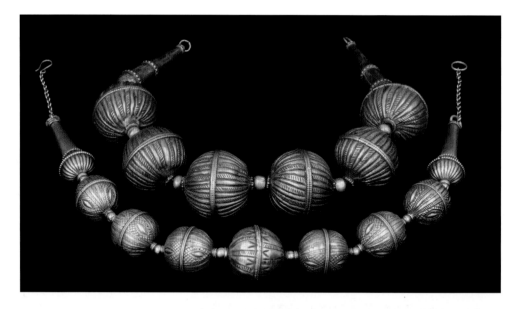

176. Zaydiya: top: beads *(qahhat),* 54 cm;

bottom: beads, 50 cm.

177. Zaydi belt, 86 cm,

property of Carmel Clay Thompson.

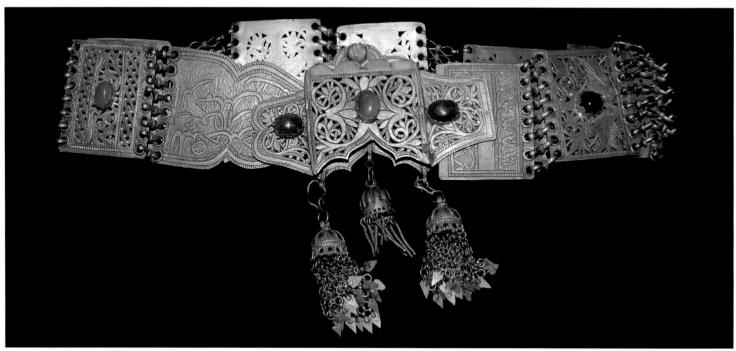

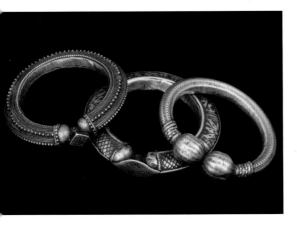

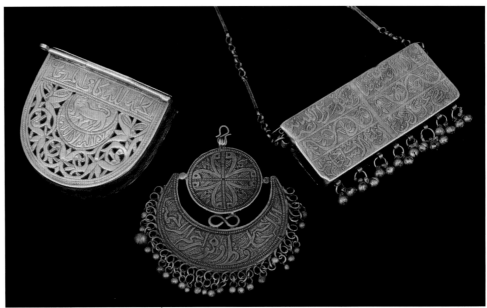

178. Zaydiya: left to right: upper-arm bracelets
(*ma'dhad*), 9.5 cm, 5.5 cm, and 6.5 cm respectively.
The last is one of a pair.

179. Zaydiya: left to right: box (*sanduq*),
for a man's dagger belt, 2.5 cm,
signed by Ali Bland; pendant (*hirz*),
7 x 8 cm; amulet (*hirz*), 9.5 cm.

The belt in figure 177 is a unique piece, probably commissioned for an occasion.
The stones on the heavy buckle are Yemeni agates. Figure 178 contains three examples of Zaydi bracelets. Special beads made in Zaydiya appear in figure 176. There are
three pieces in figure 179 with religious inscriptions. On the left is a box for a man's
dagger belt. It has the only lion I have seen in Yemeni jewelry and I include it for that
reason. The box front is inscribed "Praise be to God" and "There is no God but God."
The inscription on the woman's pendant in the middle, with the circle and crescent
motif, reads "God is the best protector, and the most merciful of all." The box front
on the right has a poem by al-Busayri, who lived in North Africa (1213–95):

> God's protection is more than enough and better than armor
>> and seeking a higher, safer ground.
> Whoever has a prophet as his model can defeat adversaries,
>> even if he faces lions.

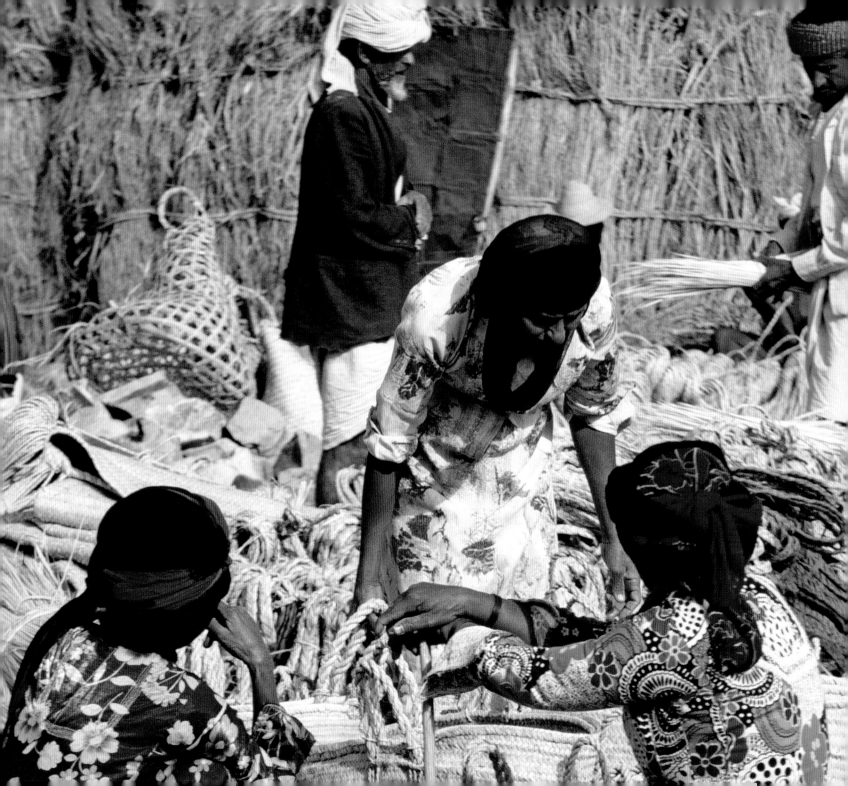

—— 11 ——

The Southern Tihama Coastal Plain

BAYT AL-FAQIH, MAWZA, AND ZABID

180. Bayt al-Faqih:

the Friday weekly market, 1980.

BAYT AL-FAQIH

Bayt al-Faqih, long a marketing center in the Tihama region, continues to have a weekly Friday market. Silversmiths there specialized in amulets for protection. The designs for the ring and pendant in figure 181 were taken from an old Arab medicine book: a series of numbers and letters is engraved on a flat piece of silver. The amulets in figure 182 all say in one form or another, "Oh, protect me, O our protector!" Bayt al-Faqih was the only place silversmiths made the rings in figure 183, which were popular throughout northern Yemen. In figure 184 the two bracelets on the right are snake bracelets. The lower one was worn by women at celebrations before and after marriage in Mansuriya; the upper one is older and has a heart shape as well as the snake design. The hollow bracelet, second from left, features a protective eye shape.

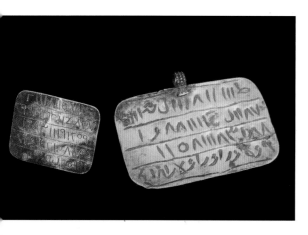

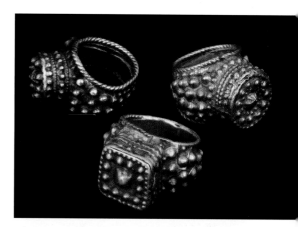

181. Bayt al-Faqih: ring *(khatim al-khushan)*, 3.8 cm; pendant, 7 cm, with similar magical numbers and letters.

182. Bayt al-Faqih: amulets; left, 5.5 cm; top, 6.7 cm; bottom middle, 5 cm; right, 5.4 cm.

183. Bayt al-Faqih: rings *(khatim marratayn)*, 1.1–1.2 cm.

184. Bayt al-Faqih; left to right: hinged bracelet, from Mansuriya, between Hudayda and Bajil, 5 cm; upper-arm bracelet, variously called *jahi, bazwan,* or *kark,* one of a pair, 9 cm; snake bangle *(abu hanash)*, 7 cm; *abu hanash* bangle, one of a pair, work of Ali Rai Khazraji, 8.5 cm.

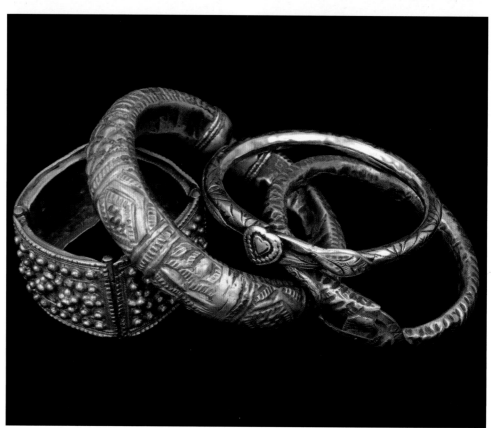

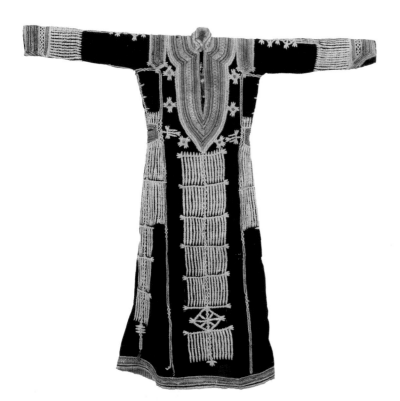

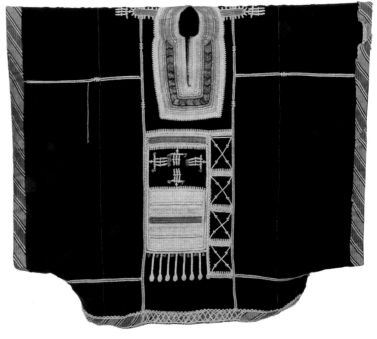

185. Bayt al-Faqih: black cotton dress embroidered with silver and white cotton thread, second quarter of twentieth century.

186. Bayt al-Faqih: black cotton dress with white and silver embroidery, mid-twentieth century.

On the far left is a hinged bracelet made in Mansuriya. Each city in Tihama had its own distinctive dress. The Bayt al-Faqih costume in figure 185 is the oldest Tihama dress in the collection, dating from the second quarter of the twentieth century. The dress in figure 186 is newer and different in style.

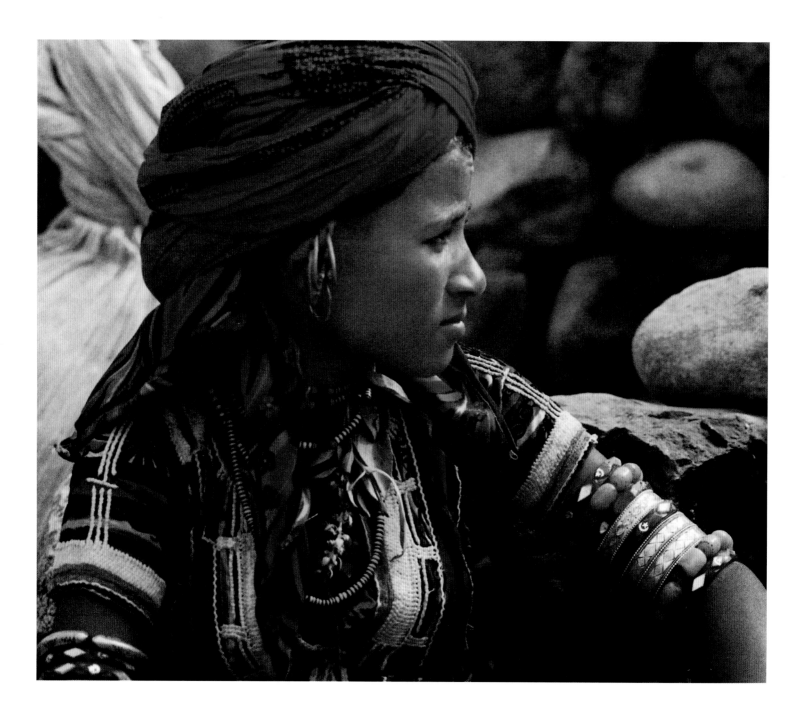

187. Bayt al-Faqih: weekly market, 1965. On her upper arms the young woman wears glass bracelets from India, silver bracelets from Mawza, near Mocha, and pressed amber beads from Germany or Czechoslovakia.

188. Mawza: silver bangles, 6 to 8.2 cm.

189. Mawza: left to right: bracelet (ma'adhid), one of a pair, 9.5 cm; bracelet, one of a pair, 10.5 cm; bracelet, one of a pair, 9 cm; bracelet, 6.5 cm.

MAWZA

The silver bracelets seen in the midst of glass bracelets on the woman's left arm in figure 187 are called *mawzi*, and were made in the city of Mawza, near Mocha on the Tihama coast, about sixty years ago.[10] More of these bracelets can be seen in figure 188. The Muslim silversmiths pressed the silver flat, then stamped the strips, and finally soldered them together. In figure 189 there are other types of Mawza bracelets, made by both Muslim and Jewish silversmiths.

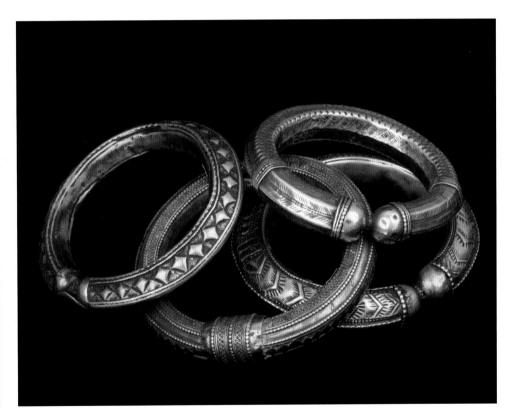

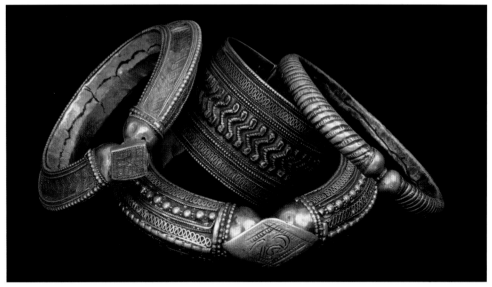

190. Zabid: decorated house, 2006.

191. Zabid: author meeting with Muhammad Rafi', left, and Muhammad Yami, center, April 2006.

192. Zabid: bracelets, left to right: upper-arm bracelet (*damlaj*), 9.5 cm; upper-arm bracelet (*muhashshara*), one of a pair, signed "Rafi'," 13.5 cm; bracelet (*muzabraqa*), one of a pair, 6 cm, with central *shabkamalaqif* motif, work of Muhammad Rafi'; bracelet, one of a pair, using the *musayyal raqbi* technique, work of Ali Muhammad Rafi' il-Sayigh. 8.5 cm.

ZABID

Founded in the ninth century, the city of Zabid reached its zenith as a center of learning and culture during the reigns of the Ayyubids and Rasulids in the Middle Ages, from the twelfth to the fifteenth centuries AD. It was a trading and agricultural center and flourished as a commercial center for indigo dyeing as late as 1980. The city is dominated today by elaborately decorated mud-brick buildings. The designs seen on the buildings occur again in the patterns in the silver jewelry. The most prominent silversmiths in Zabid belonged to the Rafi' family; the signed bracelet, bottom center in figure 192, gives special evidence of Rafi' craftsmanship. Their jewelry was worn throughout Tihama and the southern mountains.

In Zabid I met Muhammad Rafi'. He confirmed that the pair of bracelets I was trying to identify was made by his grandfather Ali Rafi' in 1952. Muhammad is on the left in figure 191; next to him in the middle is Muhammad Yami, my Zabid

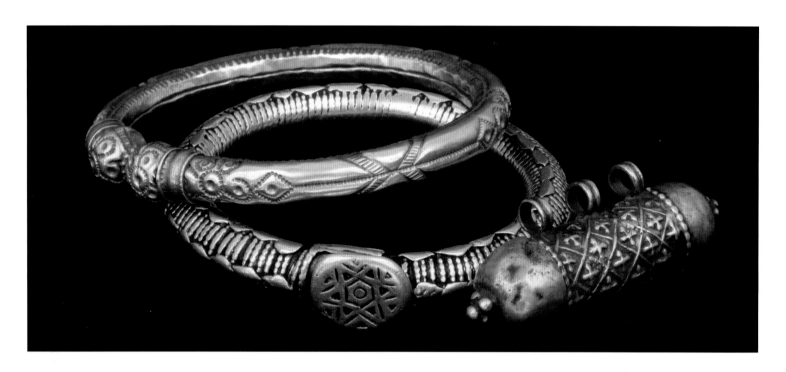

193. Zabid: left to right: bracelet, 8.5 cm, work of Ali Rafi' in 1952; bracelet *(maswad)*, 8.3 cm; amulet, work of a Rafi' silversmith, 7 cm.

194. Zabid: left: earring, 25.5 cm, work of Salih Rafi'; upper right: earring *(shalashil)*, work of Muhammad Rafi', 9 cm; lower right: earring *(shalashil)*, work of Muhammad Ramadi, 10.5 cm. Each is one of a pair.

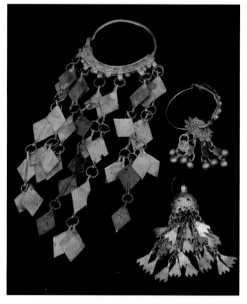

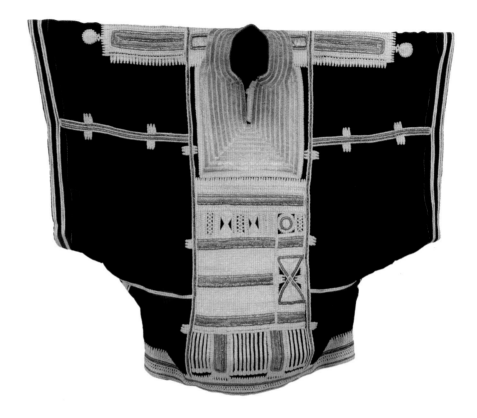

consultant. The bracelet I was trying to identify is on the left in figure 193. It is hollow and light with a delicate design. The bracelet at the center was very popular in Tihama. It features wrapped wire. The Star of David indicates it might have been made by a Jewish silversmith. There may have been Jewish silversmiths resident in Hudayda, but I do not have clear evidence of that. They certainly traveled there to sell their wares but, as far as I could determine, they lived in the mountains. The simple amulet on the right was made for a child by a Rafiʻ silversmith; it contains a written prayer. Figure 195 shows a Zabid dress from the mid-twentieth century. The Rafiʻ silversmiths also made earrings for their customers. The largest earring in figure 194 was made for tribeswomen in the Rayma governorate.

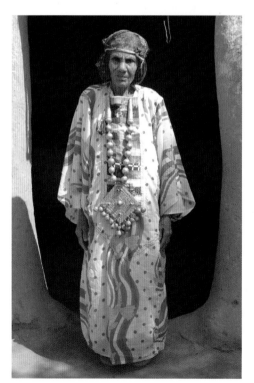

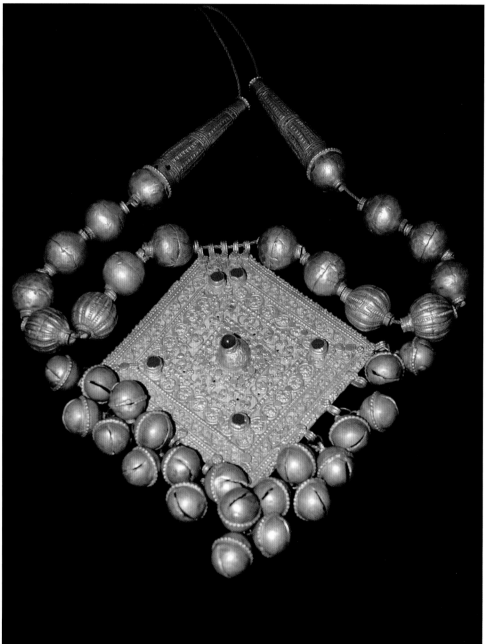

199. Zabid area: Miriam wearing her silver jewelry, March 2005.

200. Zabid area: Miriam's rings adorned with Maria Theresa thalers, March 2005.

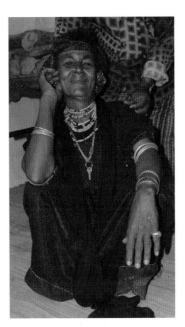

196. *(opposite, top)* Zabid area: mud house, March 2005.

197. *(opposite, bottom)* Zabid area: Fatima, tribeswoman, March 2005.

198. *(left)* Zabid area: Fatima's wedding necklace, 28.5 cm, March 2005.

Outside the city of Zabid, in a number of small villages, I was able to interview women about their wedding silver. They were tribal women and did not veil. They lived in adobe huts and welcomed the opportunity to tell their stories.

Eighty-five-year-old Fatima (fig. 197) decided to sell most of her silver to go on a religious pilgrimage to Mecca. Her hennaed hair identifies her as a pilgrim, or *hajji*. She decided to keep this one special piece, shown in figure 198, with its large size, its applied filigree, good beads and cone ends, and a profusion of bell dangles, because she liked it so much. She was hunched over and a little frightened when I first saw her in her village. When she was reassured that I did not want to buy her wedding silver, but only to hear her story and photograph her and her bridal piece, she grew visibly taller and more expressive. She brought this unusual necklace from a locked tin box beneath her bed in her mud and thatch hut. Miriam, in figure 199, had several

201. Zabid area: Zainab, aged 80, had tattoos on her face, as well as *harad*, as she displayed her family jewelry on her hennaed hands, March 2005.

202. Zabid area: Zainab shows off her upper-arm bracelets, March 2005.

203. Zabid area: Zainab shows off her rings and bracelets and hennaed hands, March 2005.

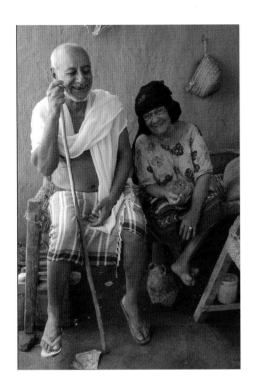

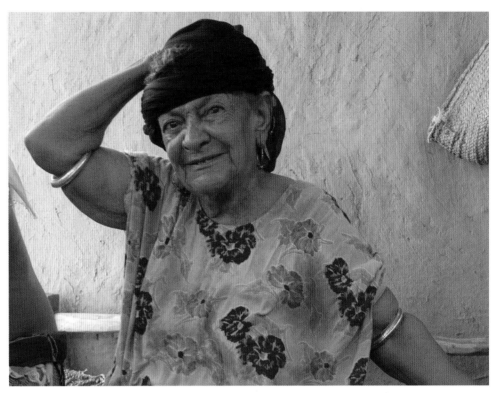

204. Zabid area: Fatima and her son, March 2005.

205. Zabid area: Fatima shows off her upper-arm bracelets, March 2005.

strands of cut agate beads. Her rings (fig. 200) are decorated with Maria Theresa thalers. Zainab, seen in figure 201, was aged eighty, had tattoos on her face, along with a mixture of turmeric and resin, and displayed her upper-arm bracelets and the rings and bracelets on her hennaed hands and wrists. Fatima, in figure 204, had to sell her wedding silver early in marriage after she lost her husband and had illnesses to deal with. But her beloved son, pictured with her, bought her a pair of silver bracelets, which she was very proud to show off.

THE SOUTH

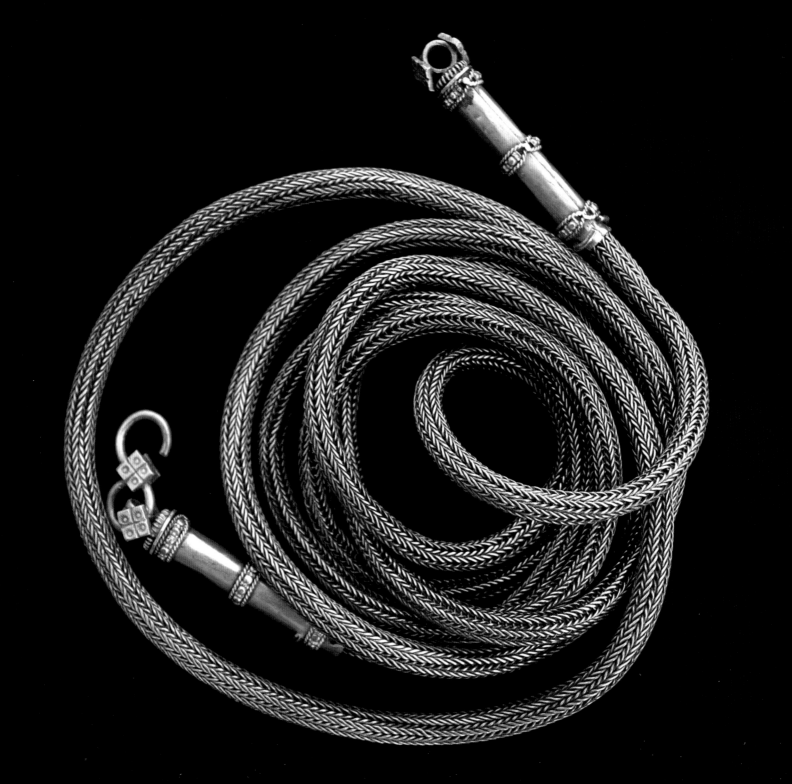

--------- 12 ---------

Hadramaut

SAYYUN

206. Hadramaut: loop-in-loop chain

woven by the women of Sah in Hadramaut.

Hadramaut, the large southeastern governorate of Yemen, is a land with green oases and large areas of desert. Saudi Arabia's Empty Quarter lies to the north. Most of the population lives in deep wadis (valleys) cut into a high plateau that Hadramis call the *yuwl*. The largest governorate in Yemen, Hadramaut exported migrants to Saudi Arabia and all over Southeast and South Asia, as well as to the coastal regions of the Arabian Peninsula and East Africa. The society at home remains quite conservative, despite the fact that so many lived abroad. All of Yemen suffered a great loss in the number of silversmiths over the last twenty-five years and Hadramaut is no exception. Sayyun, Tarim, and Qatan lost more than half, and Shihr lost more than two-thirds, of their craftsmen.

In the northern part of Hadramaut, women excelled in making loop-in-loop

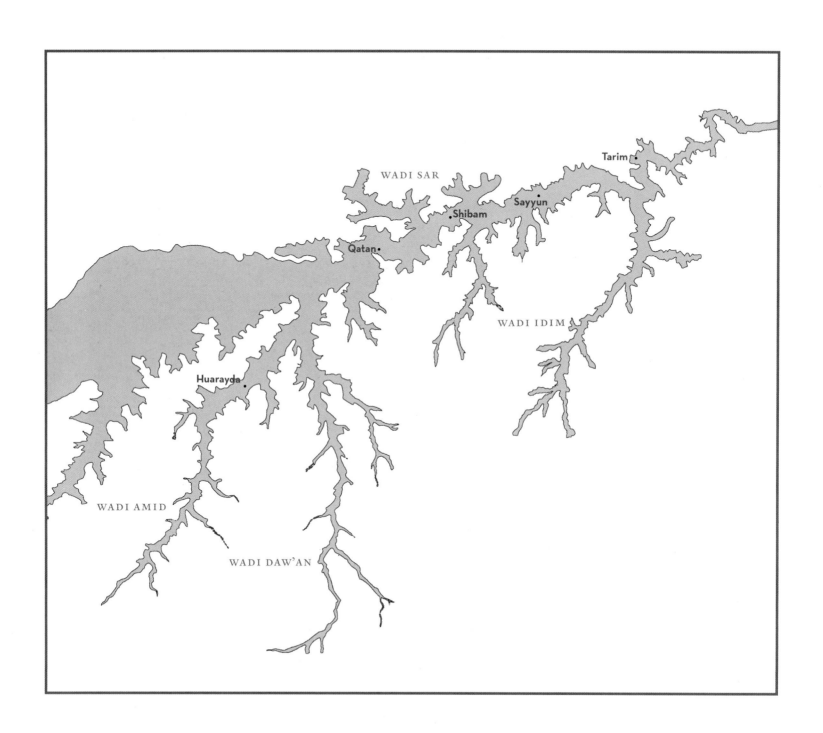

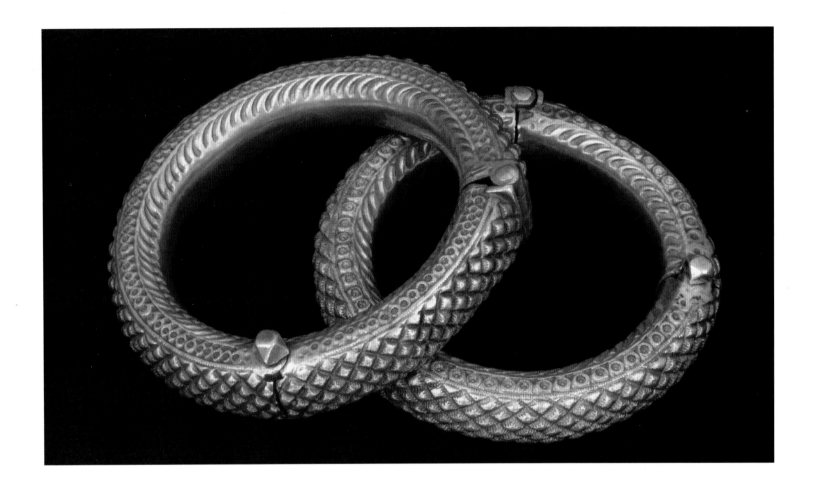

207. Sketch of northern Hadramaut based on a historical map drawn by Abd al-Rahman Hassan al-Saqqaf, director of the Sayyun Museum, with his permission.

208. Wadi Daw'an: anklets, 10 cm.

chain as in the belt in figure 206, and the men were masters of chased designs (fig. 208). The jewelry of Hadramaut often exhibited motifs taken from palm trees, as can be seen in figure 208.

The largest concentration of silversmiths in Hadramaut worked in Sayyun, Tarim, and Shihr, but other craftsmen were scattered throughout the area. In the period of my study every settlement in Wadi Daw'an had its own silversmith and they produced some of Hadramaut's most beautiful jewelry.

209. *(top)* Sayyun Museum, May 2005.

210. *(bottom)* Sayyun area: women planting garlic, 1985.

211. *(opposite, top)* Shibam: Bedouin women with a baby goat, early 1980s.

212. *(opposite, bottom)* Shibam, city of mud skyscrapers, March 2005.

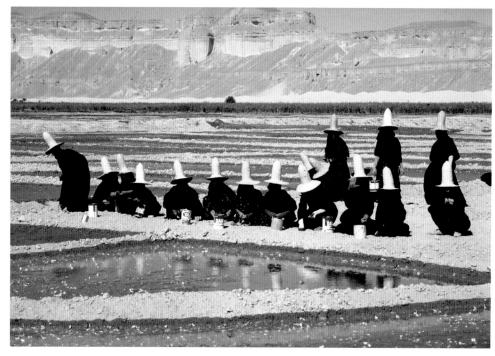

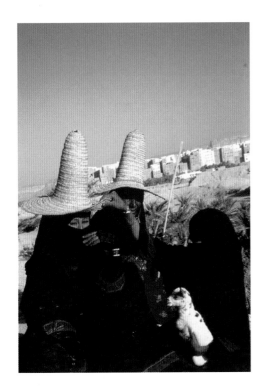

SAYYUN

The most important building in Sayyun, the largest city of northern Hadramaut, is the national museum (fig. 209), located in a restored palace of the Kathiri sultans who once ruled part of the area. At the end of every year Hadramis celebrate their culture in their schools, and the museum houses traveling and permanent exhibits honoring that heritage. It is just across the street from the public market where a number of silver dealers sit and a few silversmiths still work. In the early morning, in the flat land around Sayyun, Bedouin women (fig. 211) take their animals to graze, while peasant women (fig. 210) work in the gardens outside the big cities, wearing the tall hats typical of the area. Behind the women in figure 211 is Shibam, the fabled city of skyscrapers, which was better known for woodworking than jewelry, instead using the jewelry made in Sayyun. It is the only walled city in Yemen I know of that was located in a valley bed, rather than high on a mountain where it would have been more defensible.

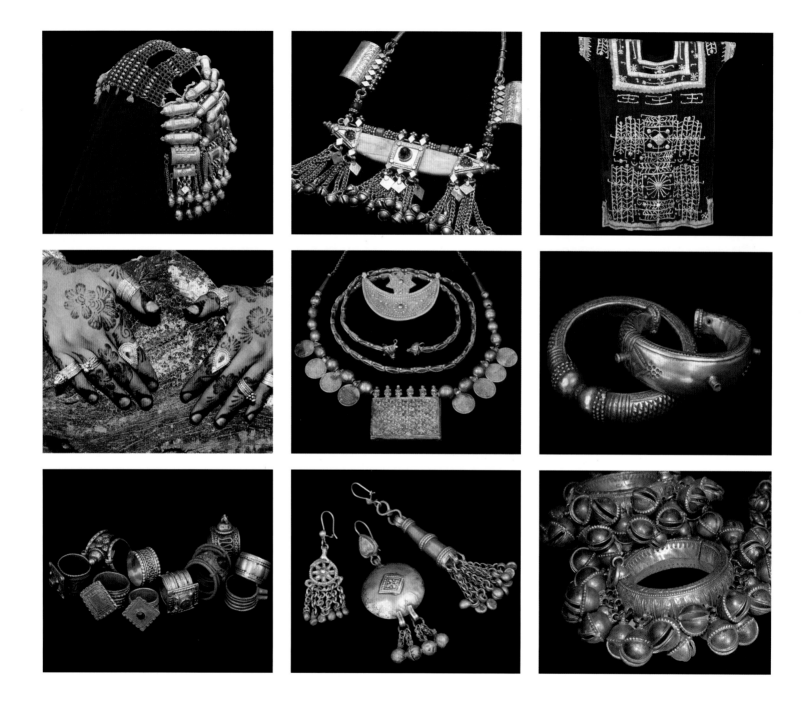

213. Sayyun: headdress *(kadida)*; cylindrical amulets *(huruz)*, 7 cm, 4.4 cm, and 3.5 cm; total weight: 1,350 grams.

214. Sayyun: amulet *(abu adhim)*, 14.5 cm.

215. Sayyun area: red velvet Bedouin wedding dress, mid-twentieth century.

216. From *Oman Adorned: A Portrait in Silver*, by Miranda Morris and Pauline Shelton.

217. Sayyun: top to bottom: a crescent and star pendant *(hilal wa-najm)*, 8 cm; a belt with fish links that held up the long dress, 76 cm; special amulet *(rigad bin yahya)*, 6.2 cm.

218. Sayyun: top: bracelet, one of a pair, 8 cm, work of Hassan Salim al-Amri, Tarim, but worn throughout Hadramaut; bottom: bracelet, one of a pair, work of Ahmad Bada'ud.

219. Sayyun: rings *(khawatim)*, 1.8 to 2.5 cm.

220. Sayyun: earrings, left to right: 5 cm, 9 cm, and 10 cm.

221. Sayyun: anklets. April 2005.

On her wedding day a Bedouin bride in the Sayyun area wore:

- a *kadida* (fig. 213), which consisted of a beaded cap for the top of the head and a cascade of fifteen hollow amulets ending in bells that clanged loudly when the wearer was dancing.

- a Hadrami amuletic necklace made of animal bone (fig. 214), most likely hyena, which promised fertility and protection against the evil eye. This was worn on the wedding night.

- a dress in brilliant colors, with the back longer than the front.

- hands and feet decorated with henna. I was unable to photograph women in Sayyun wearing henna, so I substitute a picture from nearby Dhufar in Oman.

- a star and crescent amulet; a belt, with fish links, which held up the long dress; and a special box-shaped amulet, all in figure 217.

- a variety of bracelets. The top bracelet in figure 218 was made in Tarim, but was worn throughout Hadramaut; the lower bracelet was made in Sayyun by Ahmad Bada'ud (1918–2003), who came from a silversmithing family of many generations.

- a variety of rings, which the bride wore on all her fingers (fig. 219).

- a variety of earrings (fig. 220).

- two noisy anklets (fig. 221).

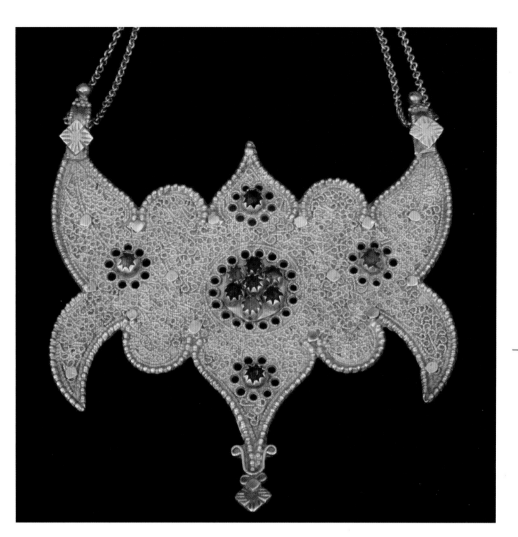

222. Sayyun: wedding basket *(sila)*, 33 cm, cowries on leather.

223. Sayyun: pendant *(kisra)*, covered with bits of twisted wire *(maftul)*, 11 cm.

224. Sayyun: public garden, October 2004.

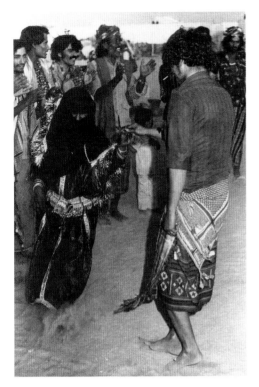

225. Bedouins dancing at the ancient well of Thamud, northeast of Sayyun in Hadramaut bordering on the southern part of the Empty Quarter, 1982.

226. Sayyun: belt *(muharraz)*, 80 cm, weighing 1,526 grams, the work of Said bin Umar Bahashwan, late grandfather of my consultant, Hassan Bahashwan, early twentieth century.

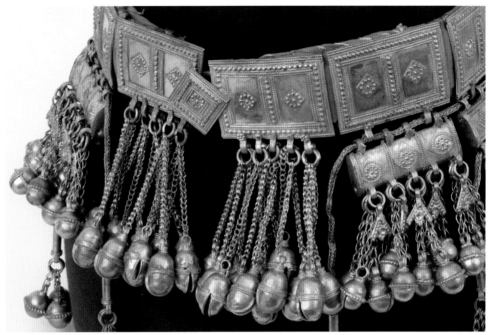

The Bedouin bride might carry a cowrie-covered leather bag (fig. 222) for her cosmetics and jewelry. Incense was used throughout the ceremony.

There are additional pieces that were worn by married women. The women of Hadramaut loved to dance to the sound of their clanging jewelry. This very elaborate belt (fig. 226) was worn throughout Hadramaut by married women. In figure 225 a Bedouin grandmother wearing a similar belt dances enthusiastically for a special celebration in Thamud, northeast of Sayyun. A *kisra* was a unique amulet with a batlike shape (fig. 223), worn by married women every day. It was used all over Hadramaut for protection, but this particular piece was made in Wadi Amid. The face of the piece is covered with bits of twisted wire.

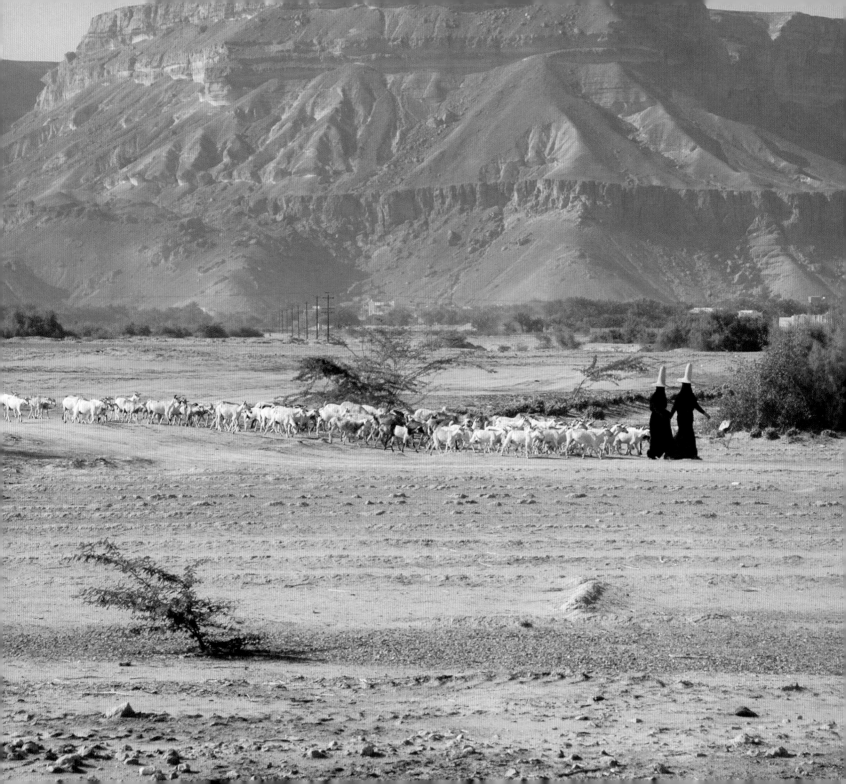

— 13 —

Wadi Amid

Most of the jewelry produced in the different silver-making centers in Wadi Amid was created for Bedouin. Throughout the Hadramaut governorate one sees in the distance Bedouin women grazing their flocks. They are wary of foreign visitors and I could never get near those who were out and about, but in Wadi Amid I was privileged to interview an older Bedouin woman who showed me her wedding treasures— her financial security in her old age. She had a number of lavishly embroidered dresses and several pieces of heavy jewelry; the belt in figure 229 is but one example. Her dresses were densely embroidered by women in al-Hurayda who specialize in that work. When I made my goodbyes, she held her grandchild in front of her, and asked me to photograph her that way (fig. 230).

My guide in Wadi Amid, Ahmad bin Zayn al-Attas, was very accommodating

227. Wadi Amid, Bedouin women and their goats, April 2005.

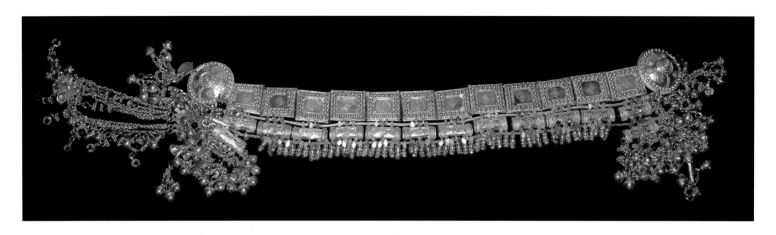

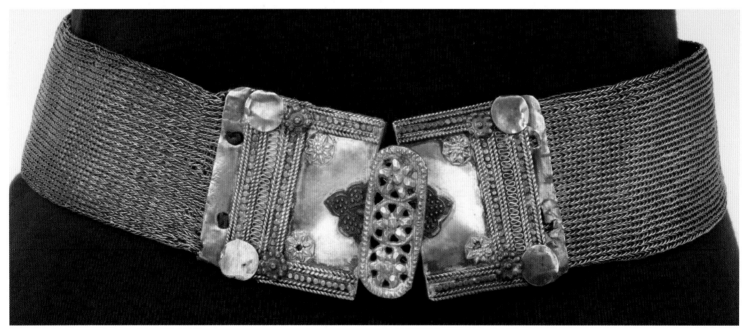

228. Wadi Amid: Bedouin wedding belt, April 2005.

229. Wadi Amid: belt, 74 cm, early twentieth century.

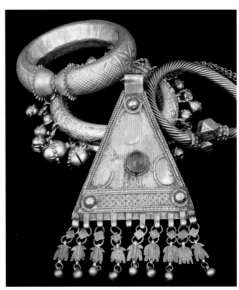

230. Wadi Amid: Bedouin woman and her grandchild, April 2005.

231. Hurayda, Wadi Amid: Bedouin wedding dress, April 2005.

232. Wadi Amid: left to right: bracelet, 11 cm; bracelet, one of a pair, 9 cm; pendant *(muthallath)*, 12 x 9.5 cm; bracelet, one of a pair, 10 cm.

and his wife was quite special. She welcomed me warmly to her home and said that before I could ask one question pertaining to my research I had to drink at least two cups of tea and eat the meal she had prepared. I was very sorry I had eaten breakfast earlier, for she had prepared me a feast! She was originally Bedouin and in preparation for my visit she had asked her sister to bring her Bedouin wedding dress (fig. 231) to photograph.

Ahmad identified many pieces of silver worn in Wadi Amid, including several that had been made there. Women all over Yemen wove silver thread into chain and mesh, but the mesh in the belt in figure 229, done in Wadi Amid, is especially fine. The metal piece with the three rosettes was added later so the belt buckle would open. Originally it was one piece donned over the head.

Salim Bahashwan of al-Hurayda, an accomplished silversmith, made the bracelets in figure 232, as well as the pendant.

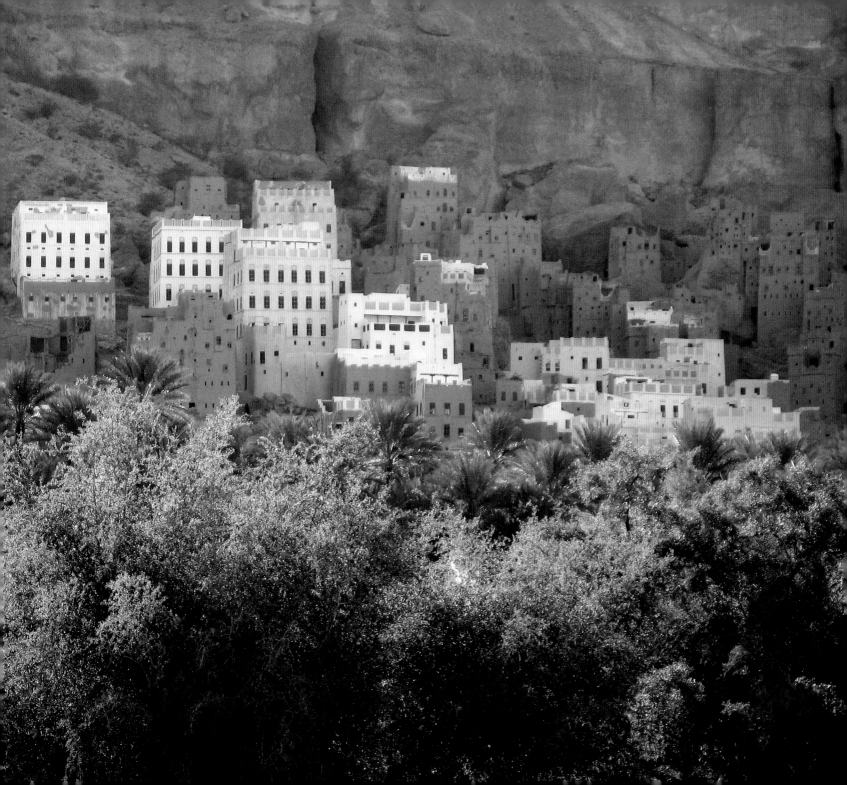

— 14 —

Wadi Daw'an

Wadi Daw'an, famous for its honey, is a quiet, magical place with vistas of lovely mud-brick skyscrapers, rich palm groves, and feathery *ilb* trees *(Ziziphus spina-christi)*, which can be seen in the foreground of the photograph in figure 233. The wadi is also known for its elusive Bedouin women, who herd their flocks in the oases, always wearing their distinctive pointed straw hats.

 In the 1938 photo in figure 236 a young woman is dressed up for a special celebration, perhaps her own wedding. She wears a mix of jewelry from Mahra and Hadramaut and the typical Hadrami striped dress, worn on ceremonial occasions in the early twentieth century. The dresses of Hadramaut were always longer in the back than the front, where they were about knee-length; the most elaborate decoration was on the back, probably because women wore several necklaces on the front.

233. Wadi Daw'an, April 2005.

234. Wadi Daw'an: Bedouin straw hat.

235. Wadi Daw'an, April 2005.

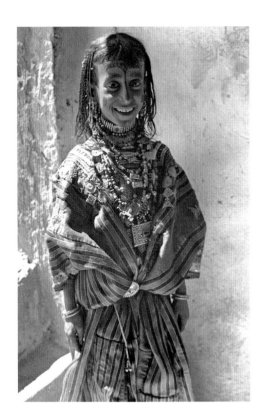

236. Freya Stark photo, Hurayda, Wadi Amid, 1938.

237. Wadi Daw'an: Syrian silk and cotton dress with couched silver thread embroidery and Indian silk inserts, first half of twentieth century.

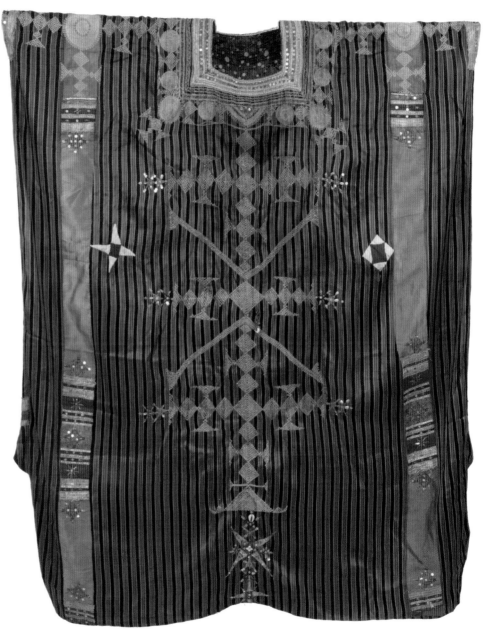

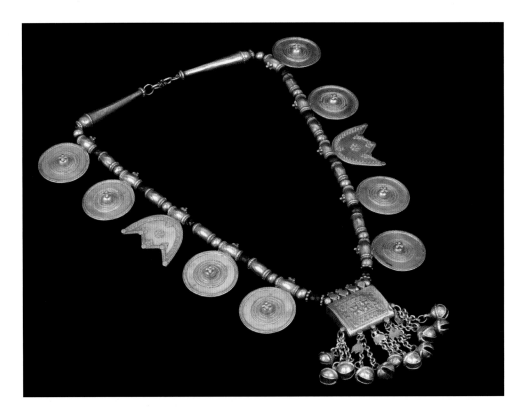

238. Hajjarayn, Wadi Daw'an:

wedding necklace, 75 cm,

second quarter of twentieth century.

239. Wadi Daw'an: nickel belt *(hizam)*, 72 cm.

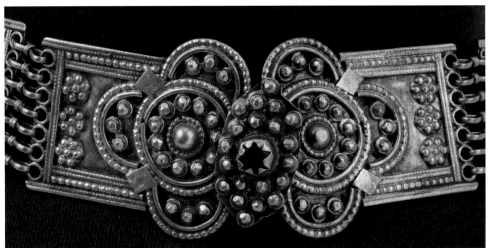

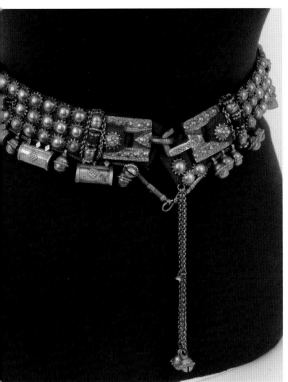

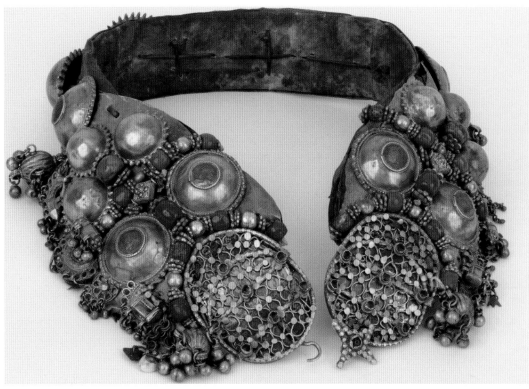

240. Wadi Daw'an: silver and leather belt *(hizam)*, 71 cm.

241. Wadi Daw'an: gilded silver and silver leather belt *(hizam)*, 85 cm.

The necklace in figure 238 was worn by a bride on the first day of her wedding. A woman's jewelry indicated her status. The elaborate belt in figure 241 was worn by a wealthy woman. A less wealthy woman might have worn the simpler belt shown in figure 240, lighter in weight and lacking those striking large coral pieces and elaborate buckle. The belt in figure 239, which is made of stamped, pre-cut nickel pieces from Aden by a Hadrami-born silversmith, is the simplest of the three. The belt in figure 242 has stamped elements and beveled red and green glass in diamond and floral shapes. It was worn all over Hadramaut, but made in Wadi Daw'an. The gilded belt (fig. 243) was made by Salim Baqtayan of Gadun, in the southern part of Wadi

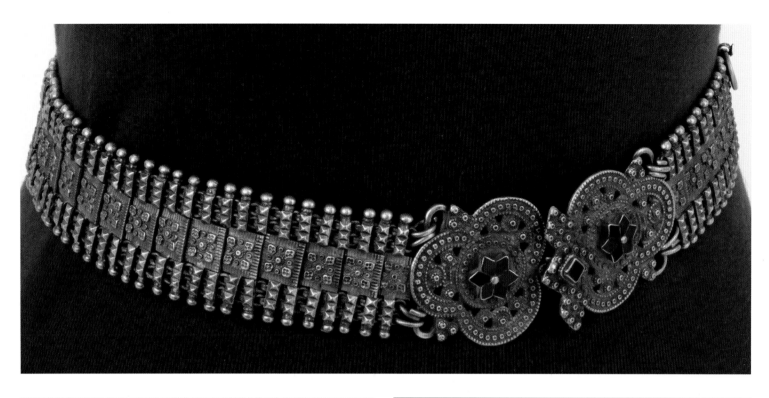

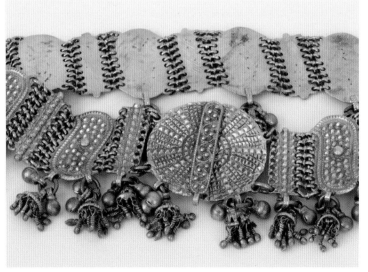

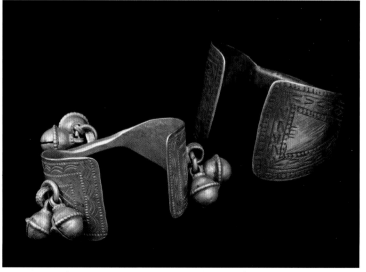

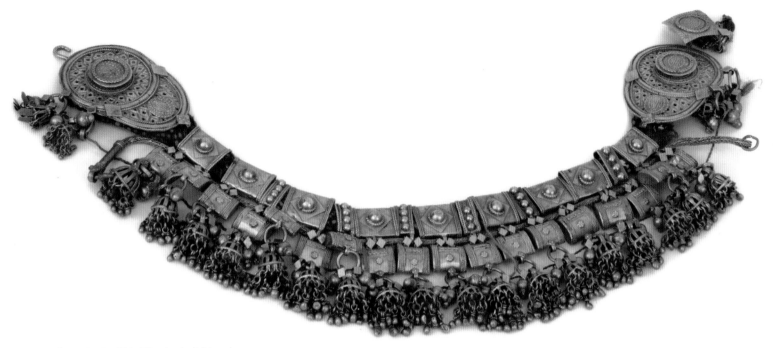

242. *(opposite, top)* Wadi Daw'an: belt *(hizam),* 72 cm, first quarter twentieth century.

243. *(opposite, bottom left)* Wadi Daw'an: gilded silver belt *(hizam),* 94 cm.

244. *(opposite, bottom right)* Wadi Daw'an: nickel bracelets, 6.5 cm and 6 cm; each is one of a pair.

245. *(above)* Wadi Daw'an: silver and nickel belt, 53 cm.

Daw'an. Figure 245 shows a belt worn by young unmarried women for religious feasts and weddings in northern Hadramaut, as well as in the governorates of Dali' and Yafi'. The silversmiths even made jewelry for children, like the bracelets in figure 244.

Many of the homes in Wadi Daw'an were built and are maintained by Hadramis who live and work in Saudi Arabia, India, or Southeast Asia. They are well kept and

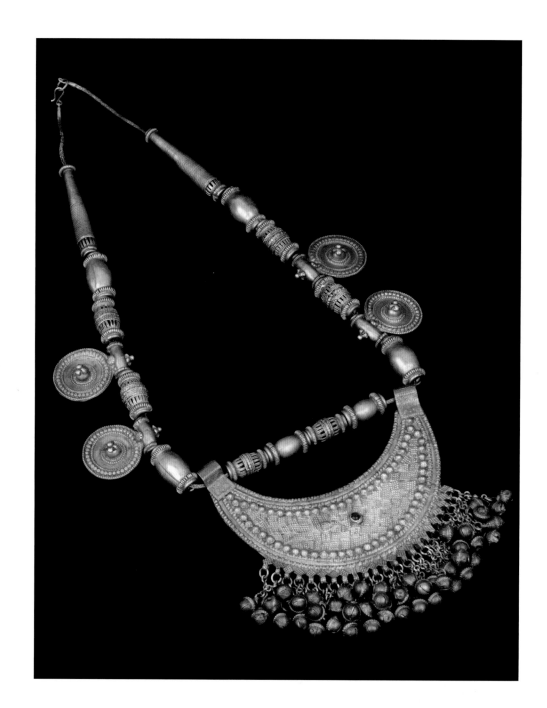

246. Wadi Daw'an: necklace (*ra'la or qilada*), 18 cm crescent; the wire-wrapped beads, called *dis*, were made in Shihr.

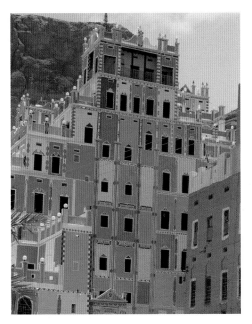

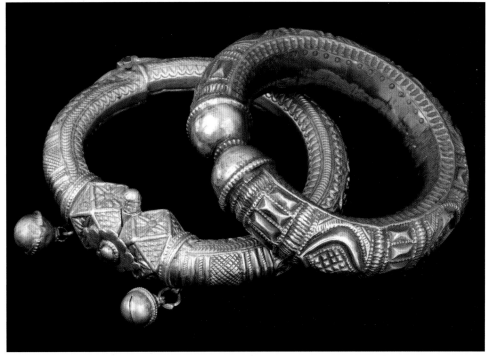

247. Wadi Daw'an: a mud-brick building belonging
to a Hadrami businessman working in Saudi Arabia,
May 2005.

248. Wadi Daw'an: anklet, one of a pair, 10 cm;
bracelet (*zind*), one of a pair, 12 cm;
both the work of Salim Baqtayan.

often painted in bright colors. Married women in Daw'an wore the crescent-shaped
necklace shown in figure 246. Salim Baqtayan crafted the anklet and bracelet shown
in figure 248. Women wore bracelets in pairs, usually on the same arm, while the
anklets were usually worn separately. The raised circles with a square insert were eye-
shaped to repel the evil eye. Throughout the Middle East, the silver jewelry worn by
Bedouin incorporated protective symbolism and stones. In parts of the region silver
itself was thought to protect against the evil eye.

Bracelets such as those in figure 249 were worn on the upper part of the lower
arm so the wearer could work comfortably. The bracelets in figure 250, from Wadi
Daw'an, which are more than one hundred years old, are the oldest pieces in the

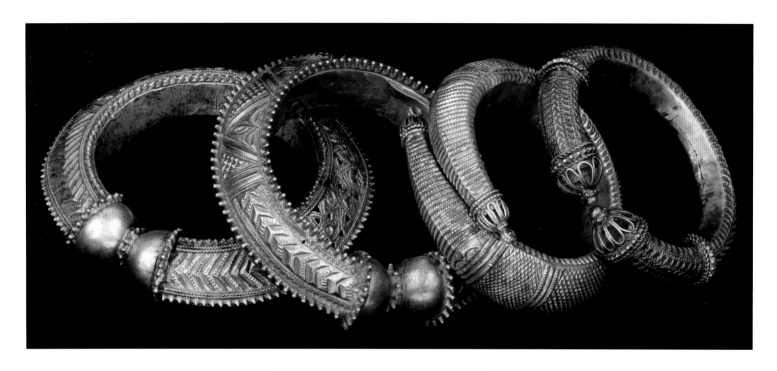

249. Wadi Daw'an: upper-arm bracelets, each one of a pair; left to right: bracelet (ma'dhad), 13 cm; bracelet, 12 cm; bracelet (mutall), 12 cm; bracelet, 10 cm, early twentieth century.

250. Wadi Daw'an: bracelets, each 6.5 cm, early twentieth century.

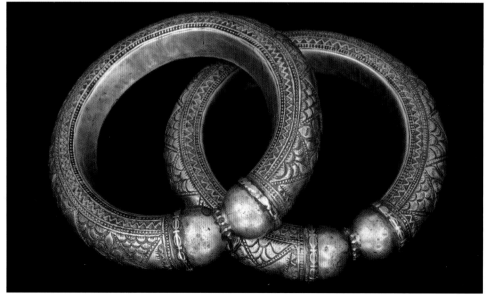

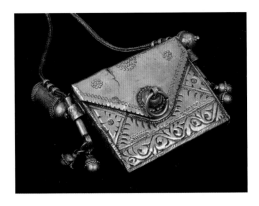

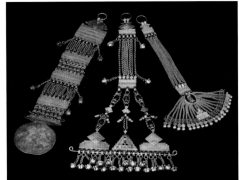

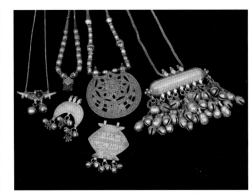

251. Wadi Daw'an: amuletic box, alternately called a *haykal daw'ani, mahfaza,* or *hirz,* 10 cm. The box was reconstructed.

252. Wadi Daw'an: headpieces (*alam*); left to right: hairpiece, 41 cm; hairpiece, 45 cm; hairpiece, with coral, 33.5 cm. *Alam* means a flag or an indicator. These pieces indicate that the wearer is married.

253. Wadi Daw'an: left to right: amulet (*nab daba'*), 7 cm; above left, amulet (*nazih*), with Yemeni agate, 2.5 cm; below left, gilded amulet (*manqus*), with inscription, "Mashallah tubarak Allah" (May God protect you!) inscribed on the front, 9.4 cm; upper middle, amulet (*hilal wa-shahr*), 10 cm, early twentieth century; lower middle, amulet (*hirz*), 7.5 cm; right, amulet, 14 cm, signed by Salim Salih Bahashwan.

collection from Hadramaut. Each bracelet was cut from a flat piece of silver and then folded over to form a cucumber shape. One end was plugged with mud and filled with hot lead. When cooled, the bracelet was chased with a design. The bracelet was then heated again so the lead would come out. The half-bead shapes were soldered on, the bracelet was pulled into a circular shape, and the bracelet was then finished. This particular pair has fine chasing and is filled with pebbles to scare away evil spirits. On her wedding day the bride carried Maria Theresa thalers in the box in figure 251. In 2006, Shaykh Dahduh in al-Khurayda told me that brides there still wear the box. The bride hung a hairpiece from her scarf on the right side of her head to indicate her bridal status (fig. 252). She also wore a variety of pendants, as seen in figure 253, to protect against the evil eye.

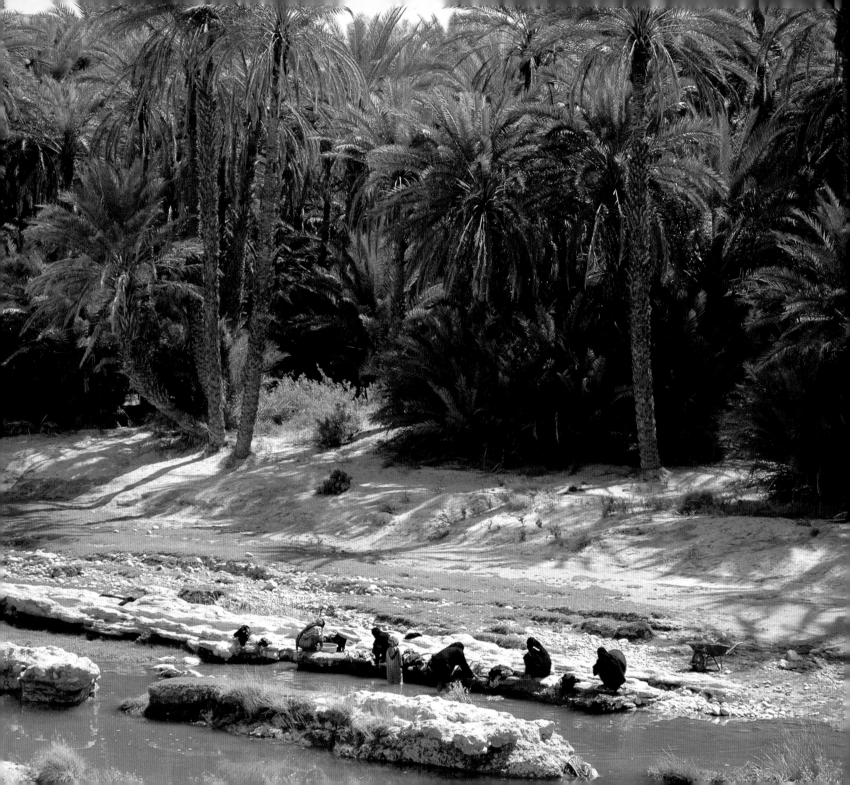

— 15 —

Wadi Idim

In the lagoon of Ghayl Umar the water runs year round. When it rains in the mountains of North Yemen, a lot of the water runs southeastward into Hadramaut. Sometimes it brings floods, but year round it gives Hadramaut a high water table and in a few places it fills *ghayl*s (lagoons) throughout the year.

The women in Yemen who know about the silver are in their sixties or seventies. In Sah, a city south of Tarim in Hadramaut, my hostess gathered female friends, put on her wedding dress, and spontaneously danced around the room wearing two heavy wedding belts that jingled as she danced. The other women clapped the rhythm of her dance, and the excitement was palpable. Her daughter, who was just past puberty and thus eligible for marriage, wore her veil even in this gathering of women because of her eligible status. She pulled me from the room and lifted her veil

254. Ghayl Umar in Wadi Idim, May 2005.

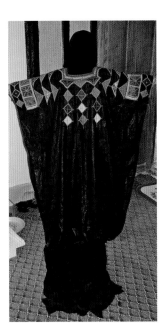

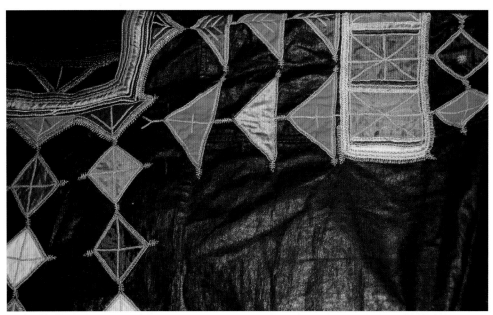

255. Wadi Idim: an indigo-dyed cotton wedding dress trimmed in Indian silk, mid-twentieth century.

256. Wadi Idim: detail of the decoration of the dress in figure 255.

257. Wadi Idim: upper-arm bracelets, 10 cm.

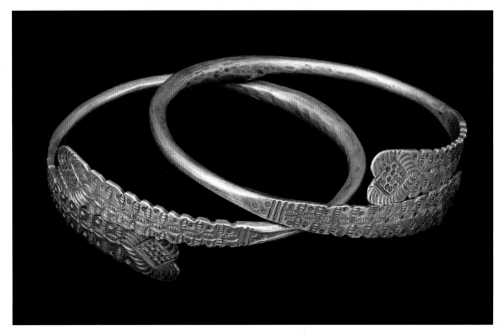

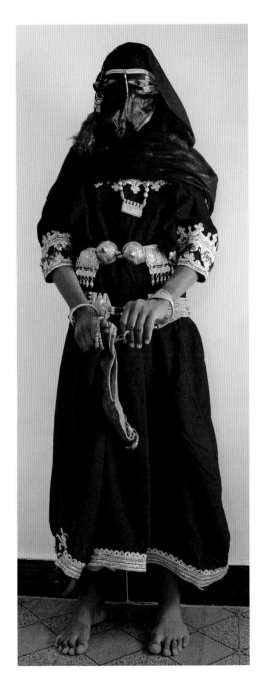

258. Wadi Idim: typical bridal attire, May 2005.

so I could see her face, while telling me of her great excitement at witnessing all this talk about past marriage customs. She had never seen her mother's wedding dress and jewelry, she told me with great enthusiasm, or heard her talk about it. I learned later that the young women in the room had borrowed my car and driver to go from house to house to get jewelry and costumes from family and neighbors so I would see the variety of what was once worn. The wedding dress (fig. 258) was a deep red velvet and the bride wore two belts—one heavy with the loud dangles for dancing, and a lower belt with multiple chains—matched bracelets on each hand, and a leather bag in her hand to carry her cosmetics and jewelry. There is a small necklace around the neck, but I think there would have been heavy amulets, had the young women had more time to scour their community for silver.

On a follow-up trip, the women brought in the lovely old wedding dress in figures 255 and 256, which dates from the mid-twentieth century. It is made of indigo-dyed cotton and trimmed in Indian silk. This is the only time I saw one like it. Its simplicity is its strength.

The upper-arm bracelets shown in figure 257 were made and worn only in Wadi Idim.

259. *(opposite)* Wadi Idim: woven belt *(hunaysha)*, silver, 140 cm.

260. Wadi Idim: painting by a schoolgirl of a woman weaving a loop-in-loop belt, May 2005.

The women in Wadi Idim wove the complex loop-in-loop chain in figure 259 themselves and wore it every day to keep up their long dresses while working. The belt resembles a snake and is called that. The length of the belt depended on the ability of the family to pay—some belts wrapped around the woman's waist as many as seven times!

The schools in Hadramaut hold a special festival at the close of the school year to celebrate the local culture. In addition to student art, local handicrafts are celebrated. I visited a school in May 2005 and found this student painting (fig. 260) in which a woman is weaving the complex belt (fig. 259) for which Wadi Idim is renowned.

————— 16 —————

Southern Hadramaut

SHIHR, THE SOUTHERN COAST, AND SOCOTRA

The ʿAmari family was the largest silversmithing family in Shihr, a seaport on the southern coast of Hadramaut where I visited in 2005. Abdullah al-ʿAmari, the ʿAmari family head, introduced me to other silversmiths and let me enjoy the refuge of his home and family when he went for evening prayer. He supported my research project and helped me immeasurably. I was very sorry to hear of his demise in 2010 at age seventy-five.

For her wedding, a Bedouin bride in the Shihr area would have worn a dress like that in figure 266, with an enormous amulet and several kilograms of jewelry. Sixty years ago, a bride from the same social context would have worn an indigo-dyed dress with the type of trim found in figure 264. Figure 267 shows a Bedouin woman

261. Shihr, Shihr Gate: entry to
the silver market, May 2006.

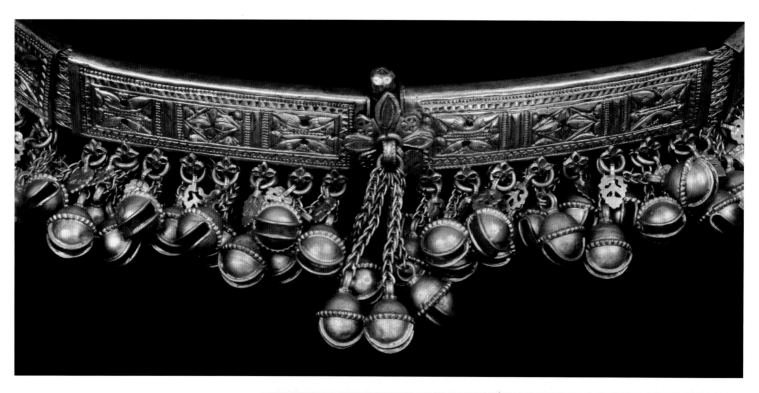

262. Shihr: belt, 95 cm, signed by Umar Salim al-'Amari and dated AH 1387 (AD 1966).

263. Shihr: belt worn by Bedouin, 80 cm.

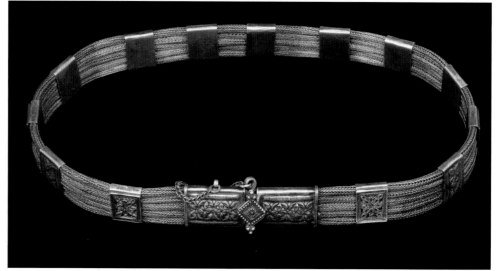

264. Shihr: beaded dress trim, mid-twentieth century.

265. Shihr: belt *(abu silus)*, 88 cm.

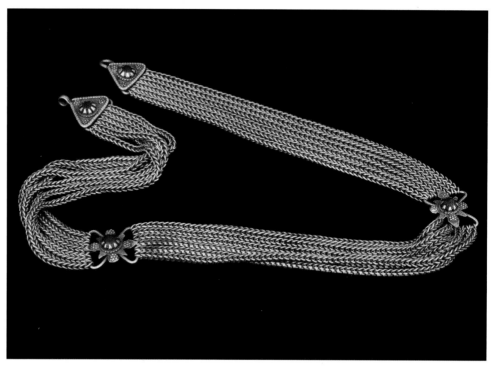

shopping in a dress store, perhaps for a wedding dress. After the requirement for a spectacular dress for the bride came the need for a heavy belt. The belt in figure 262, weighing 1,624 grams, was made in 1966 by Abdullah al-'Amari's late father. Married Bedouin women in the Mashqas area of Shihr, as well as the Bedouin of Wadi Daw'an, wore the belt in figure 263 at weddings. Both openwork and engraved spacers hold the five loop-in-loop chains together; the buckle has a pin clasp. The belt was made by a member of the 'Amari silversmith family in Shihr. The chains were most likely woven by Shihri women, but it was always hard to get accurate documentation of women's silver-making contributions. The chains in the belt in figure 265 were woven by men.

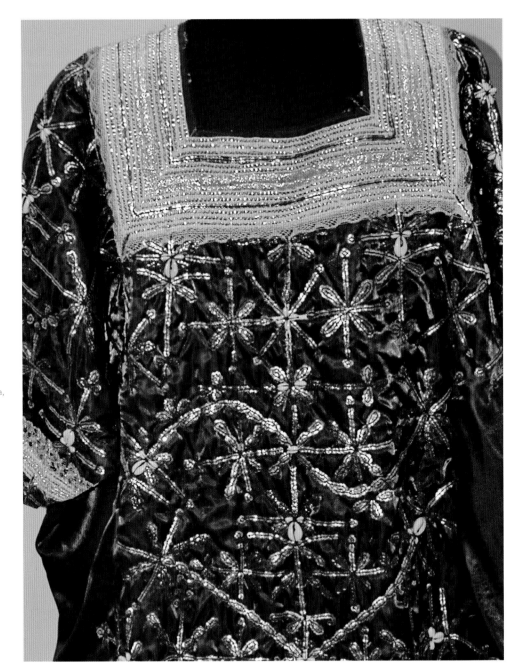

266. Shihr region, Ghail Wazir: green rayon dress, late twentieth century, from the collection of Mohammad Abdu Said Anam, photographed in Sanaa, June 2006.

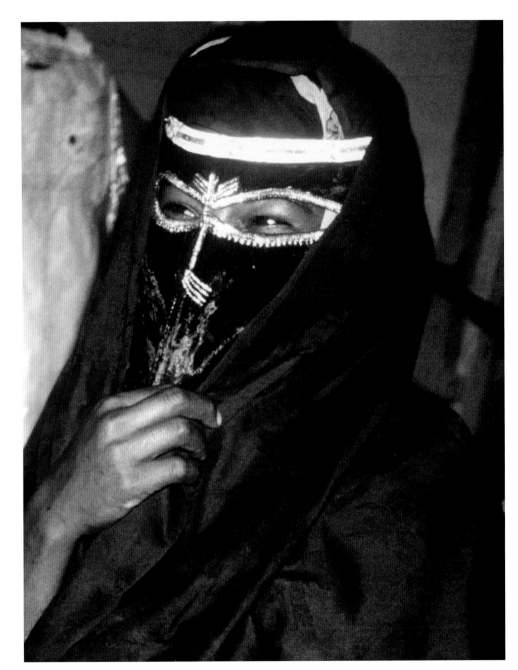

267. Shihr: a Bedouin woman,
wearing an indigo-dyed face mask,
shops for a dress, perhaps a wedding dress, 1980.

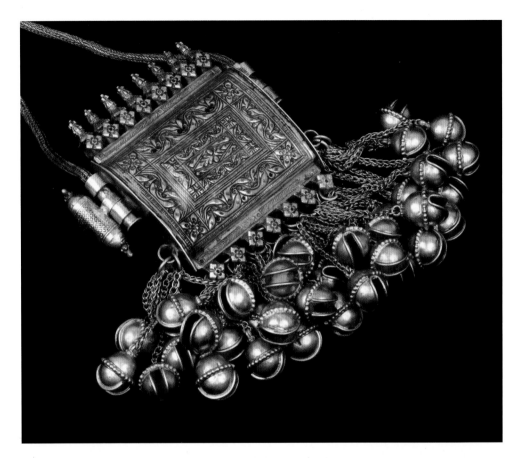

268. Shihr: amulet *(hirz haykali)*, work

of Mahfuz Said al-'Amari, dated 1958.

269. Shihr: headdress, 36.5 cm, with cast dangles.

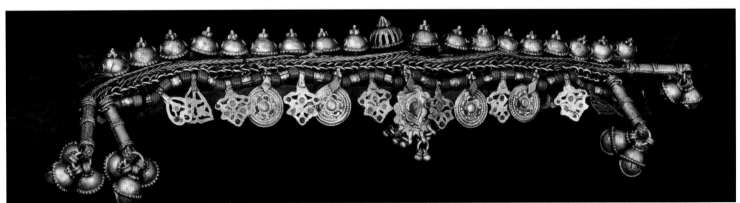

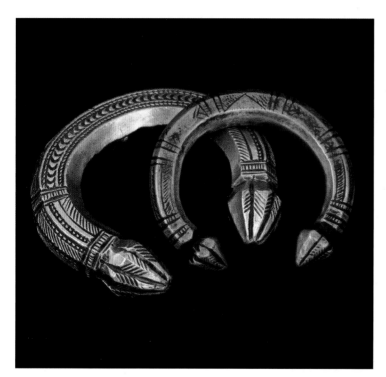

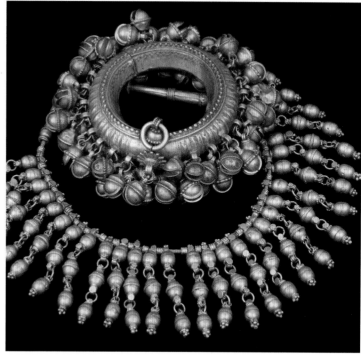

270. Shihr: bracelets, left: gilded cast bracelet, one of a pair, 7.5 cm, work of Salih Muhammad Bada'ud of Shihr; right: cast bracelet, 6 cm, worn by Bedouin in Wadi Daw'an and Sah for weddings, work of Salim Umar al-'Amari of Tarim.

271. Shihr: necklace *(muriyya marshaha),* 52 cm, work of Umar Ubayd al-'Amari; anklet, 13 cm.

The bride had to wear an amulet. The extraordinary piece in figure 268 weighs 1,740 grams, or over three pounds, and the silversmith's name is engraved on the back with the inscription, "For the health of the one who wears it." The bride wore it the day before she went to the groom; she danced and held the amulet and the snakelike chain in her hand, shaking it in time with her foot as she stamped the floor. Other items that the Bedouin bride in the Shihr area wore were heavy, cast bracelets, as in figure 270. The heaviest weighed 325 grams (11.5 ounces). The bride also wore a headdress (fig. 269) along with stalks of date clusters—symbolizing a fruitful and prosperous married life. She wore a necklace and a noisy anklet as well (fig. 271).

272. *(opposite)* Shihr: left: necklace called 'Mahri loops' *(hilqa mahriya)*, 80 cm; right: necklace, 108 cm, with the flat beads called *wushah* and the wire-wrapped beads called *dis*, late nineteenth century.

273. *(top left)* Shihr: in foreground, cast upper-arm bracelet *(zind)*, one of a pair, 11 cm; in background, bracelet *(mutall nafakh)*, one of a pair, 8.5 cm, work of Salim Said Baqtayan (born 1947).

274. *(top right)* Shihr: gilded bracelets, 5.5 cm, after gilding coated with *harad*.

Several other necklaces were made and worn in the Shihr area for ceremonial occasions. The necklace on the right in figure 272 has two beads that were always worn together, one flat and the other wire-wrapped. Difficult to create, they are no longer made today. The piece was always worn with the necklace on the left called 'Mahri loops.' Both were worn especially by Bedouin in the al-Ghayda area of Mahra.

The gilded bracelets in figure 274 were stamped in a repetitive palm design and have an application of a composition of resin and turmeric. Melted gold powder is mixed with mercury to gild the bracelets and then the turmeric mixture, which offers protection and good health to the wearer, is applied. The turmeric mixture was sometimes used on jewelry, but most often was seen on women's skin or applied to the embroidery of costumes, such as the dress from Jabal Milhan in figure 83 in chapter 5. The bracelet in the foreground of figure 273 was worn by both men and women. The hollow bracelet in the background was worn by brides all over Hadramaut.

During my research it was a special treat to meet silversmiths in remote places. I carried pictures of the pieces in my collection in large notebooks as I traveled, but I usually had no idea who had made them. When I met Umar Ubayd al-'Amari in 2006, I surprised him with a picture of this early piece of his that I had purchased as much as twenty-five years earlier.

Umar's necklace with five bosses, seen in figure 275, is called a purse. The box front is finely incised and the two amulets on the side are also delicately worked. The motif of five granules, which top the five bosses, also appears on the tops and bottoms of the cylindrical amulets. The number five has special significance in Islam as there are five pillars of the faith: prayer, fasting, giving witness (the declaration of faith), giving alms to the poor, and making the pilgrimage.

Bedouin women wore as many as eleven or as few as seven of the earrings seen in figure 276. One woman had me count the holes in her ears; there were nine in each ear. That was very direct documentation.

I had only seen Salih Muhammad Bada'ud's belt hanging in shops. I took his word that he had made the belt in figure 277, in leather and low silver, for Bedouin in Shihr some twenty-five years earlier.

275. *(opposite)* Shihr: box-shaped amulet *(shanta),* 12 cm, with two cylinder amulets and loop-in-loop chain, work of Umar Ubaid al-'Amari.

276. *(bottom left)* Shihr; earrings *('aqrat),* 3.5–4 cm.

277. *(bottom right)* Shihr: leather and nickel belt *(hiyaqa),* 152 cm, work of Salih Muhammad Bada'ud.

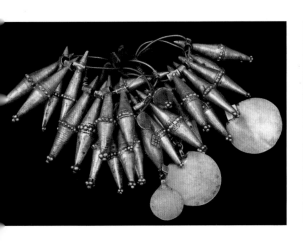

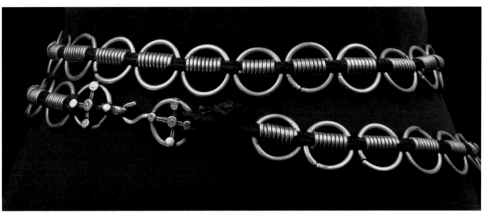

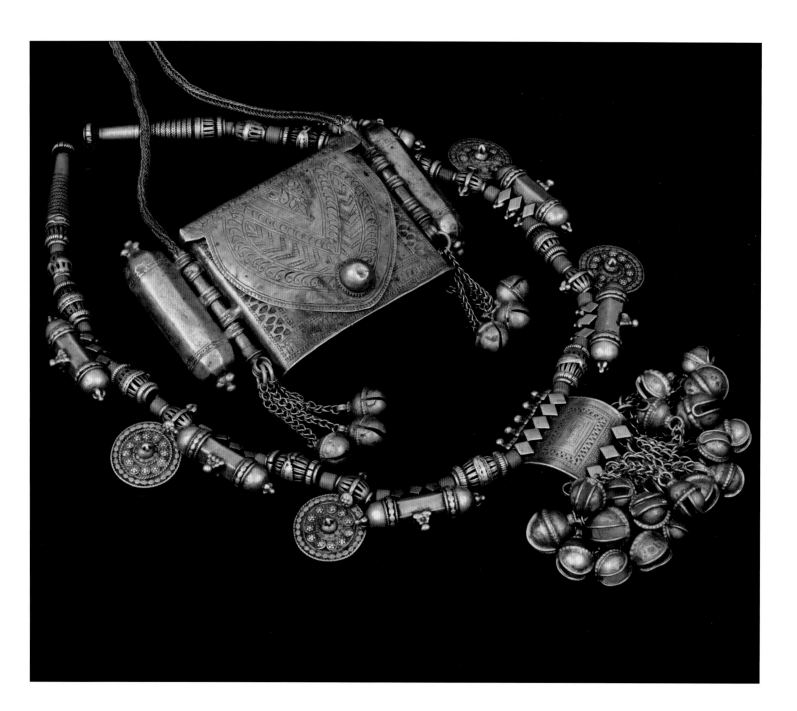

278. *(opposite)* *Al*-Qusayyar, southern Hadramaut coast: box *(shanta)*, 9 cm, work of Abu Karama Hassan; necklace *(ma'shuq abu hirz)*, 72 cm, work of Umar Ubayd al-'Amari.

279. *(right)* Al-Qusayyar: necklace *(ma'ashuqa)*, 36 cm, work of Karama Karama Hassan.

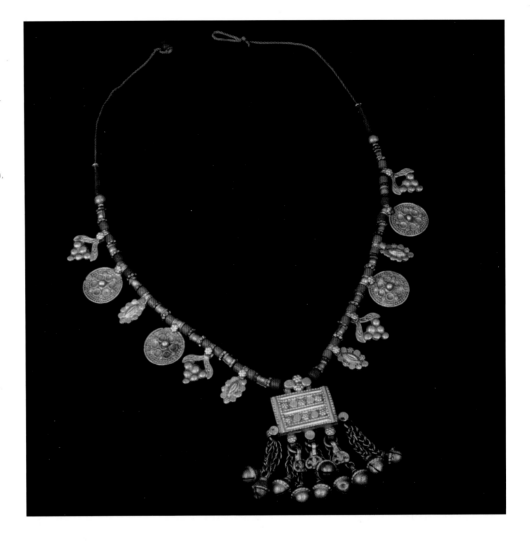

Karama Karama Hassan, aged eighty-five, took a seven-hour trip from al-Qusayyar on the southern Hadramaut coast to Sayyun, so I could interview him. The box with amulets in figure 278 was signed by his father, Abu Karama Hassan, and dated 1911. Karama Karama's own work is featured in figure 279.

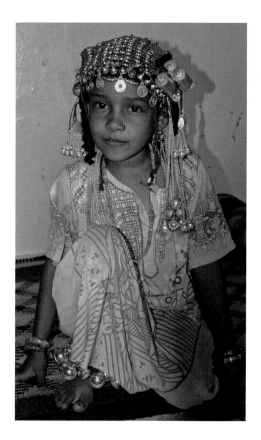

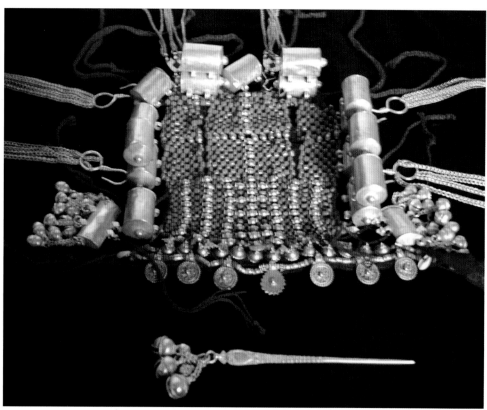

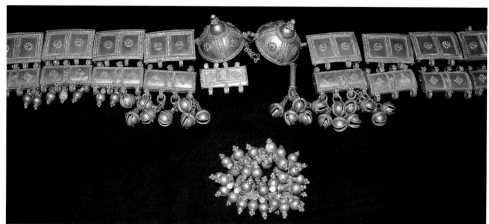

280. Al-Qusayyar: young Bedouin girl, April 2005.

281. Al-Qusayyar: headdress *(kadida)* and hair-parter, April 2005.

282. Al-Qusayyar: wedding belt and beads *(qanaqin suqih)*, worn fastened onto the belt, April 2005.

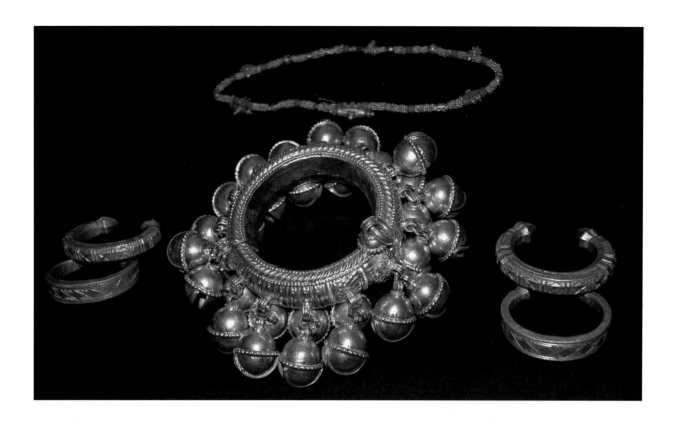

283. Al-Qusayyar: anklet (*hijl*), belt, and four bracelets.

In 2005 I met a Bedouin woman in al-Qusayyar who welcomed the opportunity to show me her wedding jewelry. She would not pose for a photo herself, but dressed her young daughter in her treasure (fig. 280). In figure 281 you see the headdress flattened out alongside a hair-parter. The headdress is smaller than that portrayed in chapter 12 on Sayyun, but is similar. The wedding belt (fig. 282) is large and heavy; the cluster of beads was worn fastened to the bride's belt to enhance the noise as she danced. Figure 283 shows the heavy anklet, the greatest noisemaker, and four small bracelets.

284. Socotra: Dragon's-blood tree, January 2009.

285. Socotra cast-silver bracelets *(mutall)*,

7 cm, made in Socotra by Shihri silversmith

Abdullah al-'Amari.

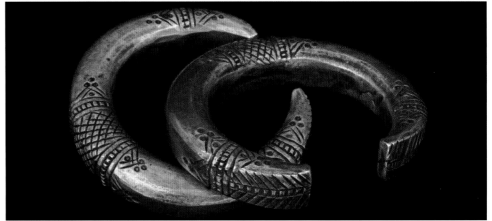

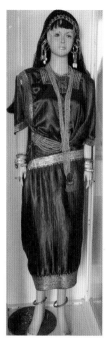

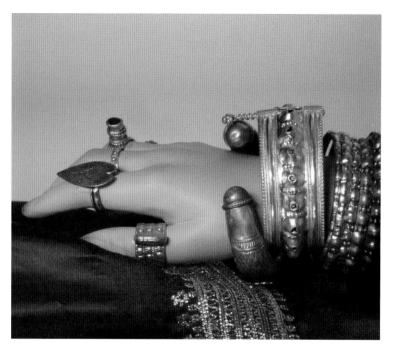

286, 287, and 288. Museum sign, museum

mannequin adorned with silver and traditional

Socotran costume, and detail of Socotran jewelry.

SOCOTRA

The remote island of Socotra, some 380 kilometers (236 miles) off the southern
coast of Yemen, has an exotic landscape and flora and fauna and has been declared
a World Heritage site by UNESCO. The dragon's-blood tree prominent in figure
284 is a symbol of Socotra and the source of a red dye that appears in its handicrafts.
The unique language of the region is akin to Mahri, once the language of the gover-
norate of Mahra and western Oman. Most of the jewelry worn in Socotra was made
on Yemen's mainland, in Shihr and Tarim and other locations in Hadramaut, as well
as Sayhut in Mahra. The Socotra Museum displays a generous collection of jewelry,
featured in figures 287 and 288, indicating that jewelry was important there, as in the
rest of Yemen. The bracelets in figure 285 were made in Tarim for Socotra.

— 17 —

Mahra

289. Mashqas, southern Hadramaut: a Bedouin woman leads her flock home in the late afternoon, April 2005.

Few tourists go to Mahra, the easternmost governorate of Yemen. In fact, few Yemenis go there, unless they are traveling farther east to Oman. The people of Mahra spoke an early south Arabian language called Mahri, a language they shared with some inhabitants of Dhufar in Oman. The jewelry of Mahra is similar to the jewelry of Dhufar. All Mahri jewelry was made in Sayhut in eastern Mahra.

My principal source for Mahra was Tayyib Bajabir. He was modest about his own silver-making capabilities, always singling out the work of Said bin Umar Babatat as better than his. His own work is quite beautiful, however, as can be seen in figure 291.

The bride in Mahra wore a gilded headdress (fig. 290), with stalks from a date tree alongside it. Around her neck were two necklaces, always worn together, as seen

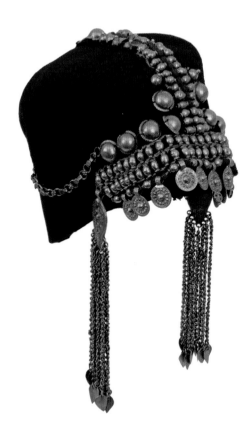

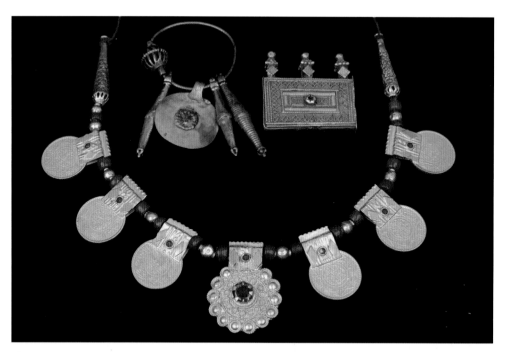

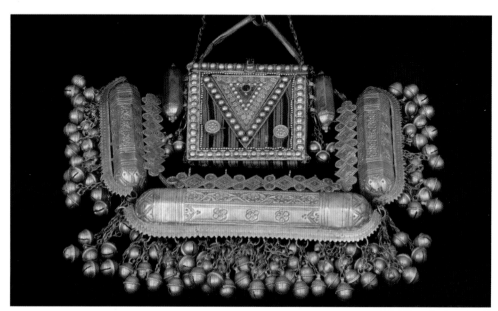

290. *(opposite, top left)* Sayhut: gilded bridal headdress *(madrib li-l-ra's)*, 19 cm. Felt cap added in U.S.

291. *(opposite, top right)* Sayhut: top left: gilded nose ring *(khursa khaysh)*, 4.5 cm; top right: gilded box *(mahfaza)*, 4.5 cm; bottom: gilded necklace, 35.5 cm. All the work of Tayyib Bajabir

292. *(opposite, bottom right)* Sayhut: top: partially gilded amulet *(shanta)*, 13 cm, work of Tayyib Bajabir; bottom: amulet *(hirz)*, 90 cm, 1,200 grams, work of Said bin Umar Babatat.

293. *(right)* Sayhut: silver thread machine embroidery on black silk dress *(burqala)*, mid-twentieth century, from the collection of Muhammad Abdu Said Anam, photographed in Sanaa, June 2006.

in figure 292. One is a box that held precious papers or coins and the second a large amulet with noisy bells. She wore a lovely silk dress, as in figure 293.

Mahris preferred gilded jewelry and they did not stint in using a large amount of gold. The usual way of dipping silver in Yemen was to use gold powder mixed with acid and water, which produced a light gold wash. The Mahris instead softened gold to powder and then mixed it with mercury, which was then applied to 83 percent silver. The resulting gold wash lasts much longer than with other techniques.

Said bin Umar Babatat, the master craftsman in Sayhut, learned his craft from

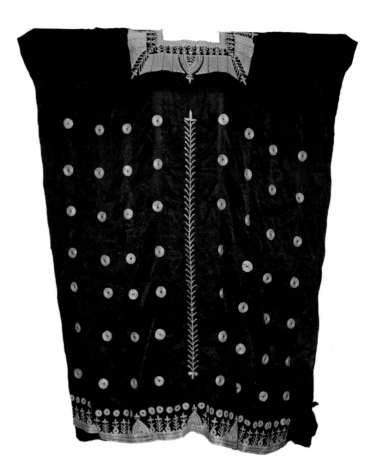

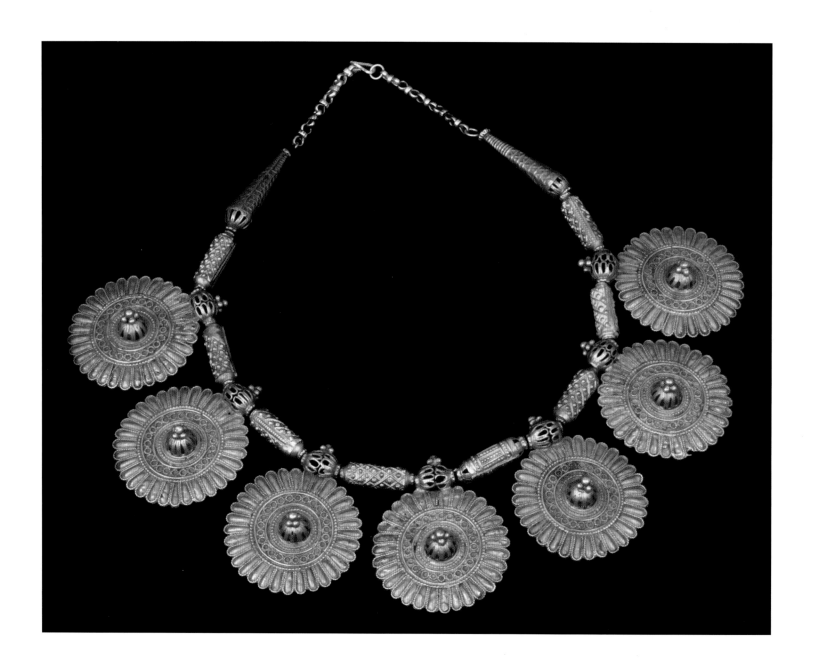

294. Mahra: gilded necklace (*muriyya*), 39 cm, work of Abd al-Shaykh Basaʾawad.

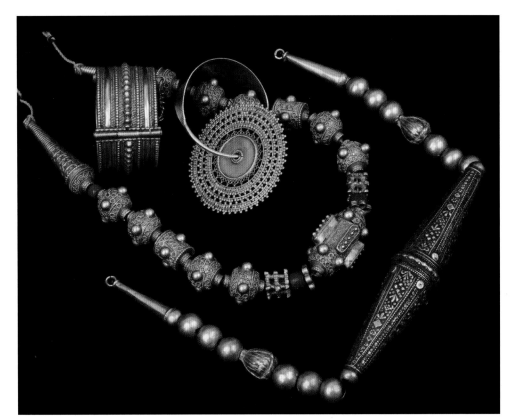

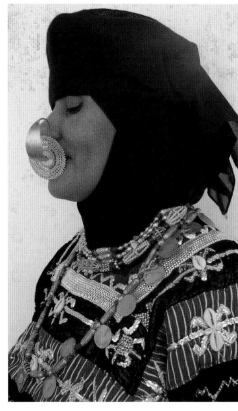

295. Sayhut: left to right: gilded bracelet, one of a pair, 5 cm; gilded nose ring (*qashmim* or *khizma*), 5.5 cm; gilded necklace (*muriyya*), 41 cm; gilded amulet (*muriyya* or *abu mutawwal*), 14.5 cm, all the work of Said bin Umar Babatat.

296. Sayhut, gilded nose ring also shown in figure 295. Photographed April 2005.

one of two Indian silversmiths who worked in Wadi Masila, an area in eastern Hadramaut. Said then taught Tayyib Bajabir. Thus, Mahri jewelry owes much to Indian designs. Abd al-Shaykh Basa'awad, another accomplished silversmith, who died about thirty-five years ago, also studied with the Indian silversmiths. He made the necklace in figure 294. The nose ring in figure 296 is the work of Said bin Umar Babatat. Other works by him are included in figure 295.

Most of the jewelry made in Sayhut was worn by Bedouin, especially in the Mashqas area of southern Hadramaut (fig. 289), between al-Qusayyar in the west

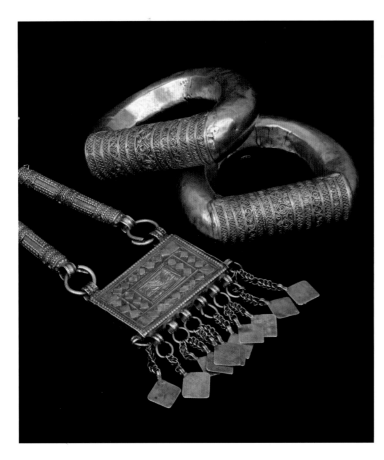

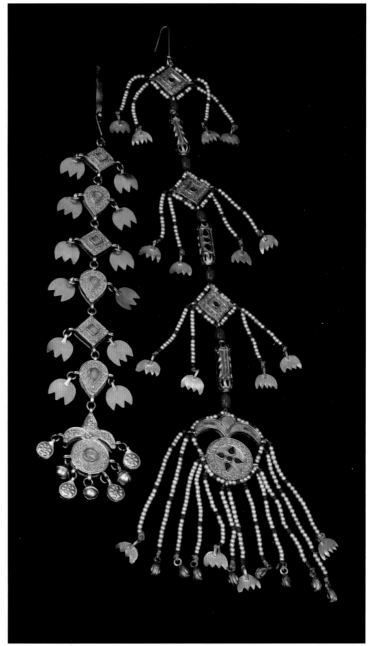

297. Sayhut: left: amulet *(mahfaza maqmusa)*, 7.2 x 4.8 cm, work of Said Bamukhtar, 1910–65; right: bracelets *(mutall)*, 12 x 10 cm, work of Said bin Umar Babatat.

298. Sayhut: left: gilded hairpiece *(mashaqir)*, 32 cm, work of Said bin Umar Babatat; right: gilded hairpiece, 42 cm, work of Tayyib Bajabir.

299. Mahra: Bedouin women near the Arabian Sea coast going for water, April 2005.

and Sayhut in the east. The amulet in figure 297 is decorated with gold-plated square pieces of flat silver; the theme is repeated in the eight square dangles. The chain is high-quality loop-in-loop and the cone ends are decorated with filigree and stamped strips of silver. It is more reminiscent of Omani than Yemeni work. The bracelets in the same picture have an unusual shape. They were put on upside down and then turned around. This pair was made for very small wrists! The hairpieces in figure 298 offer an opportunity to compare the work of Said bin Umar Babatat, on the left, and Tayyib Bajabir, on the right.

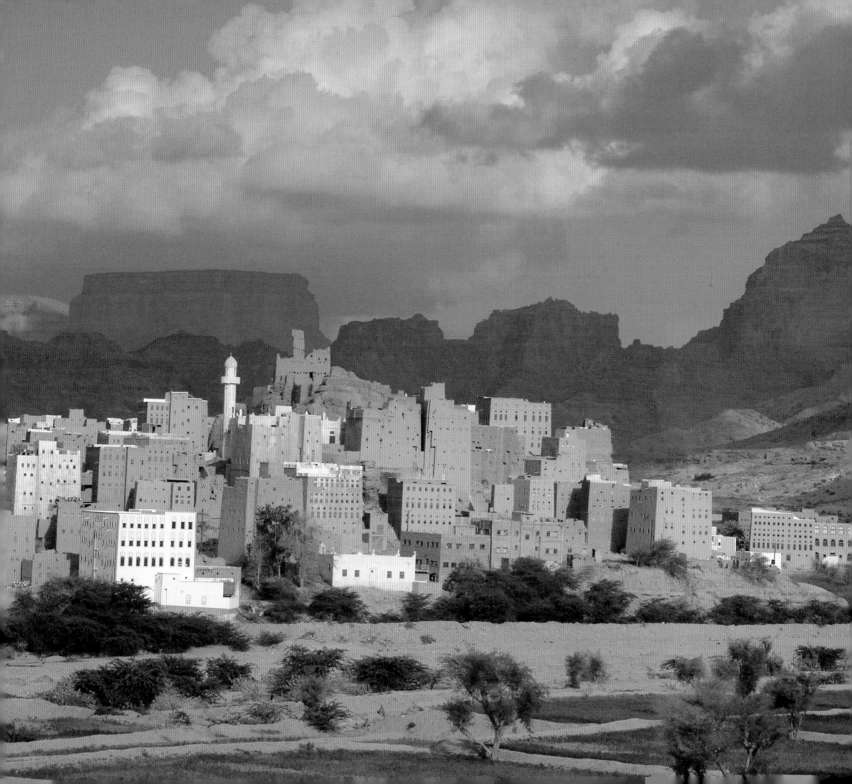

18

Shabwa

HABBAN AND ATAQ

HABBAN

Habban, in the remote governorate of Shabwa, was home to a renowned colony of Jewish silversmiths who were cut off by distance from their Jewish counterparts in the rest of the country and thus produced a distinctive type of silver jewelry. Their special necklace (fig. 301) was widely worn by Muslim brides throughout Hadramaut. The buckle on the belt seen in figure 302 was made in Habban, but women in Hadramaut wove the silver mesh shown here. Habban work is characterized by applied decoration in diamond and circular shapes and red glass cabochons, as seen in figure 303. Red glass was used as a less expensive imitation of carnelian; both were believed to promote good health. The belt in figure 304 has large pieces of Yemeni carnelian and agate.

300. Habban, Shabwa, June 2005.

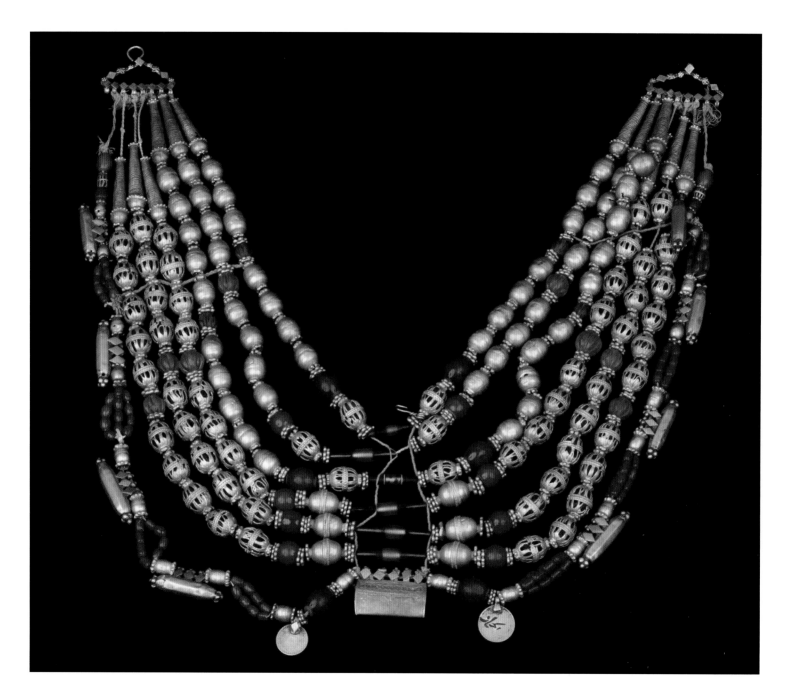

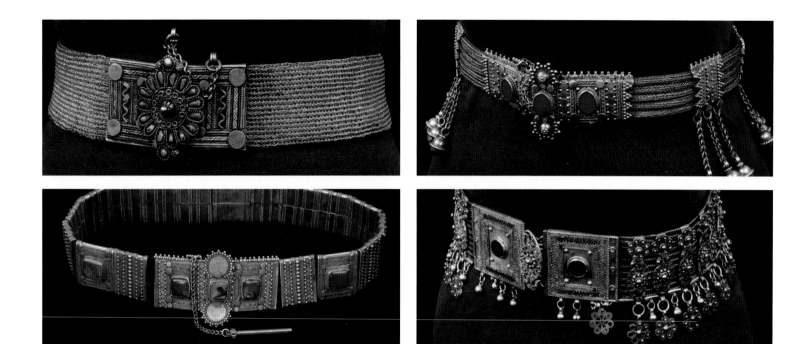

301. *(opposite)* Habban: necklace *(muriyya murassa'a),* 86 cm.

302. *(top left)* Habban: woven belt *(abu sabta),* 38.5 cm. Weaving done by Hadrami women. **303.** *(top right)* Habban: heavy belt buckle, 13.2 cm, with red glass cabochons. **304.** *(bottom left)* Habban: linked belt *(manjad),* 88 cm, with large pieces of agate.

305. *(bottom right)* Habban: belt *(hizam),* 72 cm, weighing 1,020 grams—more than two pounds.

There is speculation about the provenance of the heavy belt in figure 305 because it contains such disparate elements. The buckle appears to be Habbani. The base of silver mesh is probably Hadrami. The dangles and the whale motif appliqués are Bawsani Jewish work from the northern part of Yemen. The belt may have been redesigned forty or fifty years ago, but the pieces are over a hundred years old.

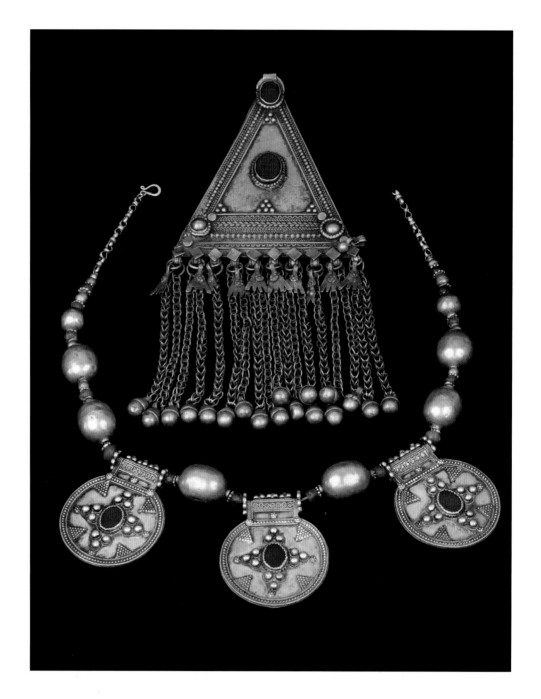

306. Habban: top: amulet *(muthallath)*, 13 x 11 cm;

bottom: necklace, 50 cm, three Habbani pendants

with red glass cabochons and eight Hadrami beads.

307. Habban: traditional dress, shown in the Yemeni House of Popular Folklore, Aden, March 2006.

308. Habban: top to bottom: hollow bracelet, with red glass stones, 10 cm; pendant *(sidr)*, with *'aqda* chain and light-colored Yemeni agate cabochon, 6.5 x 7 cm; necklace *(labba mufassasa)*, 18 cm.

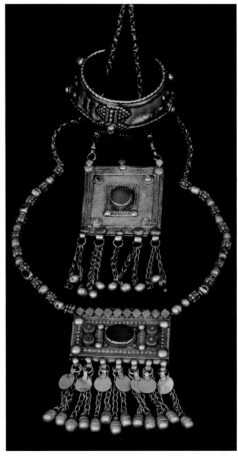

The triangular amulet and the necklace in figure 306 reflect the popularity of the color red in Habban jewelry. The Habban costume (fig. 307) also features red, along with extensive use of small shells. The three pieces in figure 308 show the variety of jewelry made in Habban. The bracelet and similar necklaces were worn widely in Marib and the Jawf, as well as in Saudi Arabia.

309. Shabwa: a mud-brick house in Khamar, between Habban and Ataq, the capital of Shabwa, June 2006.

310. *(opposite)* Ataq, Shabwa: necklace *(labba),* with cabochon of orange material like a hard resin, 21 cm.

ATAQ

Ataq, capital of Shabwa, is an hour's drive from Habban, and the *zabur* building in al-Khamr in figure 309 is about halfway between the two. Ataq has several silver shops and is the only city I know of in Yemen that has such a focus on silver. The silversmiths in Ataq were selling re-silvered old pieces to Hadrami customers living in Saudi Arabia. They had taken old nickel pieces and made them shiny. I found the piece in figure 310 just before it was to be silver-plated.

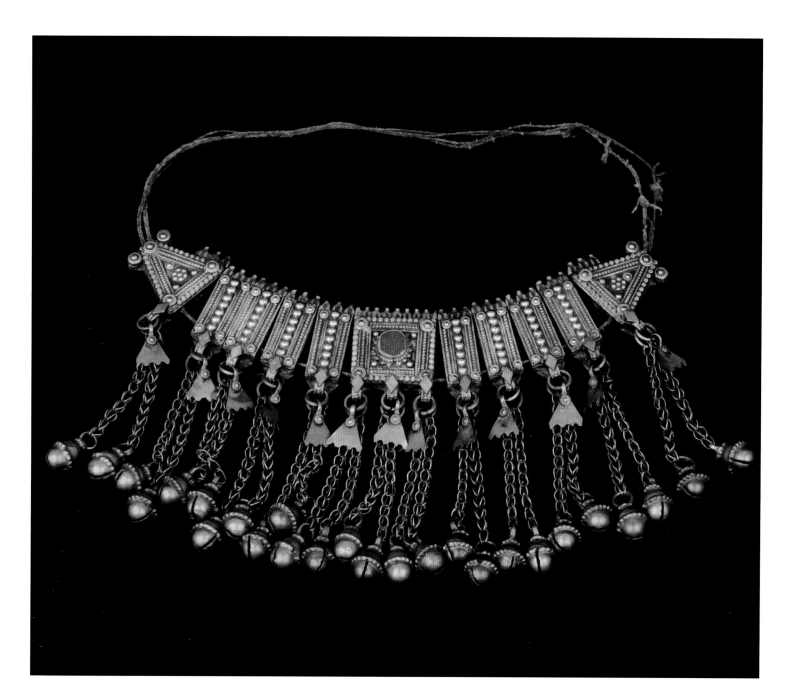

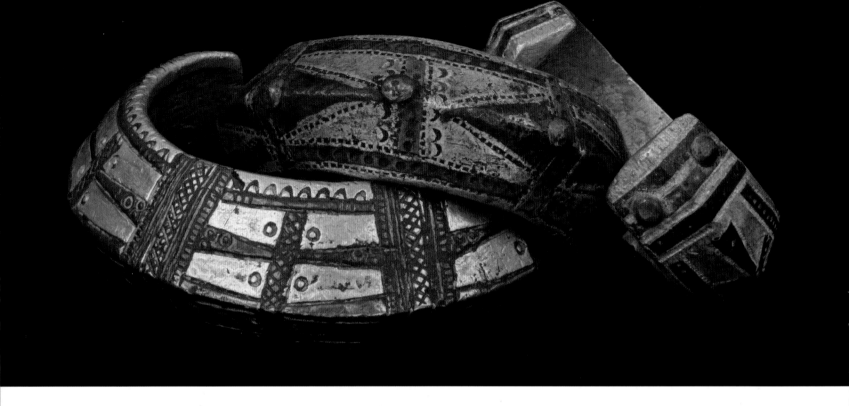

311. Ataq: aluminum and copper bracelets, 10 cm, 8.5 cm, and 7.5 cm.

312. Ataq: top: brass belt (*mahguz*), 109 cm; bottom left: brass bracelet, 7 cm; bottom right: aluminum bracelet, one of a pair, 6.8 cm.

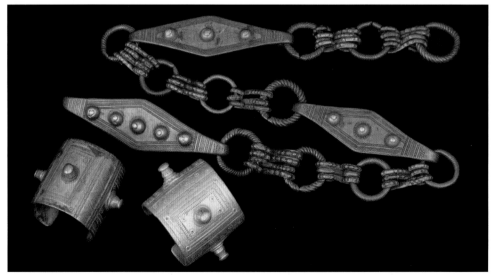

Cuff bracelets like those in figure 311, as well as in figure 312, are on display in the local museum in Ataq, described as local products, but they and the aluminum bracelet are identified elsewhere as West African, and the brass bracelet as Ethiopian.[11] I saw several such bracelets in Yemen so I assume they were made in Shabwa. Aluminum and brass are inexpensive materials, so these bracelets would have cost the Bedouin less money than silver jewelry, but still offered lovely adornment. How the design came from East and West Africa to remote Shabwa is one of those intriguing trade stories. According to Dr. Robert Liu of *Ornament* magazine, the brass belt in figure 312 is unique in the collection for it was done with cold connections, that is, no heat and no soldering. It was closed after casting. The half-beads on the buckle are affixed with lead.

The final object of interest from Shabwa is the crown in figure 313. There is little documentation for it, other than that it originated in Shabwa. The fleur-de-lis motif appears in many pieces of Hadramaut jewelry. The six-leafed flower has the shape of the Star of David, which would indicate it is the work of a Jewish craftsman, and that would place it in Habban.

313. Shabwa: brass crown *(taj)*, 18 cm high.

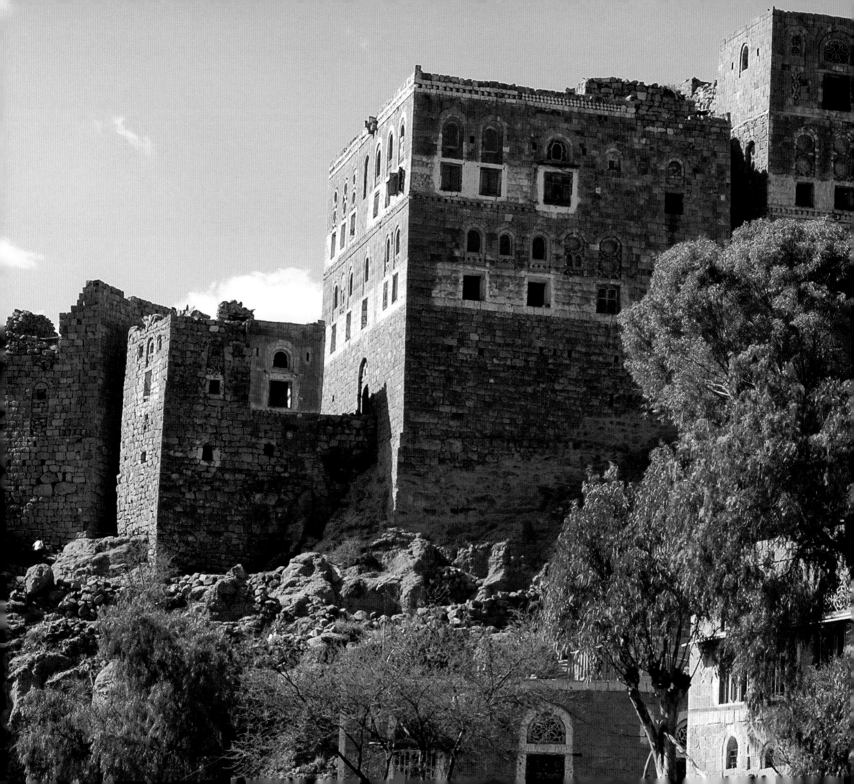

19

Dali', Yafi', and Lahij

Dali', Yafi', and Lahij are three small districts just north of Aden in the southern part of Yemen.[12] The jewelry worn there is made of low-cost metal—nickel or low-grade silver—but has strong, distinct designs; it was probably made in Aden or al-Bayda. I found no silversmiths in Lahij when I went there and did not visit Dali' or Yafi', but Najla Shamsan and her Yemeni House of Popular Folklore in Aden gave me valuable information about the jewelry and costumes of this area. The headpiece in figure 315 was worn in Dali'; it was attached to the turban the bride wound around her head and the five dangles on each side would fall over her ears. The bottom headpiece was worn in al-Qubayta in Lahij.

The pieces in figure 316 and the costume in figure 317 are also from Dali'.

314. Dali', March 2006.

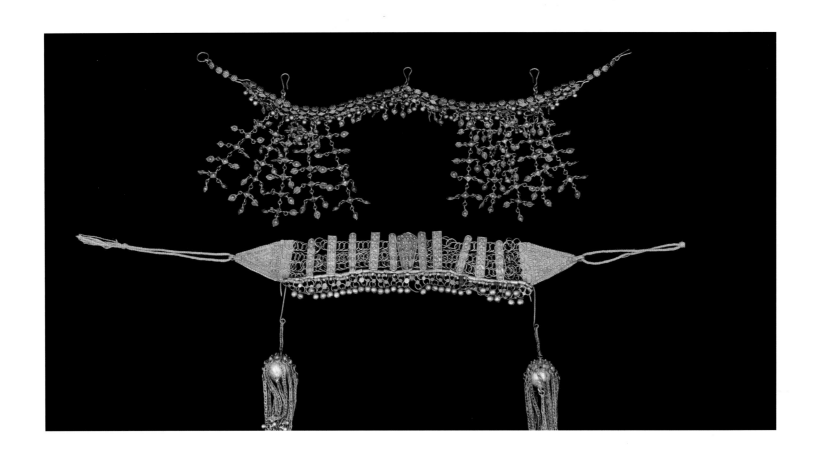

315. Dali'. top. nickel headdress *('isaba),* 39 cm, perhaps the work of an Indian silversmith in Yemen; al-Qubayta, Lahij: headpiece *('isaba),* 58 cm.

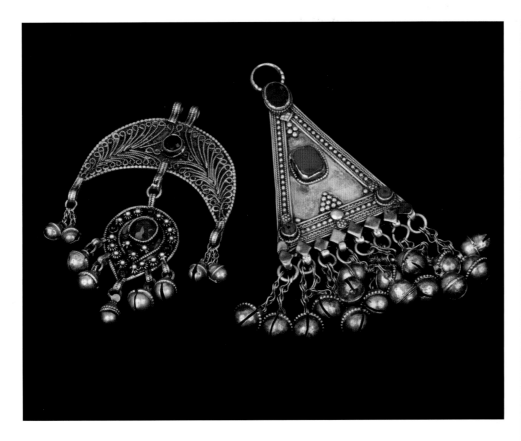

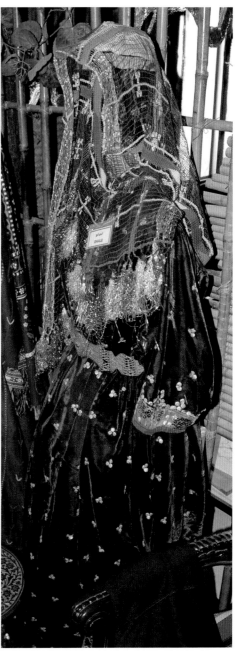

316. Dali': left: pendant *(hilal wa-lawza)*, 9 x 14.5 cm;

right: pendant *(muthallath)*, 7.5 x 10 cm.

317. Dali': velvet costume, topped with Habban headcovering,

the Yemeni House of Popular Folklore, Aden,

photographed March 2006.

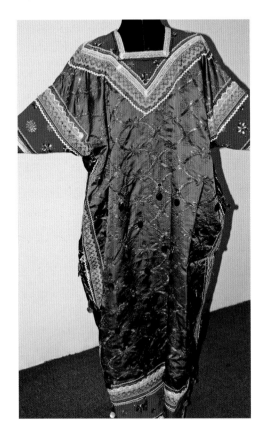

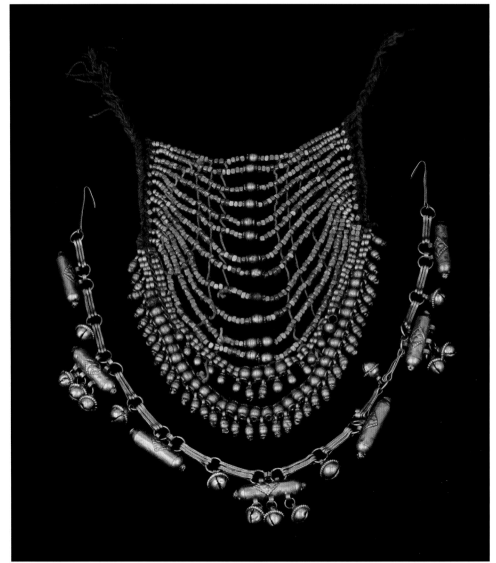

318. Yafi': machine-embroidered green nylon dress,

last half of twentieth century,

Muhammad Abdu Said Anam collection,

photographed in Sanaa, June 2006.

319. Yafi': top: nickel and string necklace *(labba)*,

20 x 26 cm; bottom: nickel necklace, 66 cm.

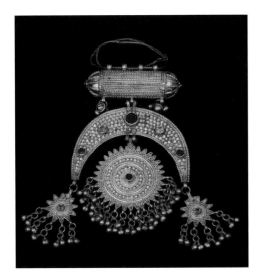

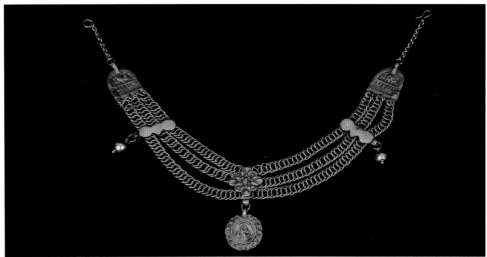

From Yafi' there are two necklaces (fig. 319), quite different from each other, and in figure 318 a green nylon costume.

The costume of Lahij, in figure 320, is similar to those of Taiz to the north, as is the jewelry in figures 321 and 322. The large necklace in figure 321 was worn by rural brides for their weddings in Aden, Lahij, and as far north as Taiz; the necklace in figure 322 has the same flattened chain, called 'river' or 'wave,' as found in the jewelry of Ibb to the north, as in figure 159 in chapter 9.

320. *(left)* Al-Qubayta: Lahij costume, the Yemeni House of Popular Folklore, Aden, photographed March 2006.

321. *(top left)* Lahij: necklace (*marshaha*), 16.5 cm.

322. *(top right)* Dali' and al-Qubayta, Lahij: necklace with flattened chain called *musattah*, 32 cm.

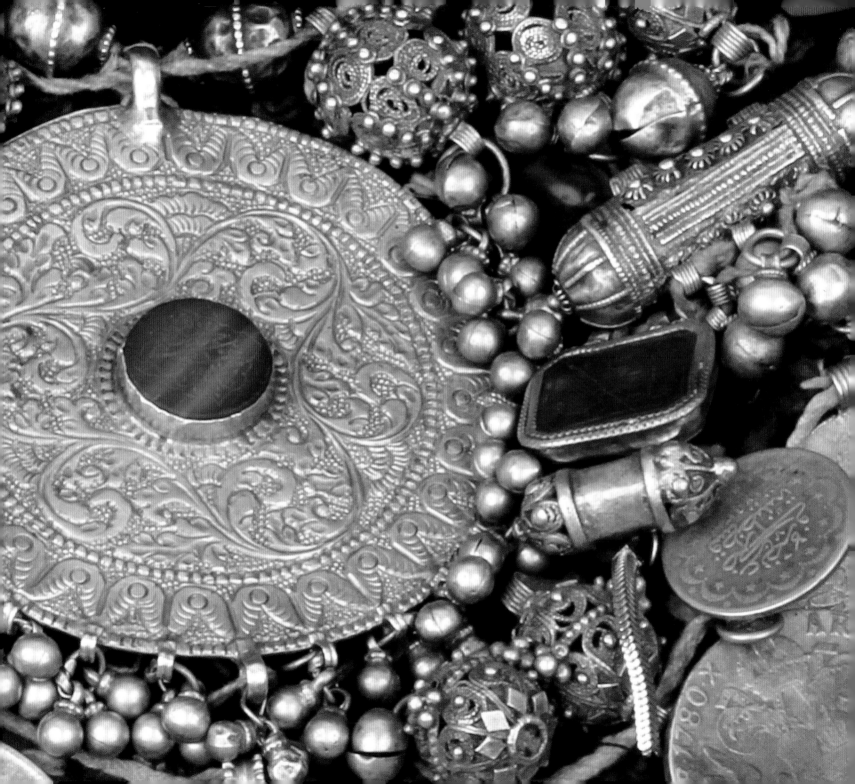

CONCLUSION

323. Detail of chest piece *(labba)* shown in fig. 77, p. 71.

Only when I pulled together all the material for this book did I realize the extraordinary richness and variety of Yemeni traditional silver jewelry. From one end of the country to the other, women and their families sought beautiful adornment to express their beliefs and their identity. The silversmiths competed to fill those desires. After eight years of study I continue to discover designs I have not seen before. The amount of silver produced and used is all the more remarkable when you consider that the maximum population of the whole country during the period of my study was about five million people.

The women who wore these pieces were Bedouin and tribeswomen. They brought much beauty and pleasure into their lives. This type of jewelry was unknown to many city women, for they did not need jewelry to hold the family wealth. They preferred light, intricate silver pieces or gold. They most likely had less jewelry than their rural fellow countrywomen, as they invested in other things, such as real estate.

So many people helped me in my endeavors that I fear I may unintentionally

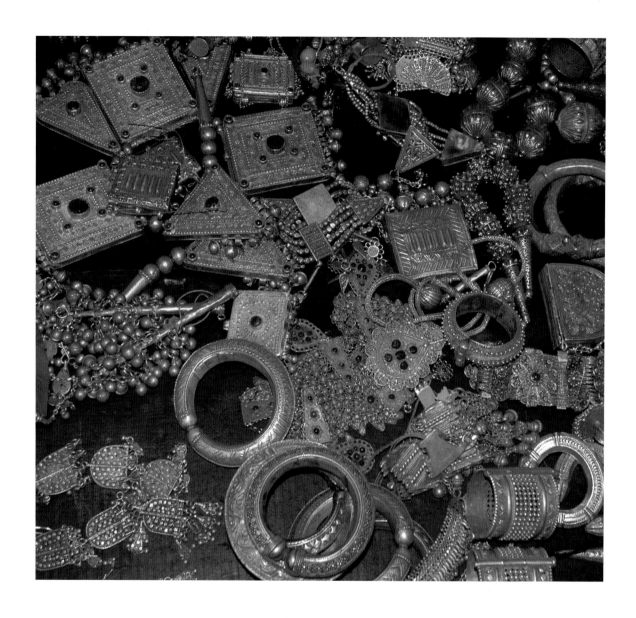

324. Miscellaneous jewelry pieces. The necklace with bright green and red glass stones is the Bawsani-style piece from Sanaa seen at the bottom of fig. 36 on p. 45. 2006.

exclude someone in my acknowledgments. My colleagues in the United States were helpful in innumerable ways, several European friends lent pictures and gave valuable advice, and Yemenis just lined up to contribute.

The tragedy is that this wonderful craft is disappearing. I hope that this book will kindle new interest and demand for these timeless pieces. In my second volume I will write about the artisans who worked so hard to make this beautiful jewelry.

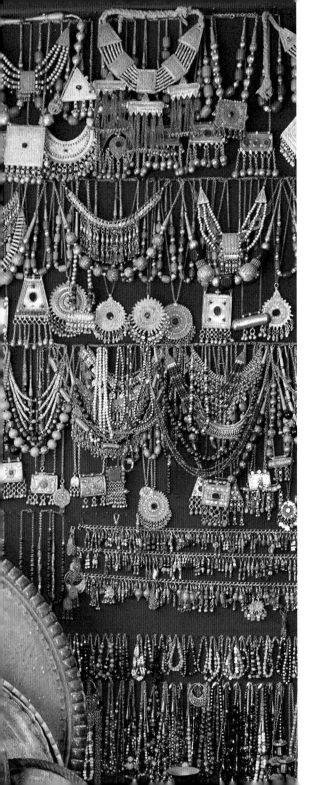

325. Detail, the silver shop of Sultan al-Amri, Taiz, 2006.

I am greatly indebted to the many people and organizations that gave me valuable support:

Kamal Rubaih and Hassan Bahashwan, consultants for the jewelry and costumes of North and South Yemen, offered advice and contacts.

Maria Ellis of the American Institute for Yemeni Studies and Chris Edens of the Yemen Center for Studies and Research, Sanaa gave extensive institutional support and advice.

The late Honorable Abdul Aziz Abdul-Ghani, Dr. Abdulkarim al-Eryani, Abdullah al-Ansi, Abdulrahman Hasan al-Saqqaf, Director, Sayyun Museum, Mohammad Umar al-Jabri, General Director, Mudariyyat of Sah, and Abduh Darjan, Director, Mudariyyat of Wasab are Yemeni officials who gave support and advice.

Dr. Najwa Adra and Anne Burnham edited the text several times with patience and encouragement. Robert Liu traveled from San Diego to Washington to photograph the jewelry and costumes. Cheryl and Jessica Andrade, Abdullah T. Antepli, Marwa Babakis, Ellen Benson, Allan Gall, Peggy Hanson, Linda Houghton, Sherry Houghton, Walid Jawad, Dr. Sylvia Kennedy, Abdul-Rahman al-Moassib, Dr. Martha Mundy, Christine O'Donnell, Dagmar Painter, Kathy Quirk, Sakina Shehadi, and Dr. Shelagh Weir gave time and wisdom.

Donations to the collection: the late Abdul Aziz Abdul-Ghani, Ambassador Yahya al-Arashi, Halima al-Badawi, Celia Crawford, Dr. McGuire Gibson, Betsy Jett, Christa Newton, and Ali Saidi.

Yemeni cultural experts: Amat al-Razzaq al-Jahhaf, curator, Muhammad Abdu Said Anam collection; Arwa Uthman, curator, The House of Folklore, Sanaa; and Najla Shamsan, curator, The Yemeni House of

ACKNOWLEDGMENTS

Popular Folklore, Aden.

Guides: Ahmad bin Zain al-Attas, Wadi Amd; Said bin Awadh and Mubarak Said, al-Qusayyar and Sayhut; Mohammad Yahya al-Mahwiti, Mahwit. Universal Travel arranged my extensive travel and gave me the wonderful services of Abd-Rahman al-Sabri, who was my driver and knowledgeable guide.

National Geographic Imaging: Howard Hull and Rob Thomas performed miracles with some of my images—especially the older ones.

Photographs: Ali Yusuf al-Amir, Dr. Jenny Balfour-Paul, Larry Bartlett, Eileen Binns, Ali al-Egri, Hanne Eriksen, Peggy Hansen, Dagmar Painter, Edward Prados, Clifford F. Ransom III, Rosemarie Ruckelshausen, Peggy Schaeffer, and Lothar Stein generously lent photos. Werner Daum and Miranda Morris helped with permissions for photos.

Silver dealers and silversmiths who shared their knowledge: Abd al-Karim Mahfouz Bataher and Hajj Ahmad Bahashwan, Aden; Abdu Said Khazraji and Ali Qassim Muhammad, Bait al-Faqih; Ali Bur'i, Bur'a; Abdo Ibrahim Kuhayyil, Dhahiyy; Miftah al-Arifi and Muhammad Abdulla al-Arifi, Hudayda; Abdulla Hassan al-'Amari, Dis al-Sharqiya; Muhammad Samahi, Mahwit City; Ali Abdulla al-Akwa', Mohammad al-Faqih, Mohammed Garamany, Hajj Mohammad Ahmed al-Ghamoush, Yahya Rassam, Abdul Ghani al-Thulayya, and Muhammad al-Wujra, Sanaa; Abdullah al-'Amari, Salih Muhammad Bada'ud, and Said Mohammed Ahmed Baqtayan, Shihr; Tayyib Bajabir, Sayhut; Ahmed Ali and Akram Sami', Sultan al-Amari, and Abdullah Ismail al-Arifi, Taiz; and Muhammad Yami, Zabid.

My family for their unflagging support: Elizabeth Ransom, Katherine Ransom-Silliman, and Sarah Ransom-McKenna; Clifford F. Ransom II and Clifford F. Ransom III.

NOTES

326. Detail from the thirteenth-century al-Muzaffar mosque, Taiz.

1. Christian Robin, "The Mine of ar-Radrad: Al-Hamdani and the Silver of the Yemen," in *Yemen, 3000 Years of Art and Civilisation in Arabia Felix*, ed. Werner Daum (Innsbruck and Frankfurt am Main: Pinguin-Verlag, 1987), 123–24.

2. The rendition of the Sanaa bride in the frontispiece uses appropriate components, but is not a historical document. I followed as closely as possible the advice of Dr. Martha Mundy and Dr. Sylvia Kennedy on how to dress the Sanaa bride.

3. For an example of a *ma'naqa* see Ester Muchawsky-Schnapper, *The Yemenites: Two Thousand Years of Jewish Culture* (Jerusalem: The Israel Museum, 2000), 136.

4. I bought the two Alani paintings through a friend when I was not in Sanaa. I tried later to find him but was unable to do so. The gallery owner who sold his paintings has also been unable to find him.

5. Women from Jabal Milhan can be seen wearing jewelry like that in the Milhan section in the frontispiece and pp. 19 and 28 of Maria and Pascal Marechaux, *Arabian Moons: Passage in Time through Yemen* (Marseille: Concept Media Pte., 1987).

6. Salma Samar Damluji, *The Architecture of Yemen: From Yafi' to Hadramut* (London: Laurence King Publishing, 2007), 72–73.

7. Heather Colyer Ross, *Bedouin Jewellery in Saudi Arabia* (Clarens-Montreux, Switzerland: Arabesque Commercial SL, 1996), p. 111, shows a simpler necklace than that in fig. 141.

8. Painting by Said Alani, as described in note 3.

9. Photograph by S.U. Graf, ca. 1965. Published in Daum, *Yemen: 3000 Years of Art and Civilisation in Arabia Felix.*

10. Photograph by S.U. Graf, ca. 1965. Published in Daum, *Yemen: 3000 Years of Art and Civilisation in Arabia Felix.*

11. Anne van Cutsem, *A World of Bracelets: Africa, Asia, Oceania, America from the Ghysels Collection* (Milan: Skira Editore, 2002), 39, 101.

12. Although the three areas are close to each other geographically, Dali' was previously part of North Yemen.

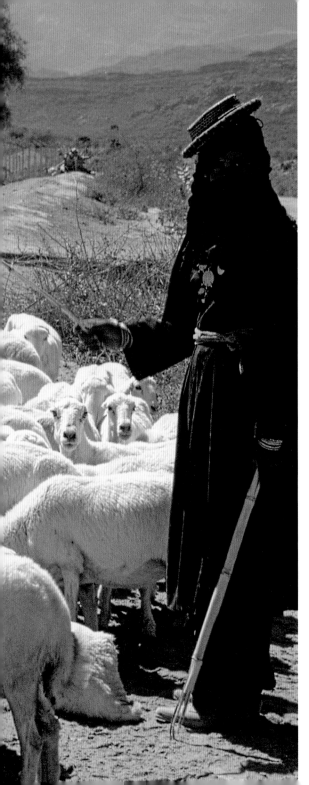

327. A Bedouin shepherdess

from the Mahwit area.

Adra, Najwa. "Steps to an Ethnography of Dance."
In *Viewpoints: Visual Anthropologists at Work*,
edited by Mary Strong and Laena Wilder,
228–53. Austin: University of Texas Press,
2009.

Ahroni, Reuben. *Yemenite Jewry: Origins, Culture, and
Literature*. Bloomington: Indiana University
Press, 1986.

Balfour-Paul, Jenny. *Indigo in the Arab World*. Oxford,
U.K.: Routledge, 2004.

Bochow, Karl-Heinz, and Lothar Stein. *Hadramaut:
Geschichte und Gegenwart einer südarabischen
Landschaft*. Leipzig: VEB F.A. Brockhaus Verlag,
1986.

Boxberger, Linda. *On the Edge of Empire*. Albany: State
University of New York Press, 2002.

Chambon, Philippe, Arnaud Maurières, and Eric
Ossart. *Reines de Saba: Itinéraires textiles au Yemen*.
Aix-en-Provence: Edisud, 2003.

Cheung, C., and L. DeVantier. *Socotra: A Natural
History of the Islands and Their People*. Science
editor K. Van Damme. Hong Kong: Odyssey
Books and Guides, 2006.

Crociani, Paola. *Portraits of Yemen*. Cairo: Hoopoe
Books, 1996.

Damluji, Salma Samar. *The Architecture of Yemen:
From Yafi' to Hadramut*. London: Laurence King
Publishing, 2007.

Daum, Werner, ed. *Yemen: 3000 Years of Art and
Civilisation in Arabia Felix*. Frankfurt am Main:
Pinguin-Verlag, 1987.

Del Mare, Cristina, and Alessandro de Maigret. *Coral
in the Traditional Ornaments and Costume of the
Yemen*. Naples: Electa, 2003.

Diamonti, Joyce. *Silver Speaks: Traditional Jewelry of
the Middle East*. Chevy Chase, Md.: The Bead
Society of Greater Washington/Publishers
Press, Inc., 2002.

Garner, Ron. "The Maker's Mark in Yemeni Jewelry."
Ornament 26, no. 4 (2003): 38–41.

Karkabi, Sami. *The Craftsmen of Hadramaut*. Lebanon:
Fondation Mohamed ben Laden pour les études
arabes et islamiques, 1989.

Kennedy, S.S.J. "Aqd Mirjan: A Ceremonial Necklace
from Yemen." *Ornament* 4, no. 1 (1979): 2–3.

Kirkman, James, ed. *City of San'a': Nomad and City*

BIBLIOGRAPHY

Exhibition. London: World of Islam Festival Publishing Company, 1976.

Klein-Franke, Aviva. "Yemenite Jewellery and Silverwork." In *San'a' History and Cultural Heritage*, edited by Saleh Ali Ba-Surra, vol. 2, 5–45. Sanaa: University of Sanaa and Almetha, 2005.

Lewcock, Ronald. *The Old Walled City of Sana'*. Paris: UNESCO, 1986.

Maréchaux, Maria, Pascal Maréchaux, and Dominique Champault. *Arabian Moons: Passages in Time through Yemen*. Marseille: Concept Media, 1987.

Messori, Rosetta, and Angela Di Maria. *Sana': Voices from the Capital of Yemen*. Rome: Fratelli Palombi Editori, 2000.

Morris, Miranda, and Pauline Shelton. *Oman Adorned: A Portrait in Silver*. Muscat and London: Apex Publishing, 1997.

Muchawsky-Schnapper, Ester. *The Yemenites: Two Thousand Years of Jewish Culture*. Jerusalem: The Israel Museum, 2000.

Mundy, Martha. *Domestic Government: Kinship, Community, and Polity in North Yemen*. London: I.B. Tauris, 1995.

Paine, Sheila. *Embroidered Textiles: Traditional Patterns from Five Continents*. London: Thames and Hudson, 1990.

Rakow, Rosalie, and Lynda J. Rose. *Sana'a, City of Contrast*. Burke, Va.: Tandem Publishers, 1981.

Ransom, Marjorie. "The Enduring Craft of Yemeni Silver." *Saudi Aramco World*, January/February 2012, 32–37.

Robin, Christian. "The Mine of ar-Radrad: Al-Hamdani and the Silver of the Yemen." In *Yemen: 3000 Years of Art and Civilisation in Arabia Felix*, edited by Werner Daum, 123–24. Frankfurt am Main: Pinguin-Verlag, 1987.

Ross, Heather Colyer. *Bedouin Jewellery in Saudi Arabia*. New and revised edition. Clarens-Montreux, Switzerland: Arabesque Commercial SL, 1996.

Ruthven, Malise. *Freya Stark in Southern Arabia*. Reading, U.K.: Garnet Publishing, 1995.

Scott, Hugh. *In the High Yemen*. London: John Murray, 1947.

Searight, Sarah. *Yemen: Land and People*. London: Pallas Athene, 2002.

Semple, Clara. *A Silver Legend: The Story of the Maria Theresa Thaler*. London: Barzan, 2005.

Simpson, St. John, ed. *Queen of Sheba: Treasures from Ancient Yemen*. London: The British Museum Press, 2002.

Stark, Freya. *The Southern Gates of Arabia: A Journey in the Hadhramaut*. London: John Murray, 1936.

Topham, John, Anthony Landreau, and William E. Mulligan. *Traditional Crafts of Saudi Arabia*. London: Stacey International, 1982.

Untracht, Oppi. *Jewelry Concepts and Technology*. New York: Doubleday, 1982, 1985.

van Cutsem, Anne. *A World of Bracelets: Africa, Asia, Oceania, America from the Ghysels Collection*. Milan: Skira Editore, 2002.

Varanda, Fernando. *Art of Building in Yemen*. London: Art and Archaeology Research Papers, 1981.

Weir, Shelagh. *A Tribal Order: Politics and Law in the Mountains of Yemen*. Austin: University of Texas Press, 2007.

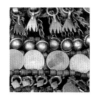

INDEX